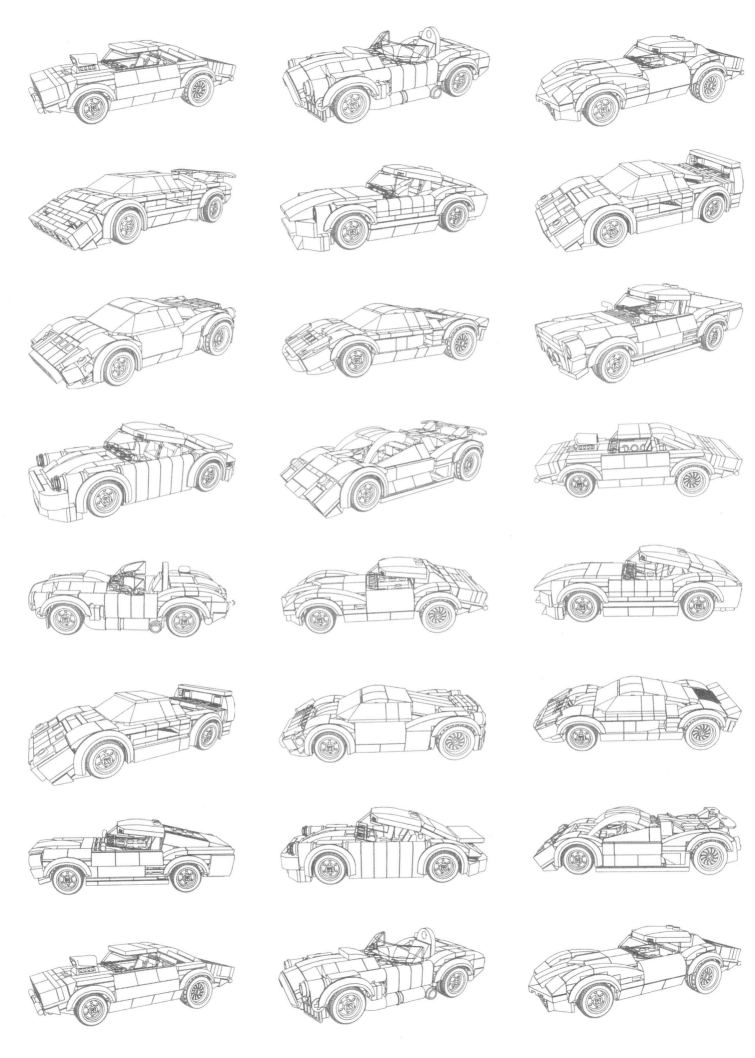

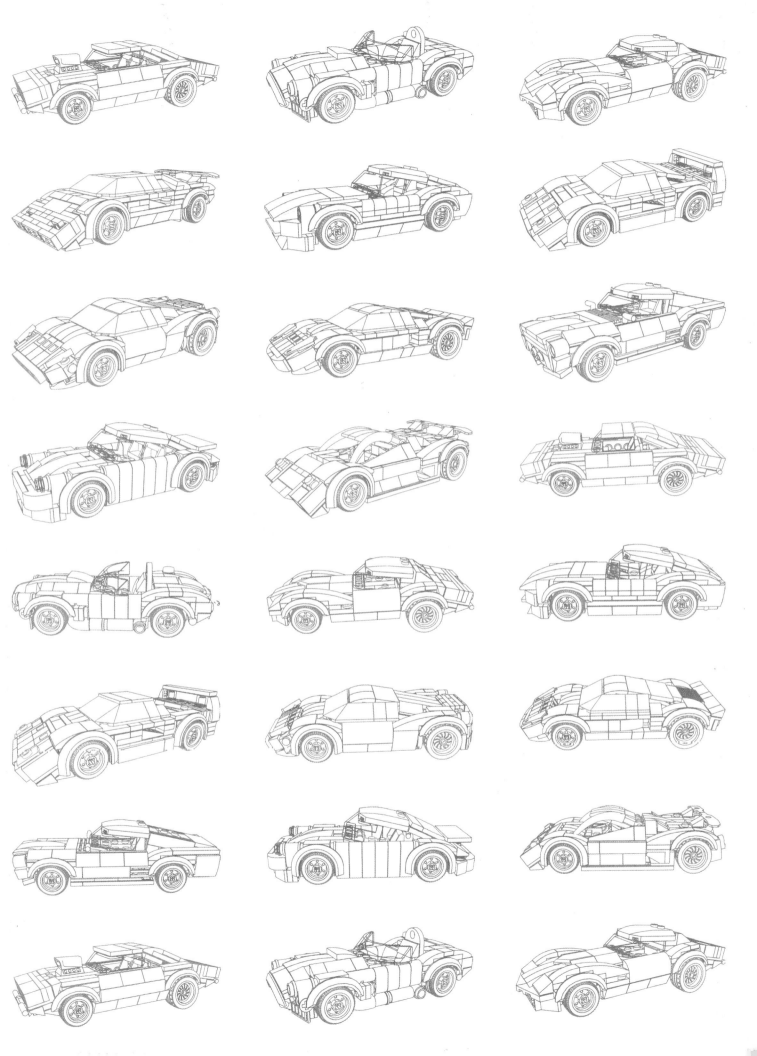

Acknowledgments

First and foremost, my thanks goes to Marcello from NuiNui for reaching out and asking me to work on this magnificent book on one of my greatest passions: cars. Next, I'd like to thank the person who contributed the most to the making of this volume, George Panteleon, for his commitment and dedication in creating fantastic LEGO® models. My heartfelt thanks for the many sleepless nights he spent creating the minutely accurate replicas you'll find in this book.

I'd also like to thank expert CAD designer Damien Roux for his unconditional support in designing high-quality CAD bricks for my renderings. And, once again, thanks to everyone who helped me with this book and the previous ones: Denis Trofimov from the MAXscript community, for providing a fundamental piece of code for my CG scripts; Trevor Sandy from the LDraw community for his constant work to improve the LPub3D software for building instructions; Robert Lansdale for his invaluable support with his Okino Graphics conversion software; Patrick Rota for helping me with the toolchain for the Python scripts and, last but not least, Nelson Painço, because my renderings wouldn't be so realistic without his initial support, years ago. Special thanks to my friend and colleague Oliver Avram for coming to my aid with his knowledge of cars and to Nathanael Kuipers for helping out in the early stages of the project.

Thanks to the entire NuiNui team for an outstanding collaboration and for giving me so much freedom.

Thanks to my children—Leonardo, Luna, and Giordano—for putting up for so long with a dad who was always on his laptop.

And finally, my greatest thanks go to someone who has worked so hard behind the scenes to make it all happen: my wonderful wife, Fabiola. Thank you, with all my heart.

Thank you all for your invaluable support!

The authors

MATTIA ZAMBONI

Mattia Zamboni has a great passion for computer
graphics, photography and cars, which he loves
to build out of LEGO® bricks. He has written several
LEGO® books, including the LEGO® Build-It Book series
and Tiny LEGO® Wonders, as well as contributing to
other successful volumes. He's a member of the Swiss
Italian LEGO® Users Group (SILUG), for which he has
held the position of LEGO® Ambassador.
He's currently a researcher in the robotics lab of the
University of Applied Sciences and Arts of Southern
Switzerland (SUPSI), where he specializes in artificial
vision systems. In his free time, he pursues his passion
for 3D computer graphics.
Check out his website at www.brickpassion.com.

GEORGE PANTELEON

Born and raised in Greece, George Panteleon studied
and worked as a naval engineer, but LEGO® bricks have
always been his greatest passion.
Over the years, he has created a wide range of works of
LEGO® art with a tendency towards scale model-making,
from small cars to large sculptures. His works have
been featured in several LEGO® books and magazines.
He's known as ZetoVince in the LEGO® community.
He's a co-founder and executive member of the Greek
LEGO® Users Group (Gricks), which organizes and
sponsors LEGO® brick events aimed at promoting this
hobby in Greece. Check out his creations at
www.instagram.com/zetovince and on Flickr.

If you can't afford them... build them!

The Dream Car theme is thrilling to many people all over the globe, including the authors of this book. All car lovers dream of someday being able to drive—or even own!—one. And until then, you can have fun with this book.

In it you can find a selection of some of the most epic cars that, quite literally, have made history. Enjoy reading information, technical specifications and amusing trivia about each car... and then roll up your sleeves and get ready to build them for real! Build all the models described in the book and discover a whole range of building techniques—the basis for creating small-scale models that maintain the characteristic lines that make them immediately recognizable—thanks to the detailed, step-by-step instructions included. So get ready to unleash your creativity and build your very own LEGO® Dream Cars!

Using the link or the QR code for each model, you can download to your PC, Mac, or tablet a compressed (.zip) file containing:
· an MS Excel® spreadsheet with a list of the LEGO® pieces you need
· an MP4 file with a video of the instructions
· a Wanted List in .bsx format to upload directly to the Bricklink marketplace (www.bricklink.com) so you can purchase the LEGO® pieces required to build each model.

For additional resources you can also check out the dedicated website www.brickpassion.com/lego-dream-cars

Where to find your bricks

To get the most out of this book, all you need is enthusiasm... and bricks. You may not own all the pieces you need, but don't worry—that's perfectly normal. So be creative—build your model in a different color or try for another solution!

However, if you do need to buy individual bricks, you have several options:

• The official LEGO® website (https://shop.lego.com/en-US/Pick-a-Brick)
• BrickLink (www.bricklink.com), a well-stocked international marketplace that sells new and used bricks
• Brick Owl (www.brickowl.com), a website that sells individual bricks
• Brick Scout (https://brickscout.com/), a website that sells sets, individual bricks and Minifigures
• eBay and other valid online auction sites
... just to name a few.

By searching the web you may even be able to find a local shop!

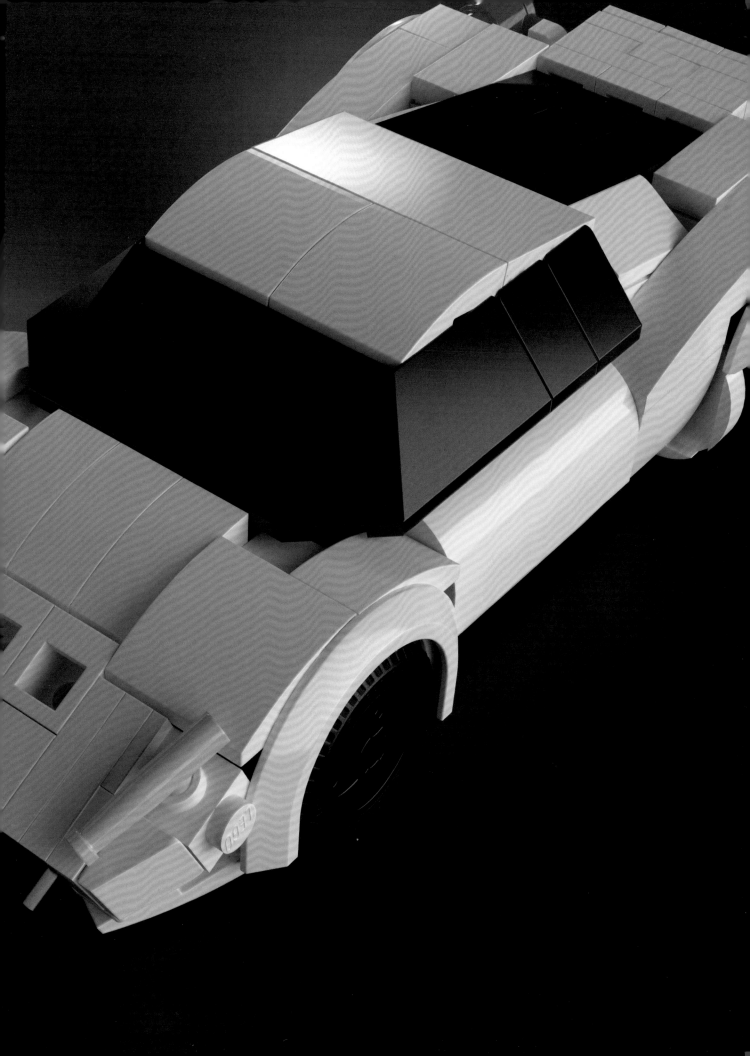

Table of contents

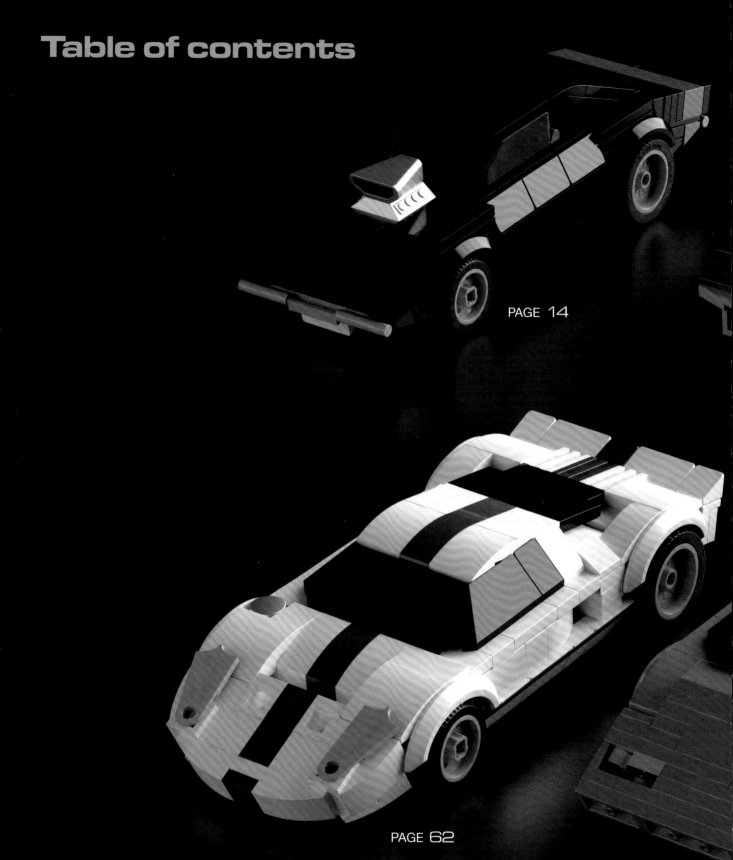

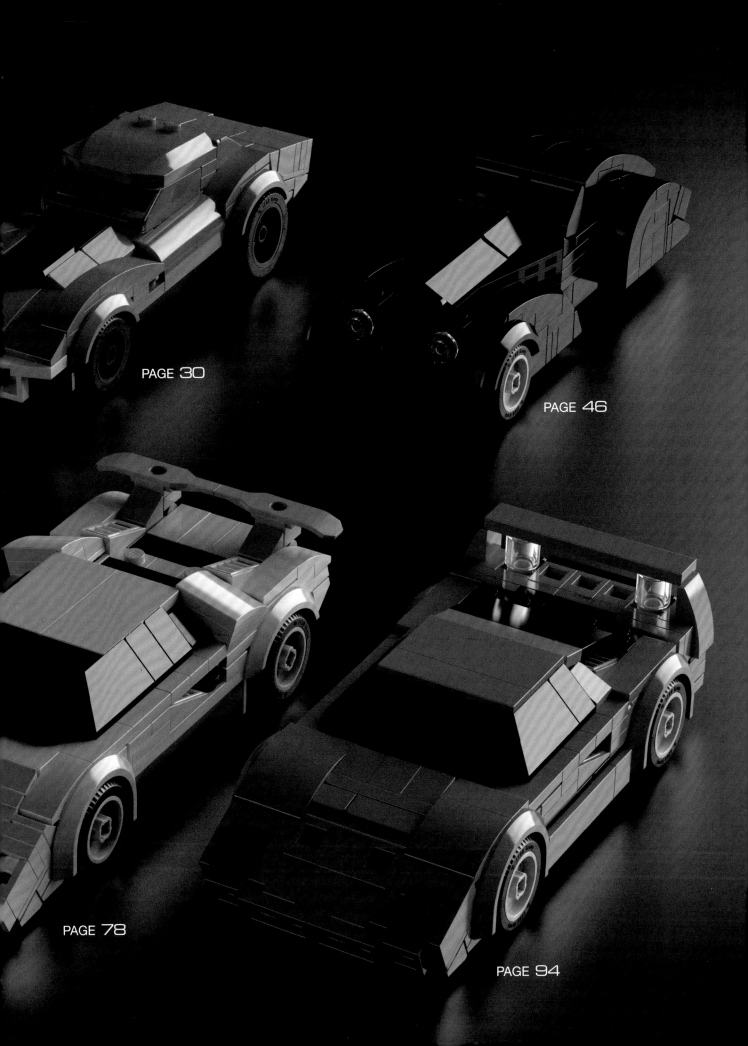

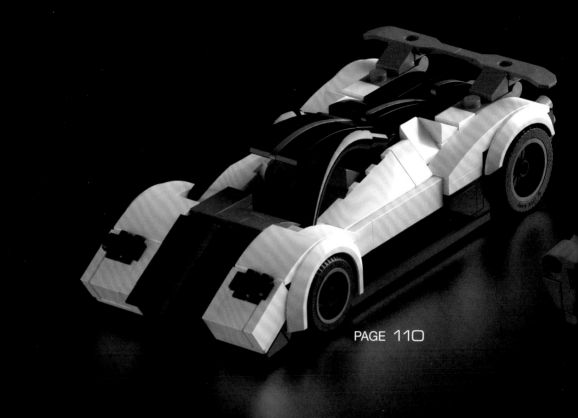

PAGE 110

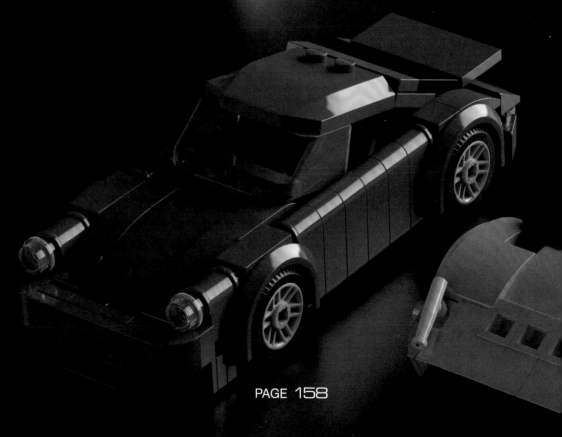

PAGE 158

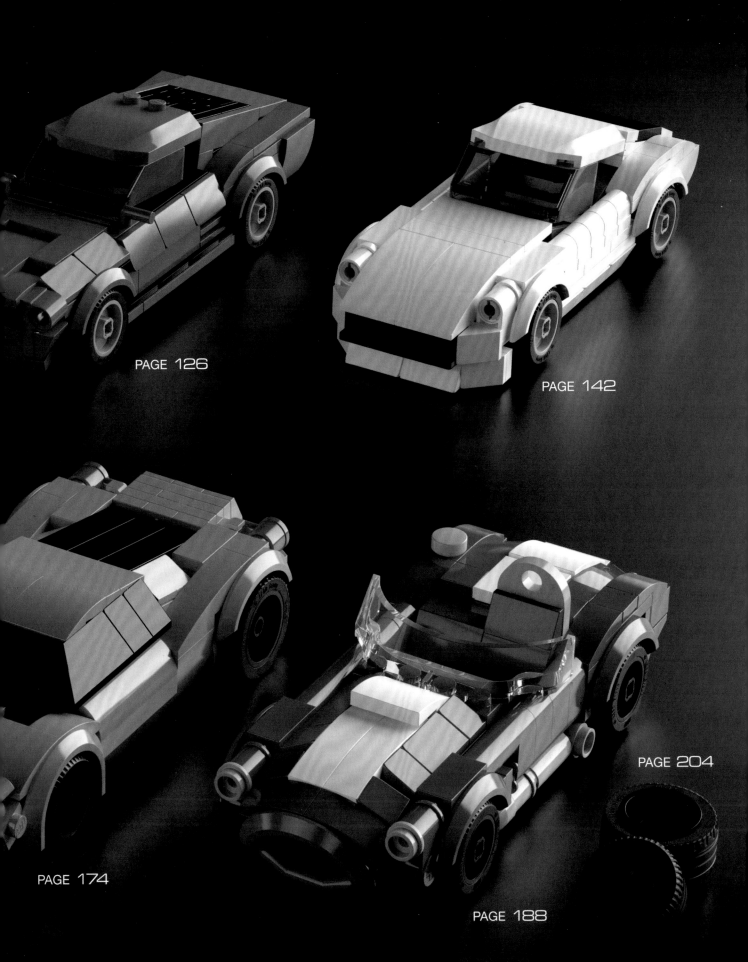

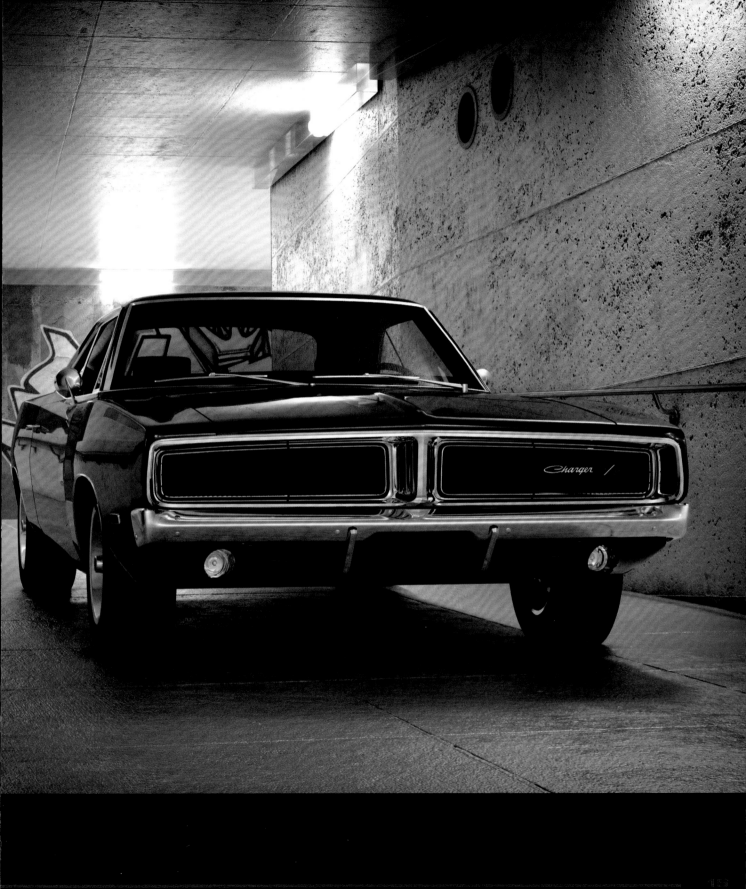

The Charger was Dodge's answer to the "muscle car", a vigorous sports model that was sweeping across the US in the '60s. Introduced in 1966, the Charger was in its second generation three years later, and the '69 model, distinctive then as now, was the star of the series. With its imposing size and bad-boy front end, the Charger stood out from the rest of the pack because of its unique "electric razor" grille that completely covered the headlights.

The R/T model (from Road/Track), introduced to enhance the Charger's muscular image, had the most features. There was the powerful 7.2-liter 440 Magnum engine (capable, with appropriate modifications, of doing wheelies and burning rubber) or the optional, excellent 7-liter HEMI with hemispheric combustion chambers.

Several versions of the Charger competed in NASCAR races, achieving varying amounts of success, although this never tarnished the model's mythical image. In any case, this image was born and evolved outside the world of racing, in television and movies. This ensured everlasting fame for the Charger '69 among a much larger segment of the public. Who can forget the bright orange "General Lee" with the Confederate flag on the roof from the TV series *The Dukes of Hazzard*? Its crazy acrobatics, although contrived, brought about the destruction of several cars in each episode, so much so that of the 300 original vehicles used in the series, fewer than 20 made it all the way to the end. And let's not forget the *supercharged* version in the seminal *The Fast and the Furious*, a stellar success celebrating the speed and competition inherent to the spirit of the Charger. Beauty, power, and show biz: these are what created the Charger myth.

GENERAL DESCRIPTION:

Years produced:	1968-1970
Number produced:	89,199
Average price:	$3,600
Estimated present market value:	$33,100
Model it replaced:	Charger I generation
Replaced by:	Charger III generation

PHYSICAL CHARACTERISTICS:

Dimensions:	17.4 x 6.4 x 4.4 ft
Weight:	3,924 lb

POWER:

Maximum speed:	143 mph
Acceleration:	0-60 in 5.6 seconds
Fuel consumption:	8.4 mpg

ENGINE:

Number of cylinders:	V8
Displacement:	425.58 cu. in.
Engine power:	425 hp
Drive:	rear-wheel drive

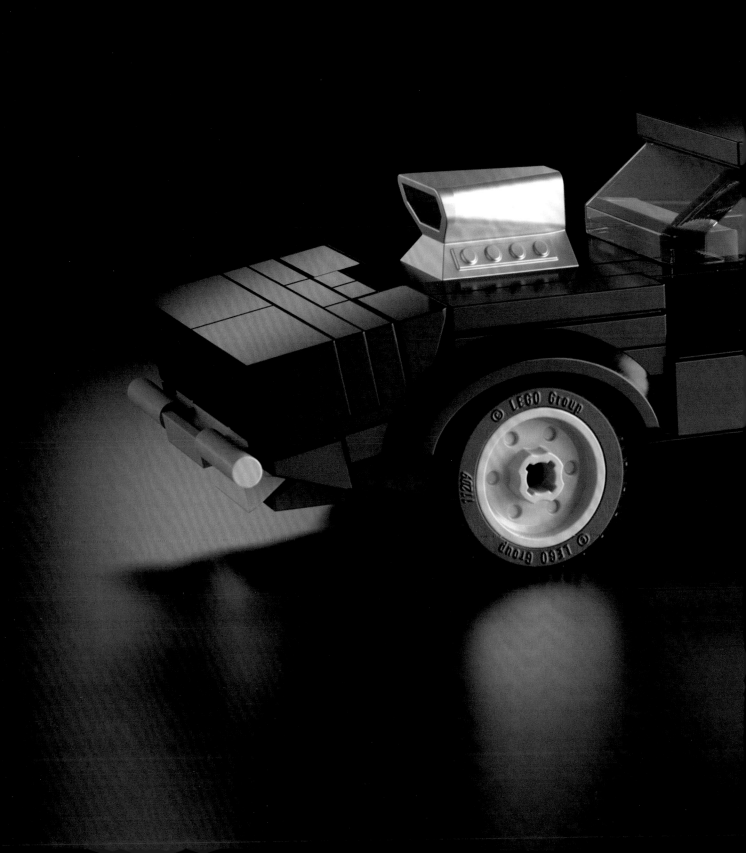

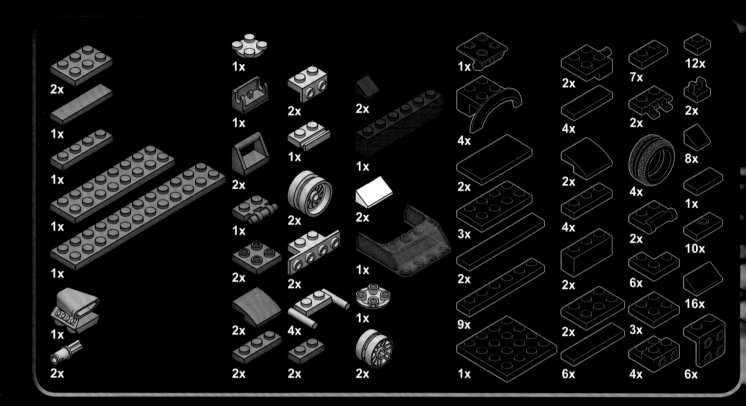

2x · 1x · 1x · 1x · 1x · 1x · 2x

1x · 1x · 2x · 1x · 2x · 2x · 2x · 2x

2x · 2x · 1x · 4x · 2x

2x · 2x · 1x · 2x · 2x · 1x · 1x · 2x

1x · 4x · 2x · 2x · 3x · 2x · 2x · 9x · 1x

2x · 4x · 2x · 4x · 2x · 2x · 6x

7x · 2x · 3x · 4x · 6x

12x · 2x · 8x · 1x · 10x · 16x · 6x

LEVEL OF DIFFICULTY

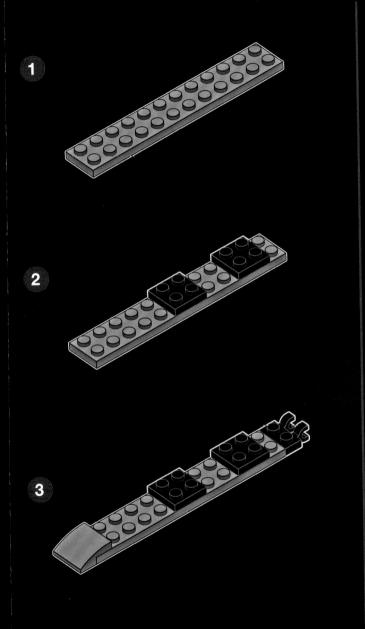
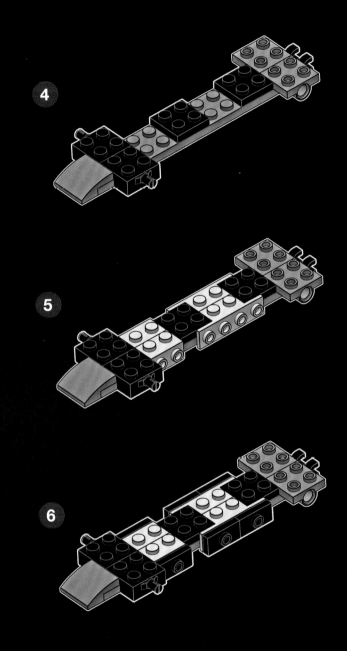

7

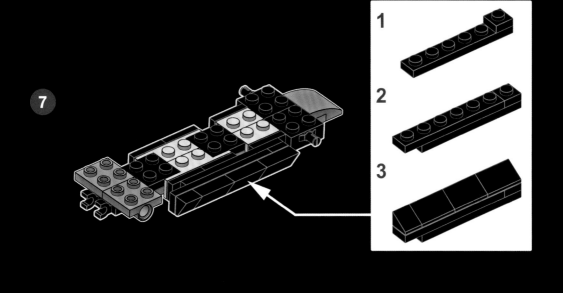

1

2

3

8

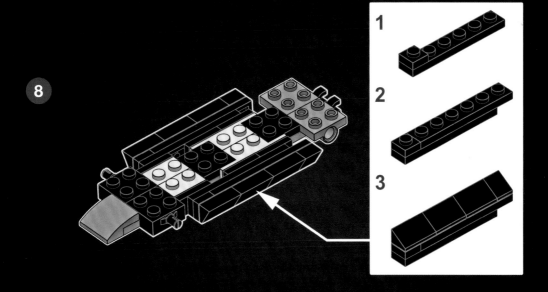

1

2

3

9

10

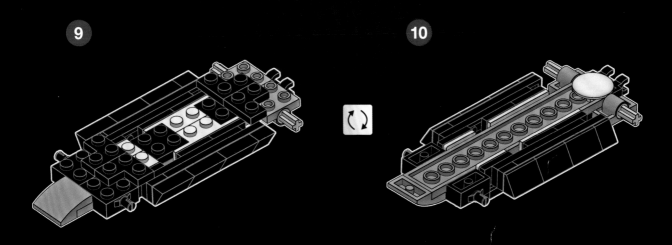

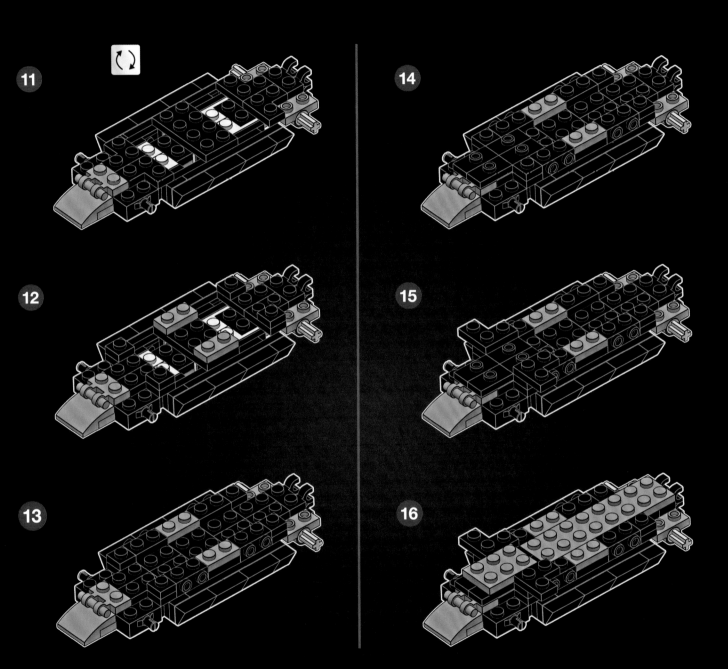

11

12

13

14

15

16

17

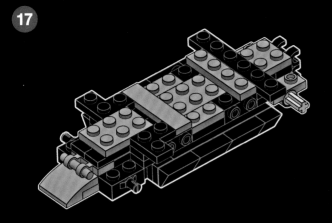

19

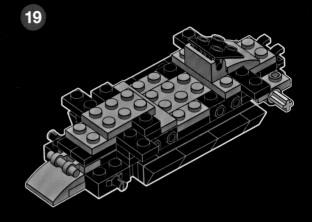

18

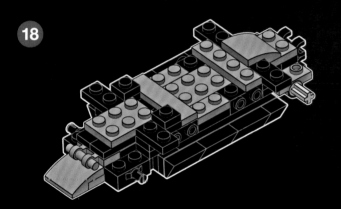

20

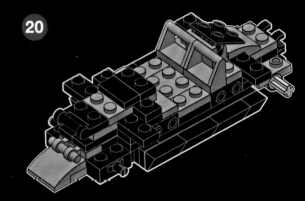

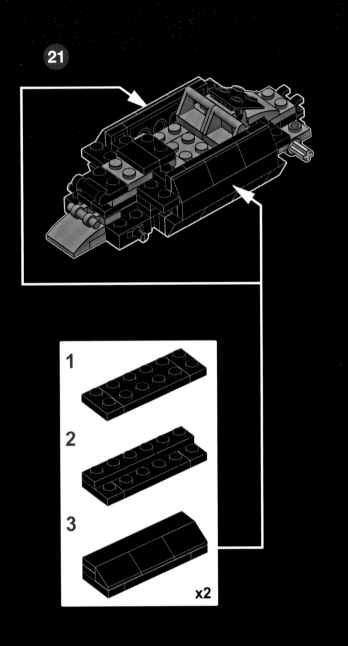

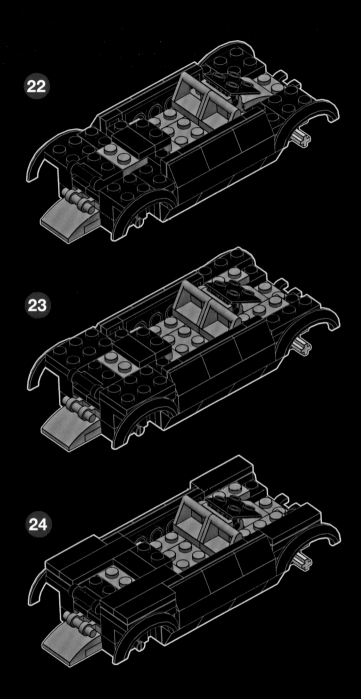

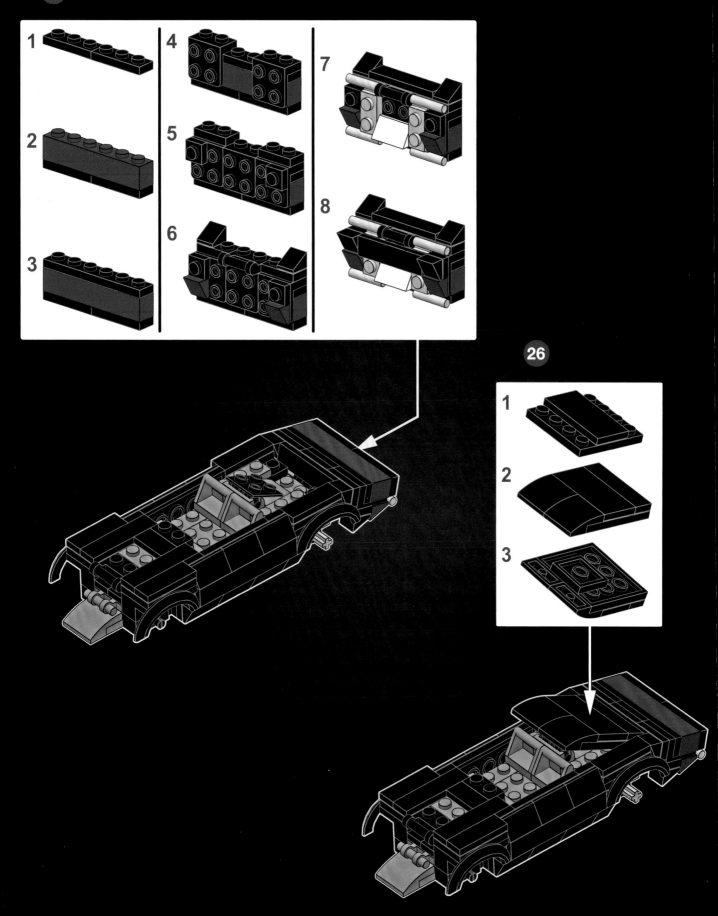

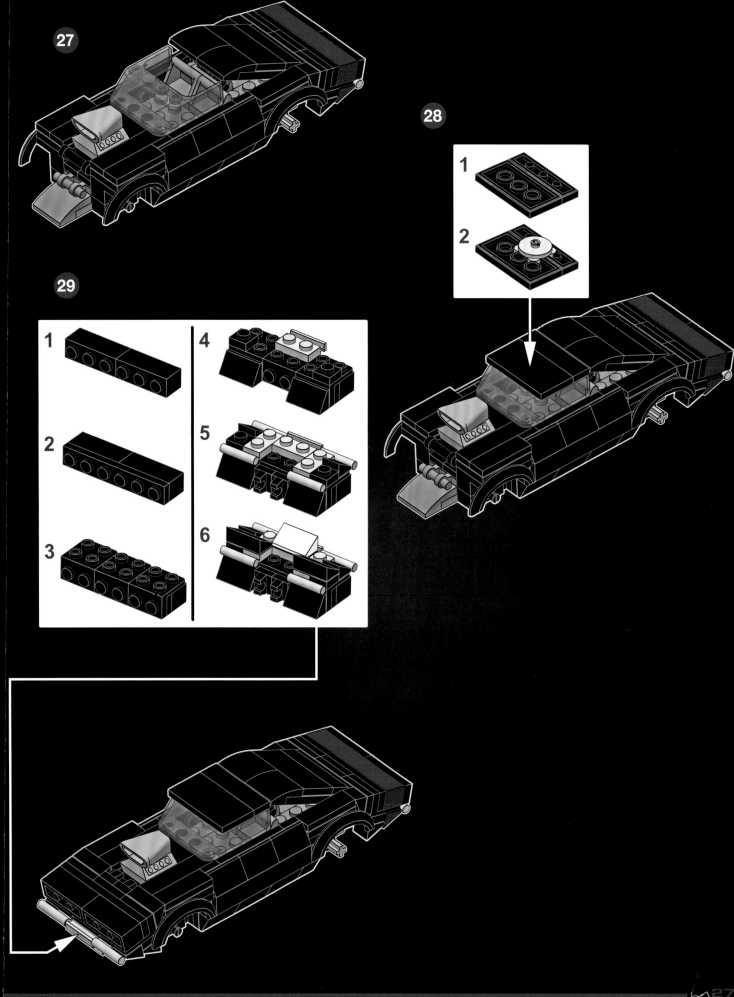

30

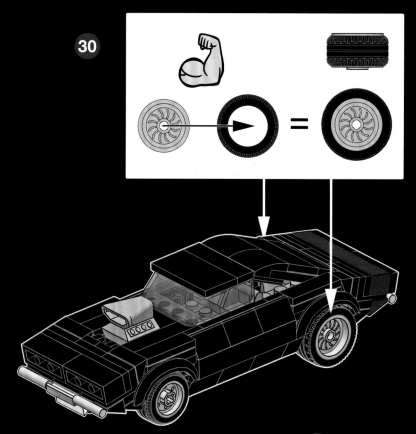

B Bonus step

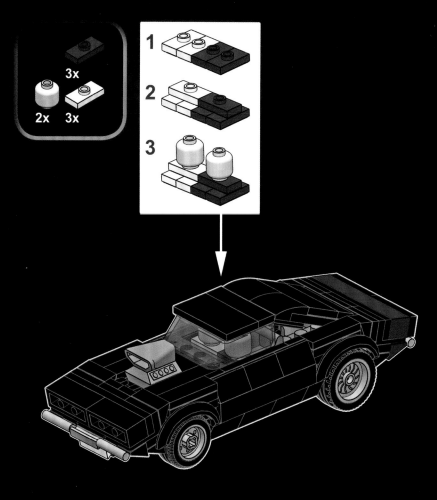

Alternative Versions

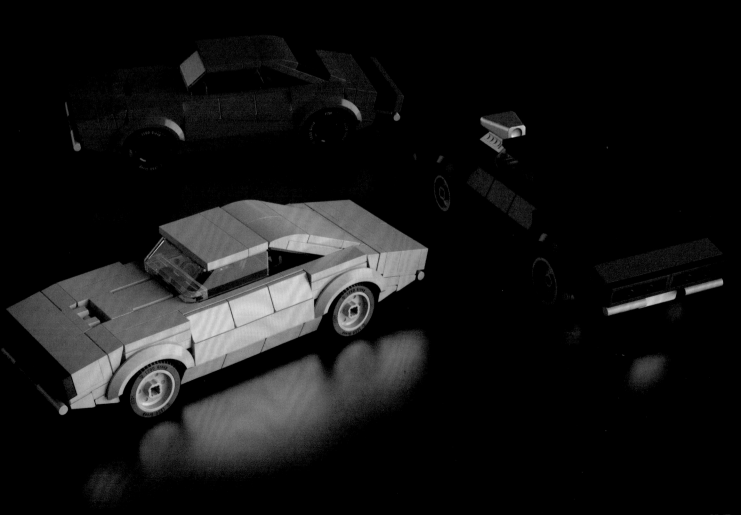

CORVETTE
Stingray

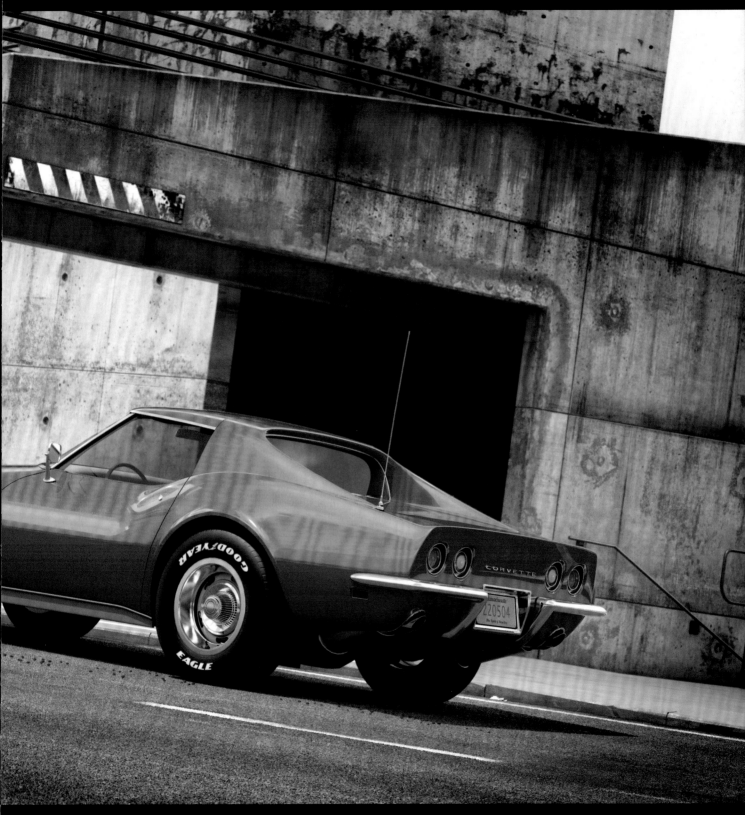

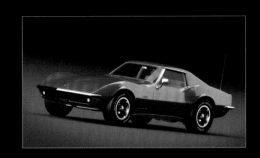

One of the most sought-after sport coupes of all time, the Corvette Stingray (C3) was an outgrowth of the Sting Ray concept, developed by Larry Shinoda in 1963. It belongs to the third generation of the Chevrolet Corvette, hence the C3 designation. This generation is also known as the "Mako Shark II", an appropriate name, as it was inspired by the form and even the color of the fearsome mako shark. The Stingray model, produced from 1969 to 1976, was at the pinnacle of aerodynamic design, thanks to its V8 big-block engine that put out 430 hp and marked the apogee of Corvette performance, competing successfully in the Gran Turismo category starting in 1969.

Endowed with the sleek elegance of a predator and advanced technology, the Stingray was a precursor of the Corvette of the future, and, as such, morphed directly into the consumer version, the Corvette C3. At the peak of the engine's power, however, the adoption of catalytic converters and new norms for emissions control gradually brought about a reduction in its size, culminating in the 200 hp 1982 small-block model.

The decrease in power took nothing away from the strength of the myth, though, as we can see from two curious facts. First, in spite of Chevrolet's efforts to keep the car's launch a secret, the 1968 Corvette appeared in toy stores before it showed up in auto shows, eventually providing an amusing anecdote for collectors even in a scale of 1:64. Second, at a certain point in its history, the Corvette became the "car of the astronauts", since many of the bold explorers of space made it their car of choice. This meant lots of free publicity, although it seems that in order to convince the astronauts to purchase a Corvette, the car dealer near the Space Center offered them a special price.

SPECIFICATIONS

GENERAL DESCRIPTION:

Years produced:	1968-1982
Number produced:	542,741
Average price:	
	$4,663 (1968) to $18,290 (1982)
Estimated present market value:	
	$19,700 to $43,300
Model it replaced:	Stingray C2
Replaced by:	Stingray C4

PHYSICAL CHARACTERISTICS:

Dimensions:	15.1 x 5.8 x 4 ft
Weight:	3,520 lb

POWER:

Maximum speed:	130 mph
Acceleration:	0-60 in 6.9 seconds
Fuel consumption:	12.7 mpg

ENGINE:

Number of cylinders:	V8
Displacement:	326.72 cu. in.
Engine power:	300 hp
Drive:	real-wheel drive

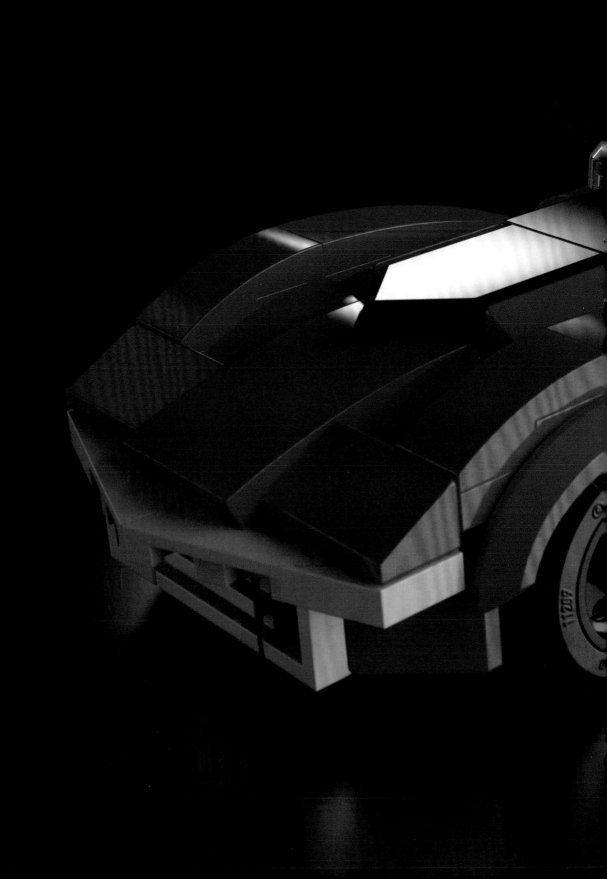

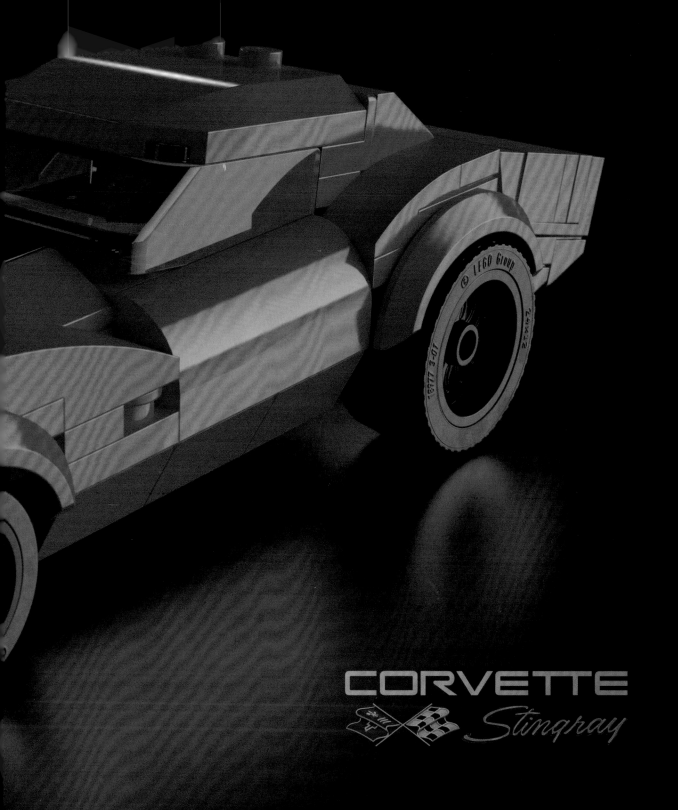

CORVETTE Stingray

CORVETTE Stingray

4x
2x
1x
2x
3x
1x
2x
2x

2x
1x
1x
2x
1x
2x
1x
2x
1x

1x
1x
1x
2x
2x
1x
1x

1x
2x
4x
1x
2x
2x
3x
1x

2x
2x
2x
3x

2x
4x
6x
2x
2x
6x
7x
2x 15x

2x
1x
1x
1x
2x
1x
2x
1x
2x

2x
1x
1x
2x
1x
2x
2x
1x

1x
2x
2x
2x

LEVEL OF DIFFICULTY

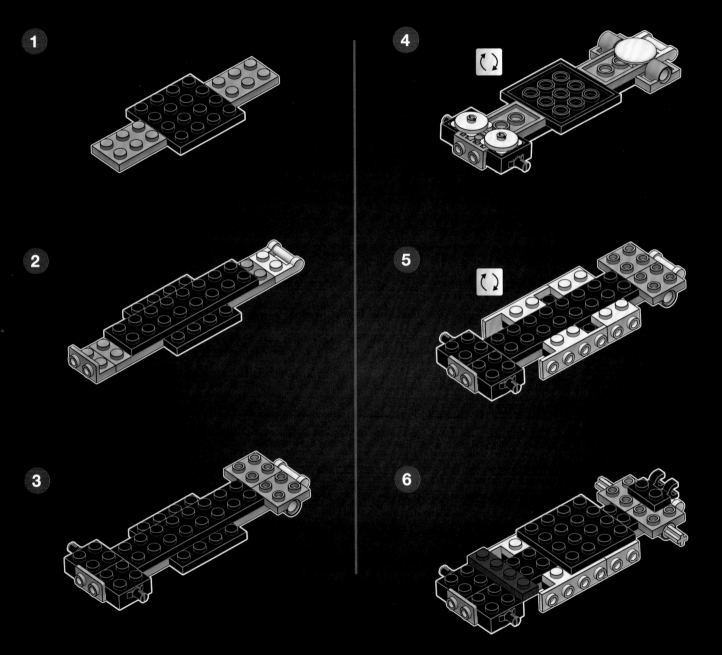

7

9

8

10

11

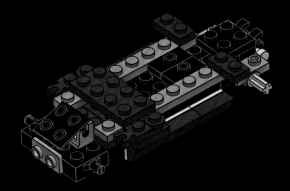

12

13

1

2

3

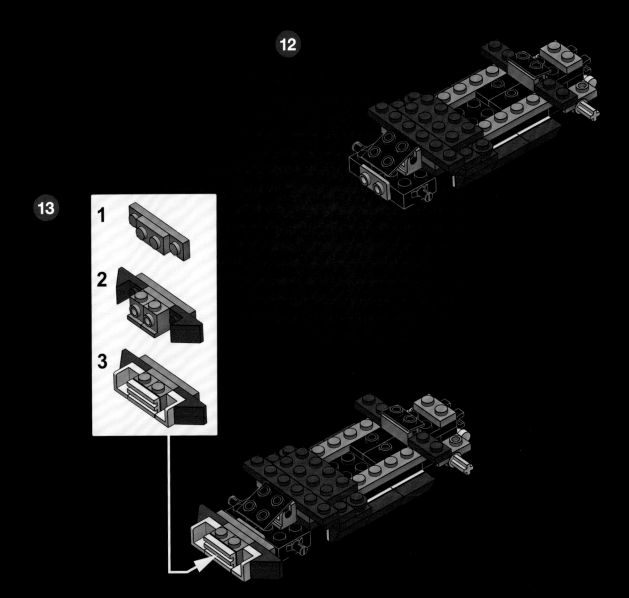

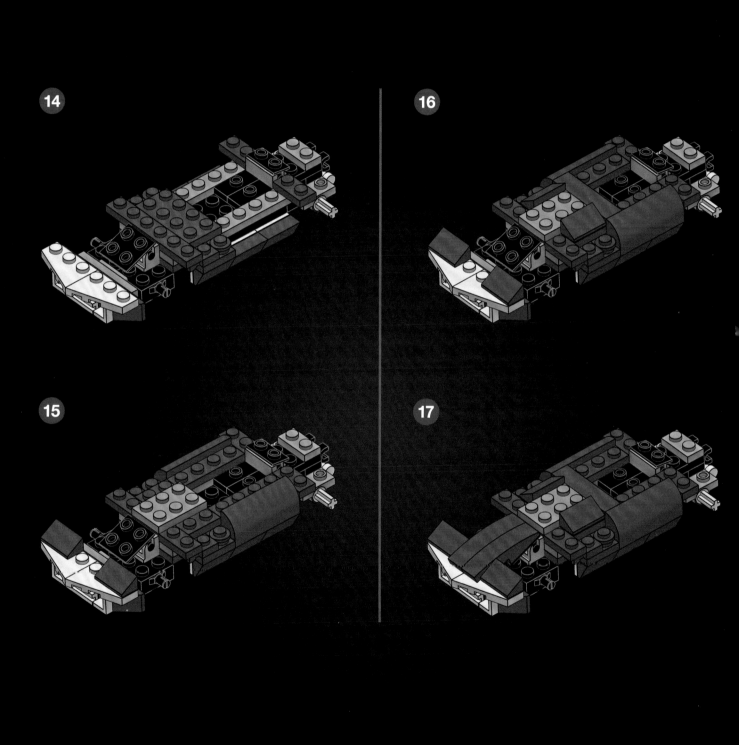

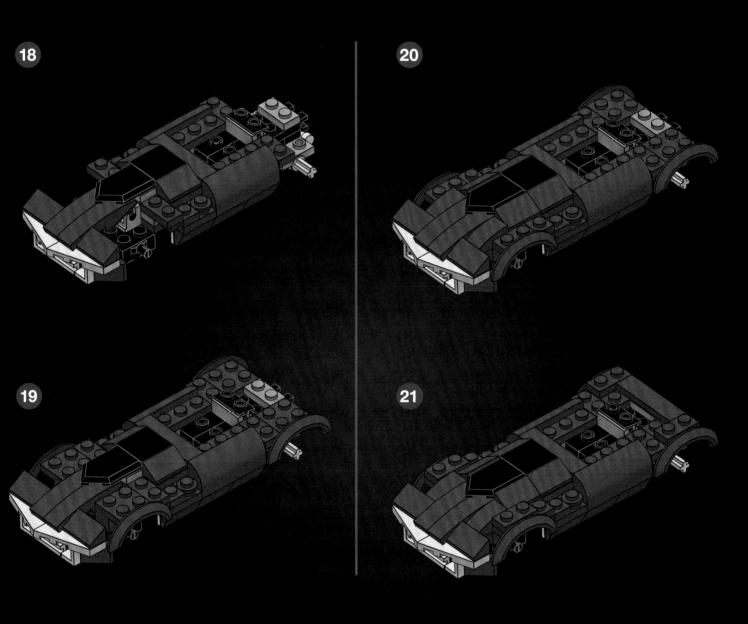

18

19

20

21

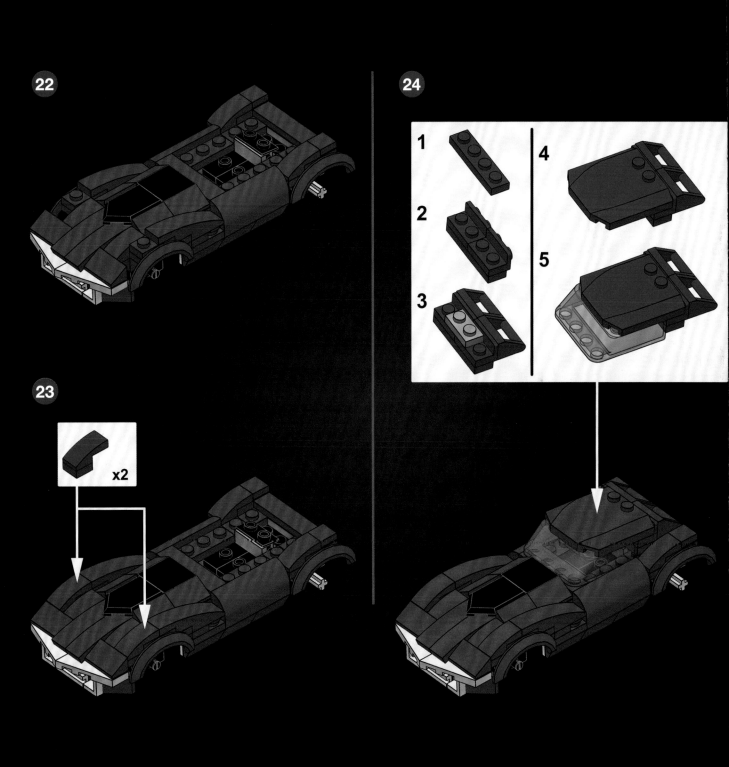

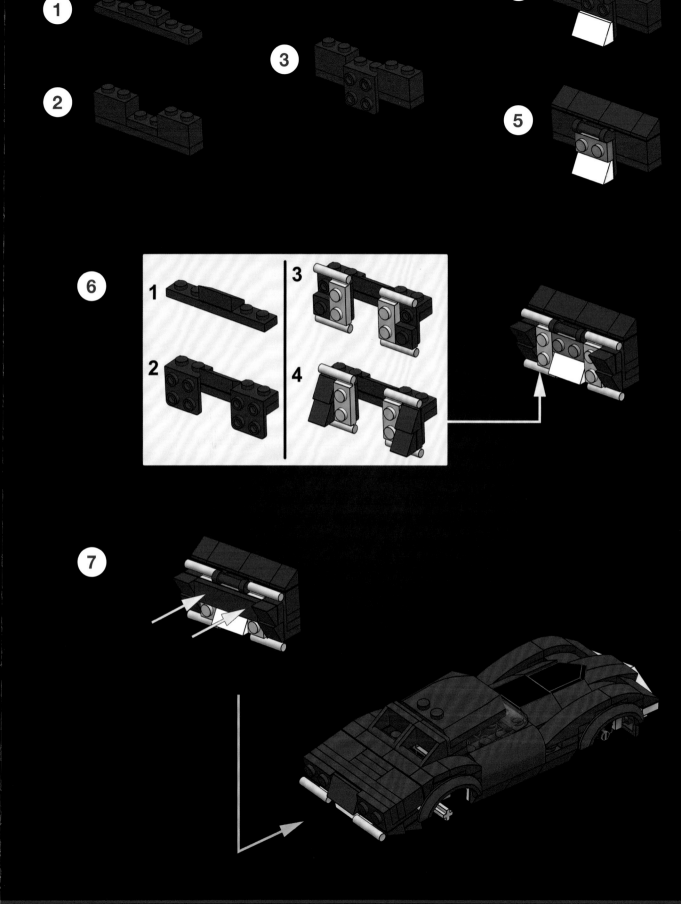

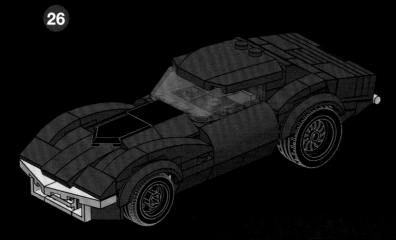

B Bonus step

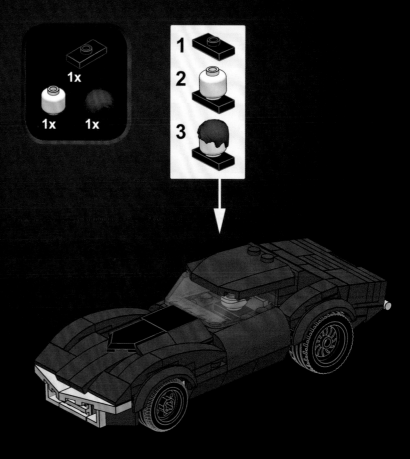

Alternative Versions

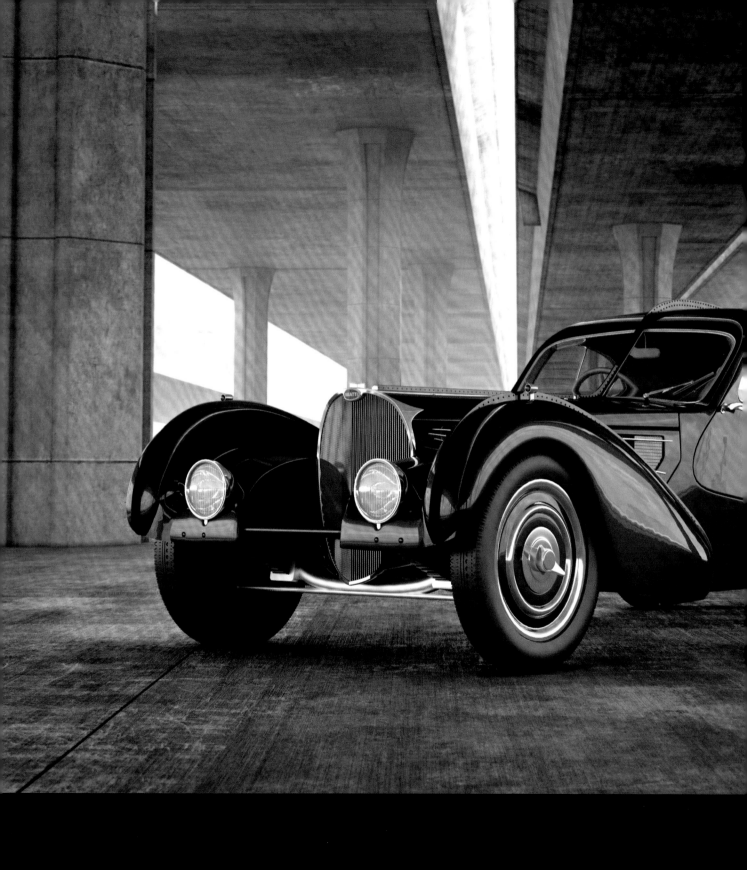

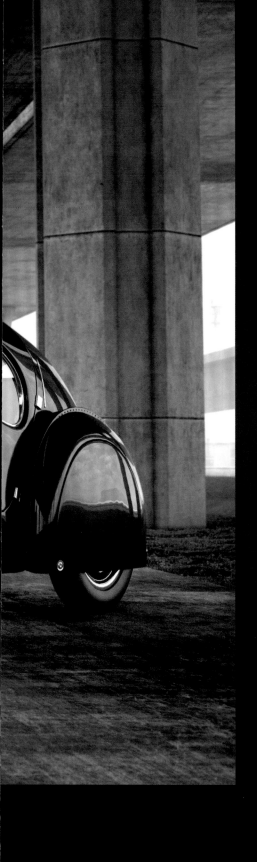

BUGATTI
ATLANTIC

Type 57SC

BUGATTI
ATLANTIC

Type 57SC

HISTORY

The history of the Bugatti Atlantic Type 57SC, considered by many to be the most beautiful car ever made, is as thrilling as any adventure story. Produced in 1936, the Atlantic wedded the successful 1934 Type 57 to the Aérolithe prototype of 1935. The Aérolithe's aeronautical design was straight out of science fiction. Its magnesium and aluminum body (Elektron alloy) was difficult to weld (and therefore was riveted together) but caught on fire easily. To resolve this problem, Bugatti redesigned the Atlantic entirely in aluminum but kept the rivets and the disquieting look of the Aérolithe, with its conspicuous dorsal fin. The chassis was then lowered ("surbaissé" in French, hence the S in the model name), and a compressor (supercharger) was added (hence the C) to enhance the already powerful straight-eight engine that propelled the Atlantic to 130 mph. There were a few shortcomings: above 37 mph, the engine noise became almost deafening (with the compressor installed), visibility was poor, and the interior became unbearably hot in the summer. But being beautiful can forgive many things... especially since only four of these cars were produced.

Production of the Atlantic 57SC began in 1937. The cars survived World War II intact, but one vanished, hidden in Bordeaux to avoid its being requisitioned by the Nazis and never seen again. The Aérolithe prototype also disappeared, perhaps disassembled for spare parts. Of the three remaining Atlantics, one was wrecked in a collision with a train in 1955 and reconstructed a few years later, while another was sold in 2010 for $30 million, purportedly the highest price ever paid for an automobile. As a fitting ending to the story, the last two Atlantics surviving in their original condition were given awards at the Concours d'Elegance, in Pebble Beach, California, where, unsurprisingly, the most out-of-this-world Dream Cars of all time strut their stuff.

SPECIFICATIONS

GENERAL DESCRIPTION:

Years produced:	1936-1938
Number produced:	4
Average price:	N/A
Estimated present market value:	
	$30,000,000 to $40,000,000
Model it replaced:	Bugatti Type 49
Replaced by:	Bugatti Type 101

PHYSICAL CHARACTERISTICS:

Dimensions:	wheelbase 9.8 ft x 4.4 ft
	(wheelbase/axle width)
Weight:	3,417 lb

POWER:

Maximum speed:	130.5 mph
Acceleration: 0-60:	less than 10 seconds
Fuel consumption:	N/A

ENGINE:

Number of cylinders:	inline 8
Displacement:	198.75 cu. in.
Engine power:	197 hp
Drive:	rear-wheel drive

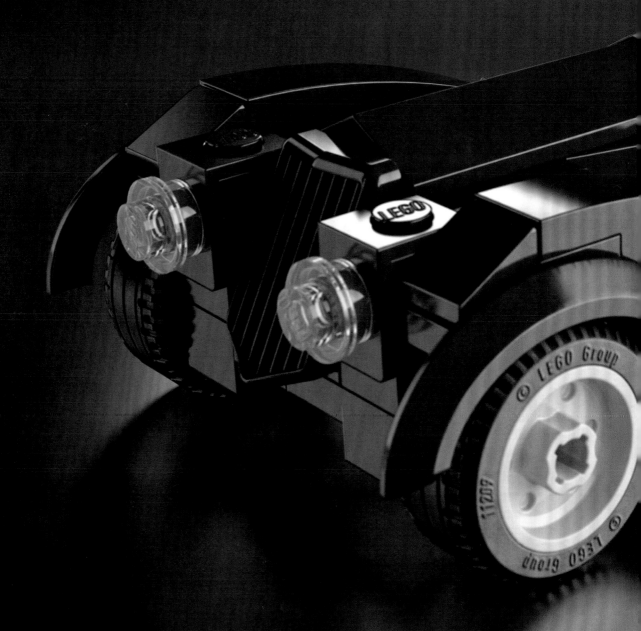

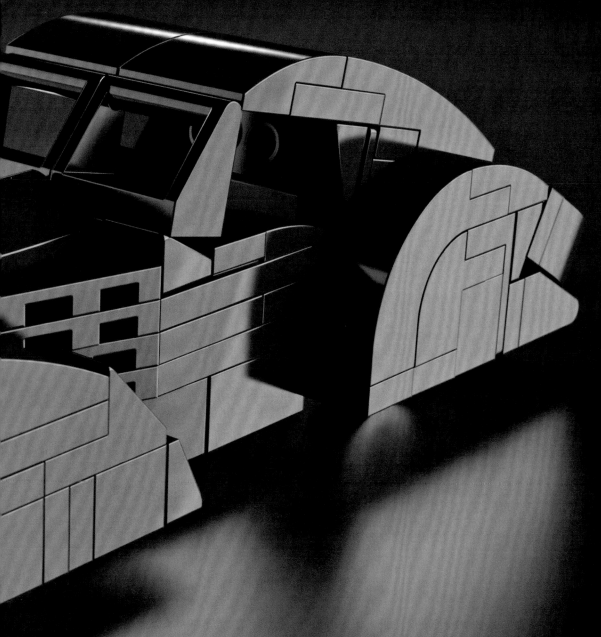

BUGATTI
ATLANTIC

Type 57SC

BUGATTI
ATLANTIC

Type 57SC

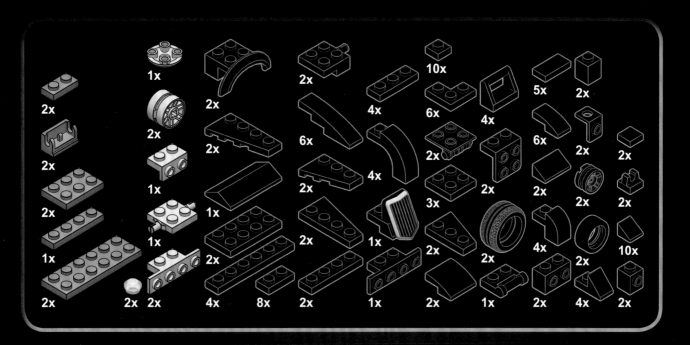

LEVEL OF DIFFICULTY

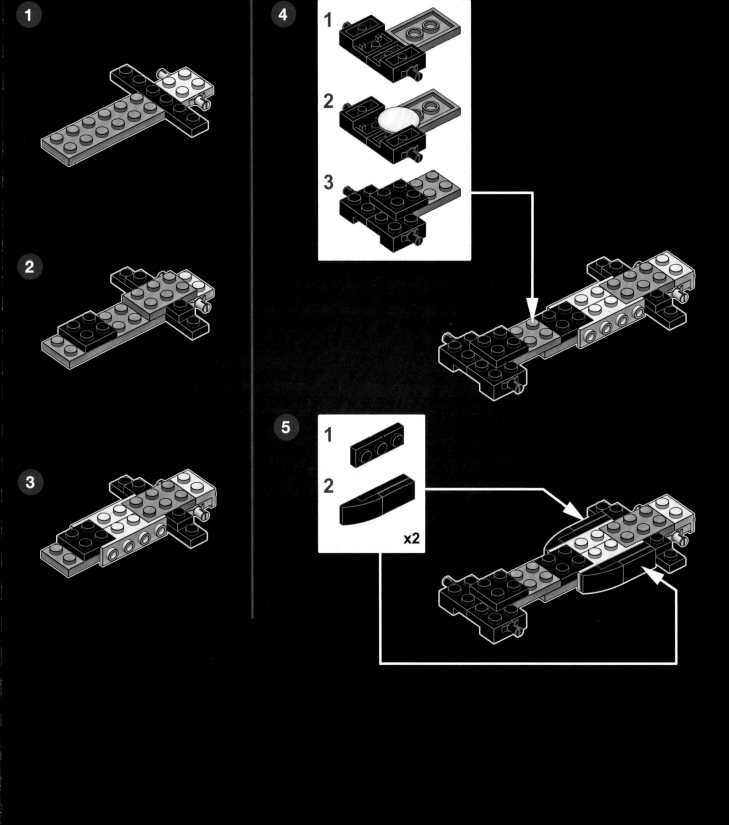

6

7

8

1

2

9

10

12

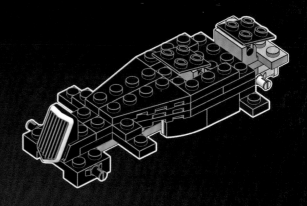

11

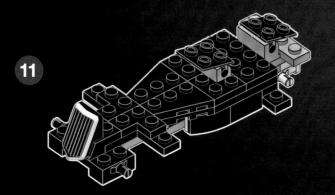

13

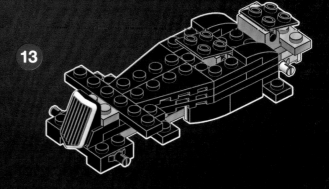

14

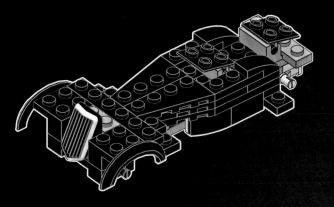

15

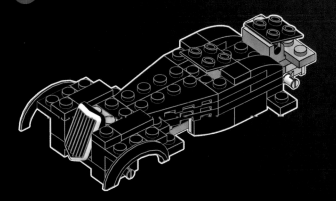

16

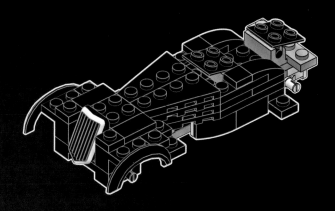

17

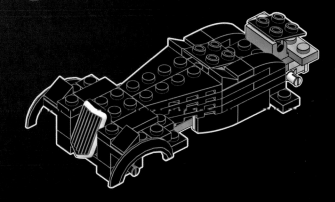

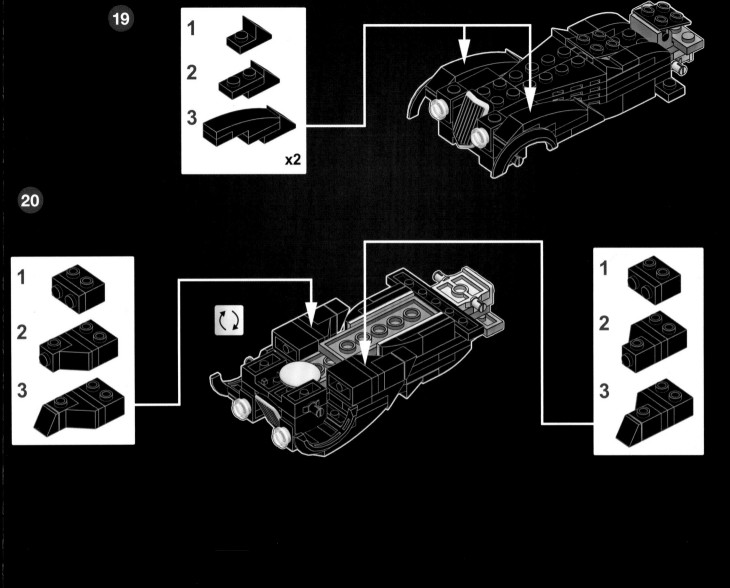

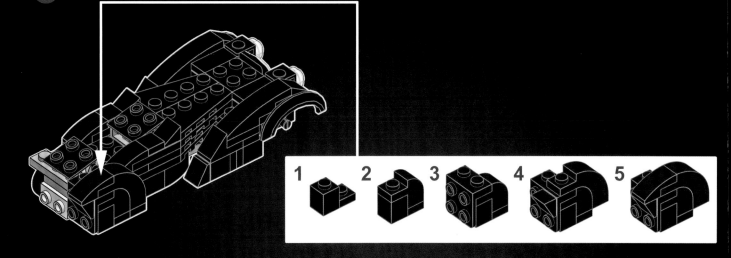

23

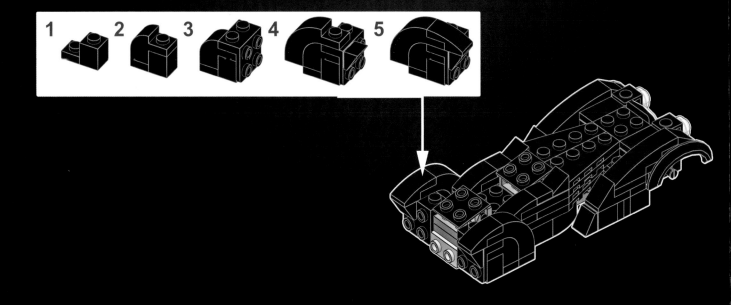

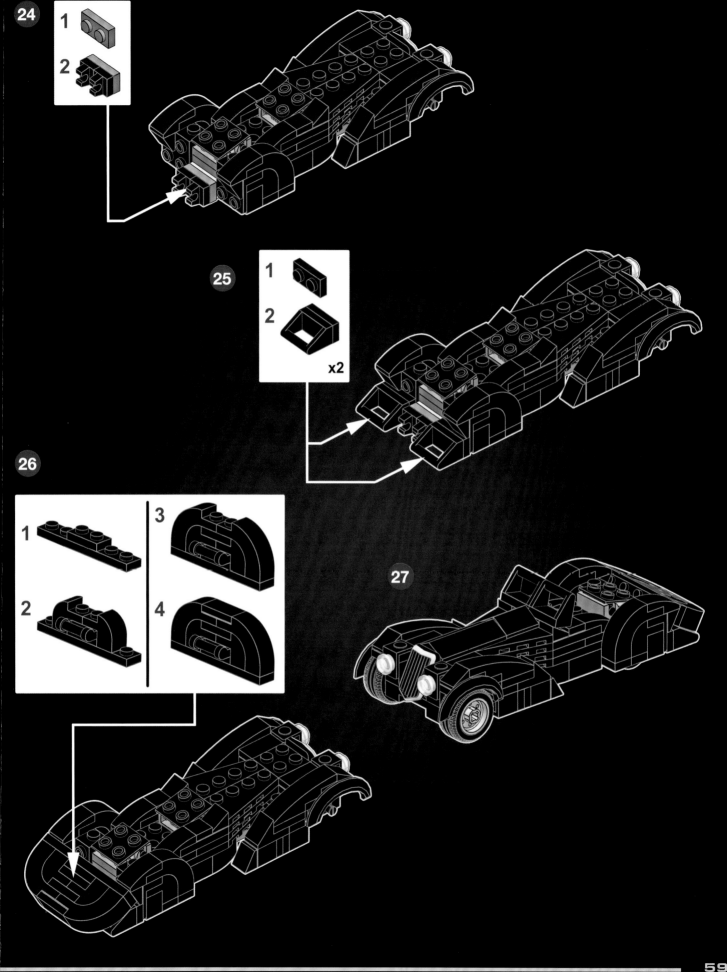

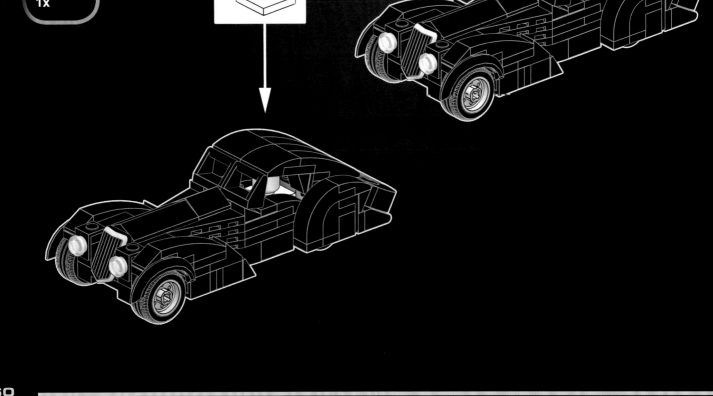

B **Bonus step**

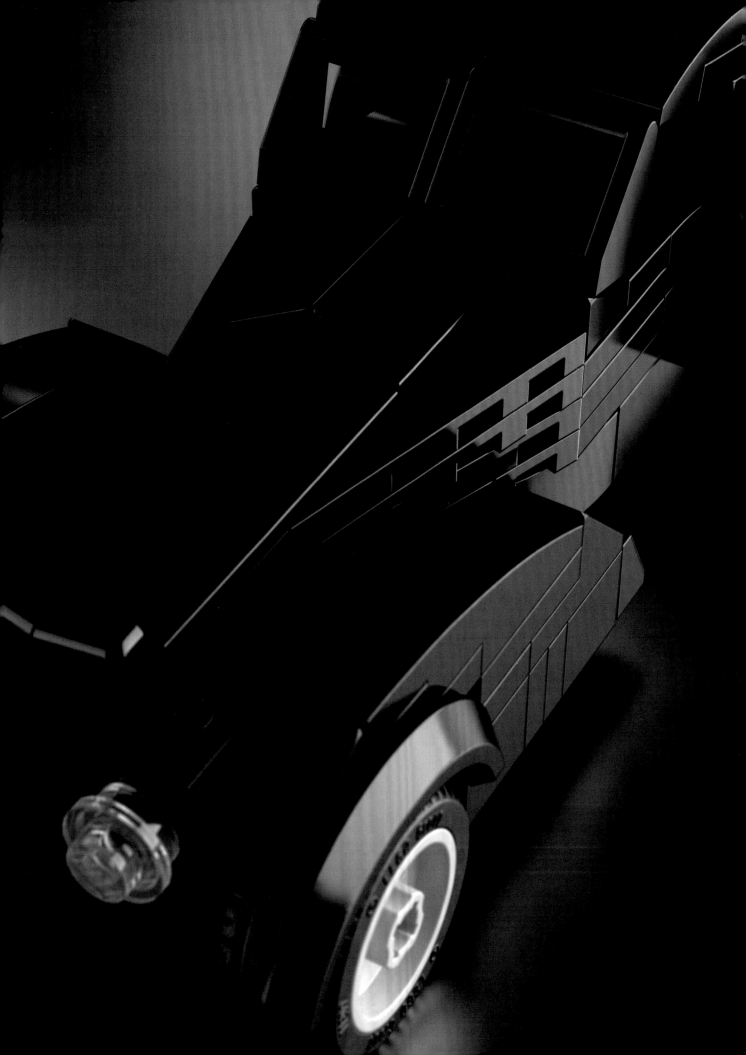

FORD GT

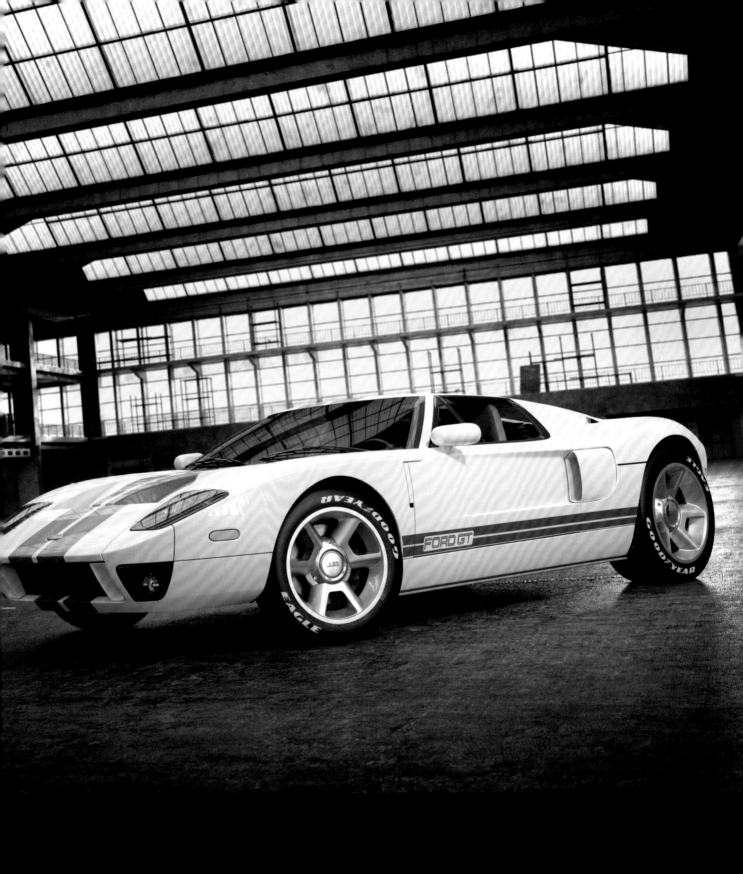

FORD GT

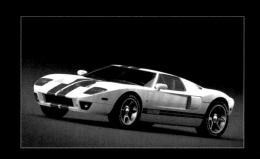

HISTORY

The Dream Car *par excellence*, Ford's reissue of this model was introduced in 2003 as a fitting celebration of the company's centennial and of one of its most historic automobiles, the Ford GT40 of the 1960s. Although structurally quite different from its illustrious ancestor, the GT unequivocally kept its form and competitive spirit.

The new GT was more massive and taller (more than 3 inches higher than the original 40 inches) and, of course, more advanced. Made of aluminum, carbon fiber, and magnesium, it was constructed using innovations like a superplastic mold and the latest welding techniques, and it made the most of its 5.7-liter Ford Modular V8 engine supercharged with a Lysholm twin-screw volumetric compressor. Thanks to well-timed modifications, and with methanol for fuel, this generation of Ford GTs has broken many records, including fastest car in the world: 293 mph. Its exuberant performance has led to various avatars in the realm of fantasy—in video games and cartoons, for example, or as the basis for two characters in the world of *Transformers*.

However, it is the GT40's past glory that gives one a complete sense of the brief history of the Ford GT. Incarnating Henry Ford II's dream to challenge the racing giants of the '60s—the Ferraris—the GT40 was like David fighting Goliath. Despite the GT40s' disastrous showing on the Nürburgring and in Le Mans in 1964 (when they encountered suspension and stability problems at only 100 mph as they were starting off), successively modified versions won many prizes. In 1966, the 7-liter Ford GT40 Mk II was victorious in Daytona, Sebring, and Le Mans, winning the last race four times in a row until 1969. What more crushing victory over the titans?

SPECIFICATIONS

GENERAL DESCRIPTION:
Years produced:	2004-2006
Number produced:	4,038
Average price:	$140,000 to $240,000
Estimated present market value:	
	$270,000 to $600,000
Model it replaced:	Ford GT 40
Replaced by:	Second generation Ford GT

PHYSICAL CHARACTERISTICS:
Dimensions:	15.2 x 6.4 x 3.7 ft
Weight:	3,306 lb

POWER:
Maximum speed:	205 mph
Acceleration:	0-60 in 3.3 to 3.8 seconds
Fuel consumption:	14 mpg

ENGINE:
Number of cylinders:	V8
Displacement:	329.53 cu. in.
Engine power:	550 hp
Drive:	rear-wheel drive

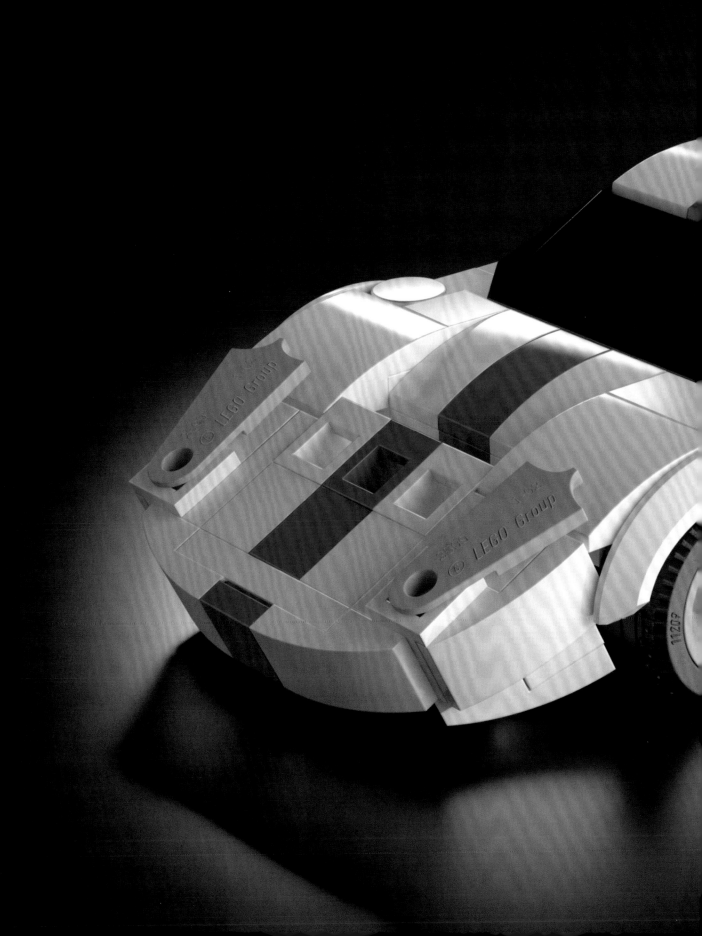

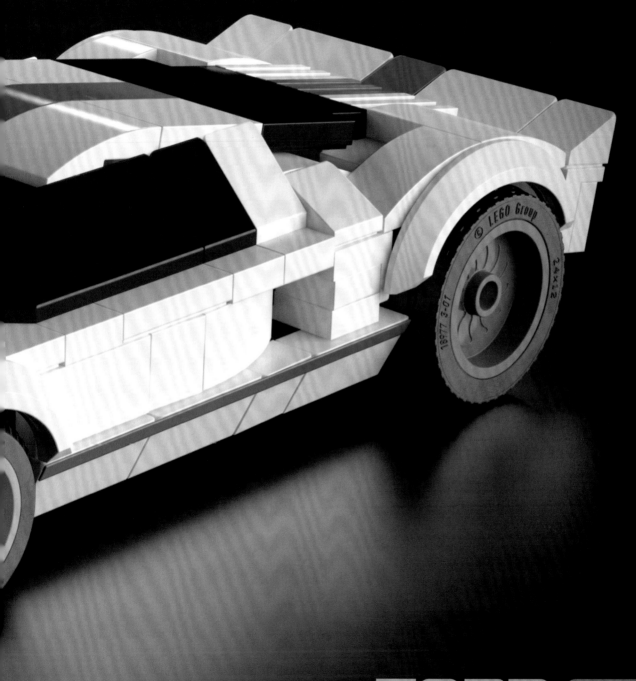

FORD GT

FORD GT

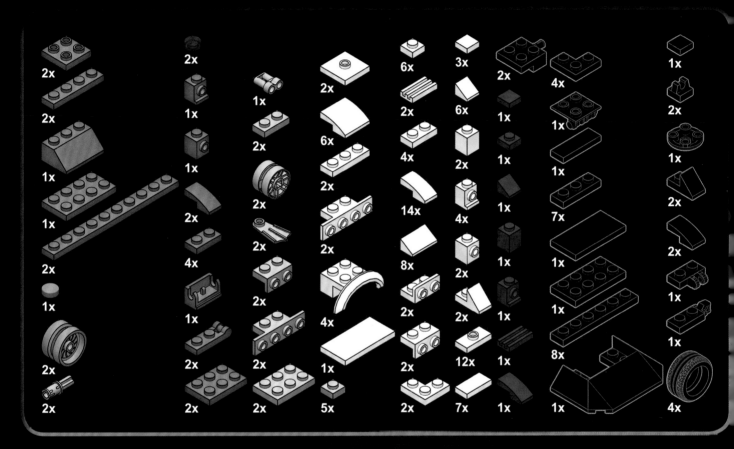

2x 2x 1x 6x 3x 2x 1x

2x 1x 2x 2x 6x 2x 6x 4x 2x

1x 1x 2x 6x 4x 2x 1x 1x

1x 2x 2x 2x 14x 4x 1x 7x 2x

2x 4x 2x 8x 2x 1x 1x 1x

1x 1x 2x 4x 2x 2x 1x 1x 2x

2x 2x 2x 2x 12x 1x 8x 1x

2x 2x 2x 5x 2x 7x 1x 1x 4x

www.nuinui.ch/upload/lego-dream-cars-ford.zip

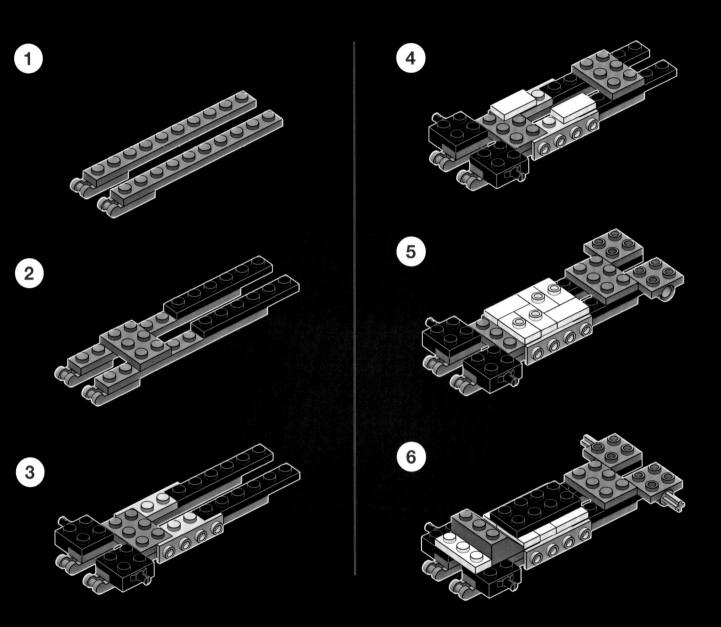

1

2

3

4

5

6

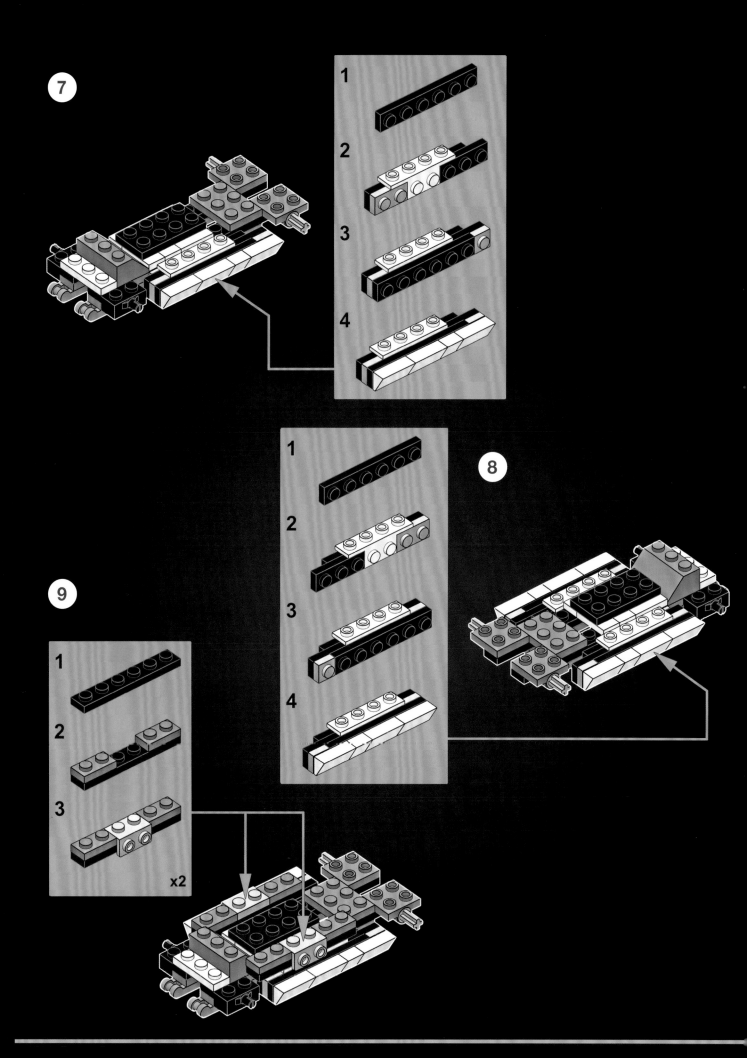

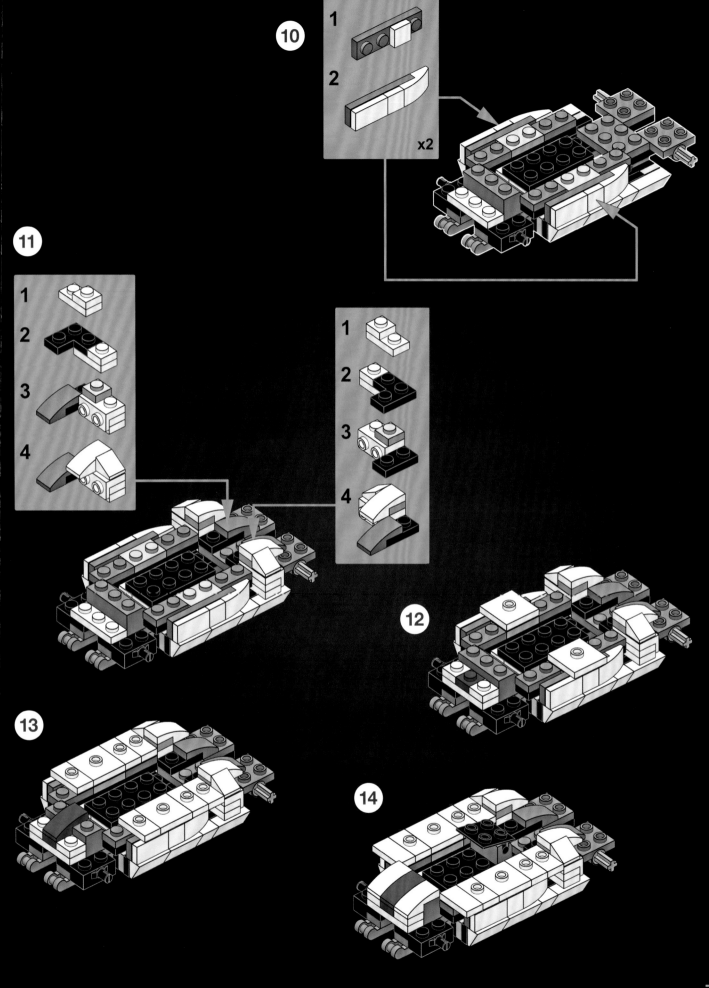

15

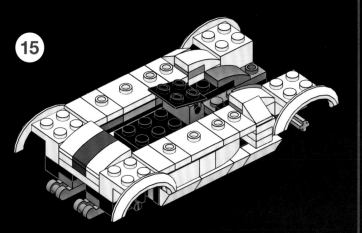

17

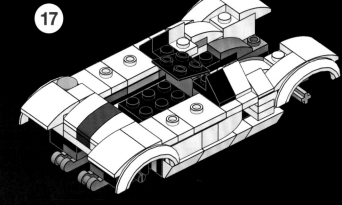

16

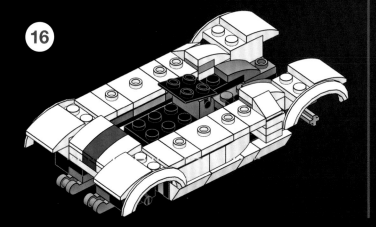

18

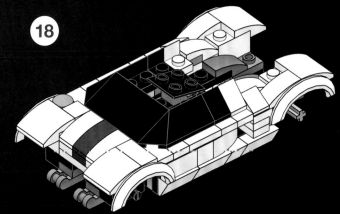

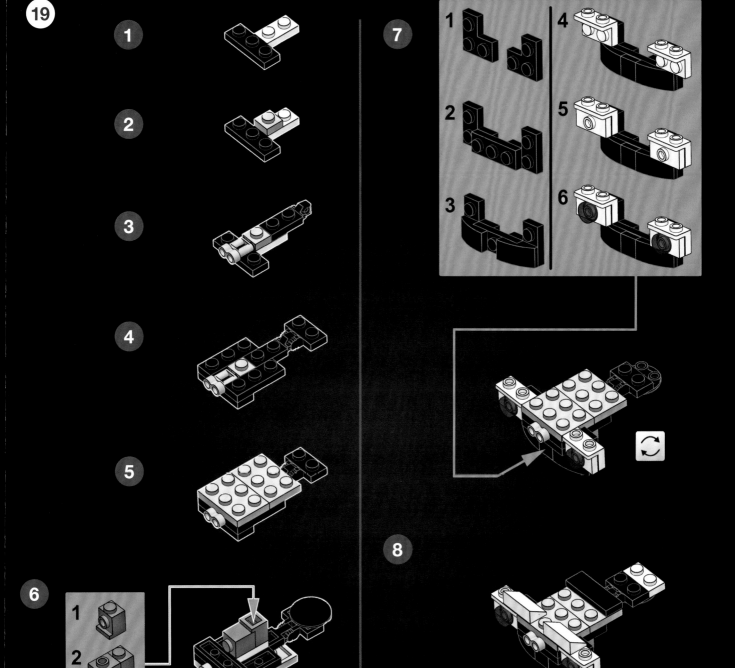

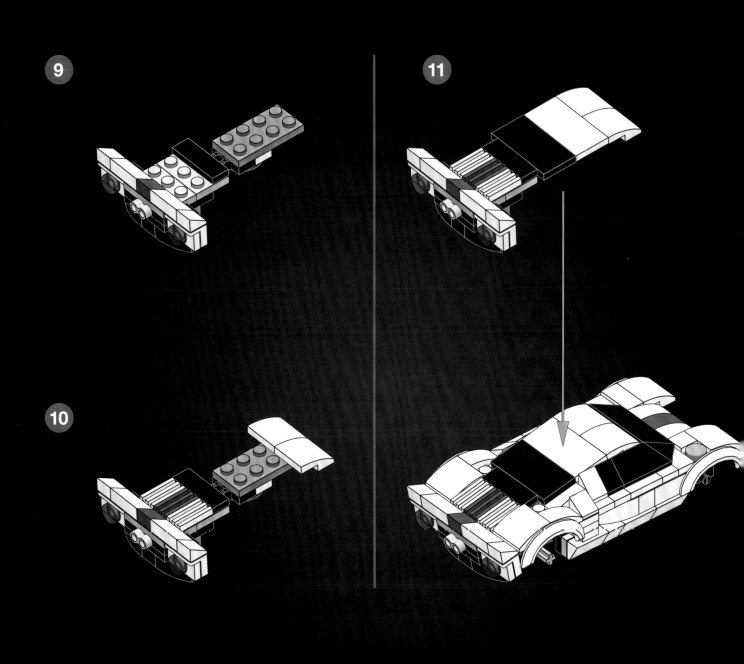

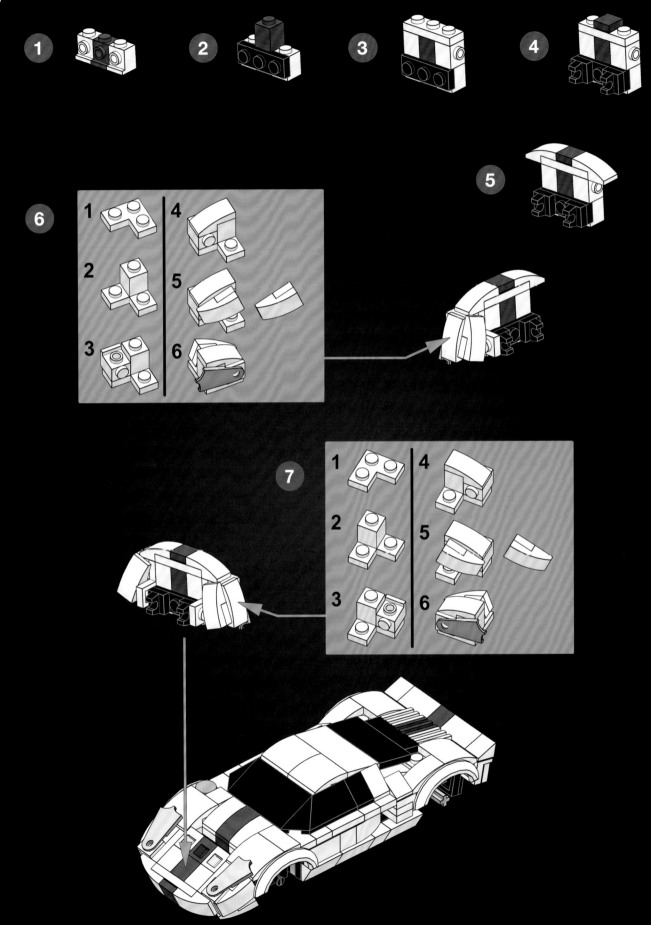

21

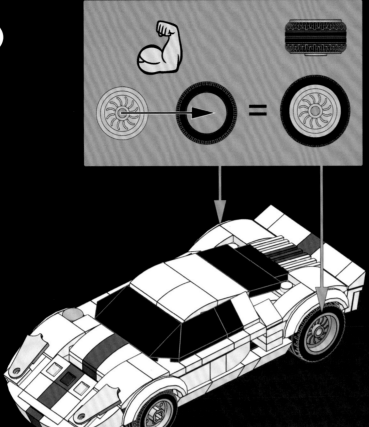

22

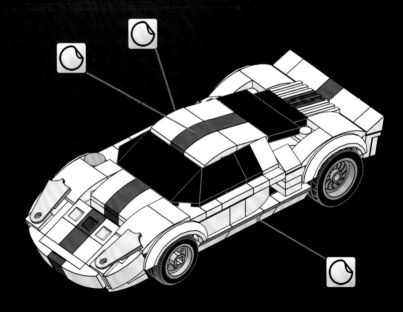

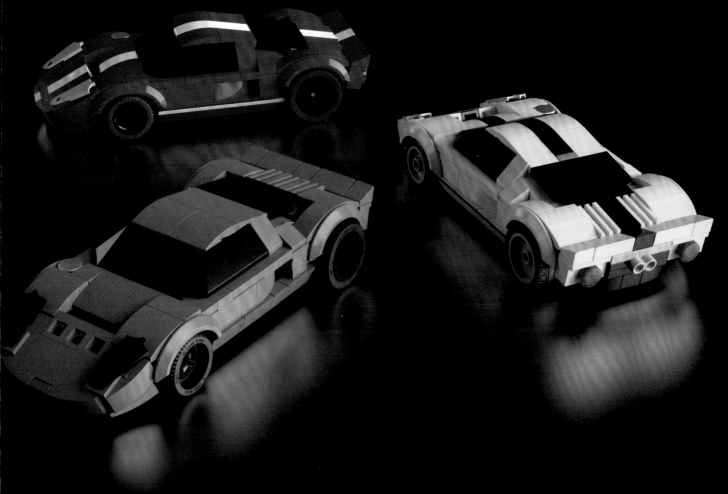

Lamborghini
Countach

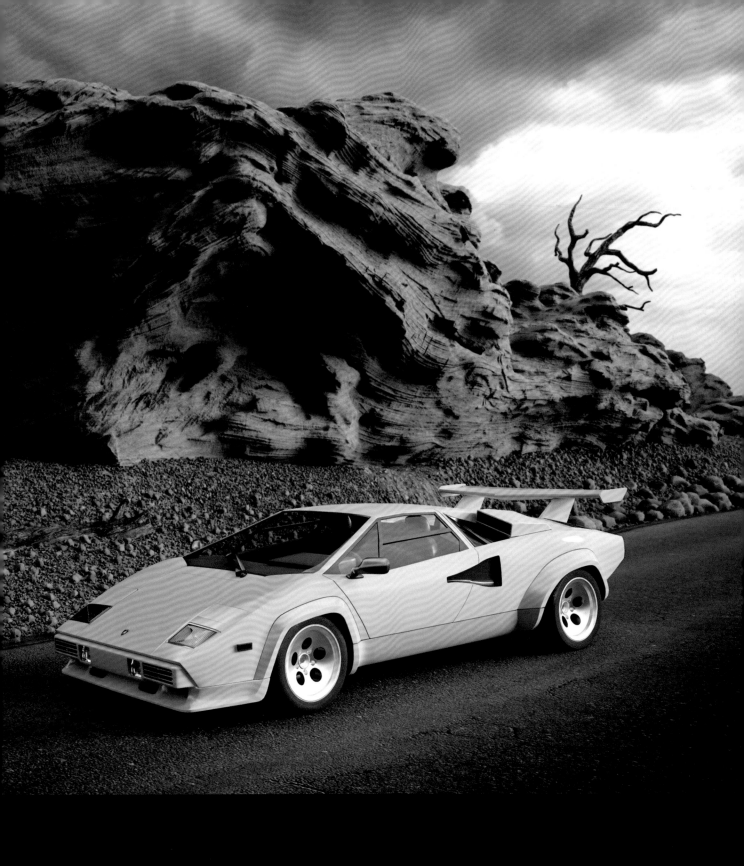

Lamborghini
Countach

HISTORY

Already standing out because of its name (from *contacc*, "contagion", an old Piedmontese exclamation of alarm during times of plague), the Lamborghini Countach made its debut in 1971 in Geneva, marking the 1970s and the next two decades with its futuristic presence. The company (which traditionally made agricultural tractors) already had the extraordinary Miura in its catalog, but in 1971 it astounded everyone by introducing something never seen before: a central engine two-seater that seemed to have fallen out of the sky from the future. It had an almost pyramid-like wedge design, scissor doors, dynamic handles and an aggressive grille, all covered in an aluminum "skin" on a multitubular shell.

The car wasn't ready for the public until 1973. The LP400 had a 375 hp V12 engine that could reach 196 mph, with six carburetors, four camshafts, and four exhaust pipes. Successive versions (the LP400S, LP5000, and the four-valve LP5000S) revealed continual innovations, like super-wide Pirelli P7 tires, a rear spoiler, an enhanced 4.75-liter engine to maintain the 375 hp while complying with new emissions norms, and a subsequent beefing-up of the engine to 5.2 liters and 420 hp in order to reach speeds of 200 mph.

The Countach was a racing car, a reason why the company adopted a policy of not making it too comfortable, in order to discourage Sunday drivers from getting behind the wheel. The futuristic design hid a few defects, like poor rear visibility and interior space reduced to a minimum. However, the car's outward appearance made it impossible to prevent its admirers from considering it the fastest car in the world (which it was not). Just how much its looks counted can be seen by the fact that the optional huge rear spoiler of some models was chosen by most customers even though it reduced the maximum speed by 9 mph.

SPECIFICATIONS

GENERAL DESCRIPTION:

Years produced:	1974-1990
Number produced:	2,049
Average price:	$100,000
Estimated present market value:	
	$150,000 to $800,000
Model it replaced:	Lamborghini Miura
Replaced by:	Lamborghini Diablo

PHYSICAL CHARACTERISTICS:

Dimensions:	13.6 x 6.2 x 3.5 ft
Weight:	3,284 lb

POWER:

Maximum speed:	158 to 205 mph
Acceleration:	0-60 in 4.5 to 5.9 seconds
Fuel consumption:	7 mpg

ENGINE:

Number of cylinders:	V12
Displacement:	238/293/317 cu. in.
Engine power:	370 to 448 hp
Drive:	rear-wheel drive

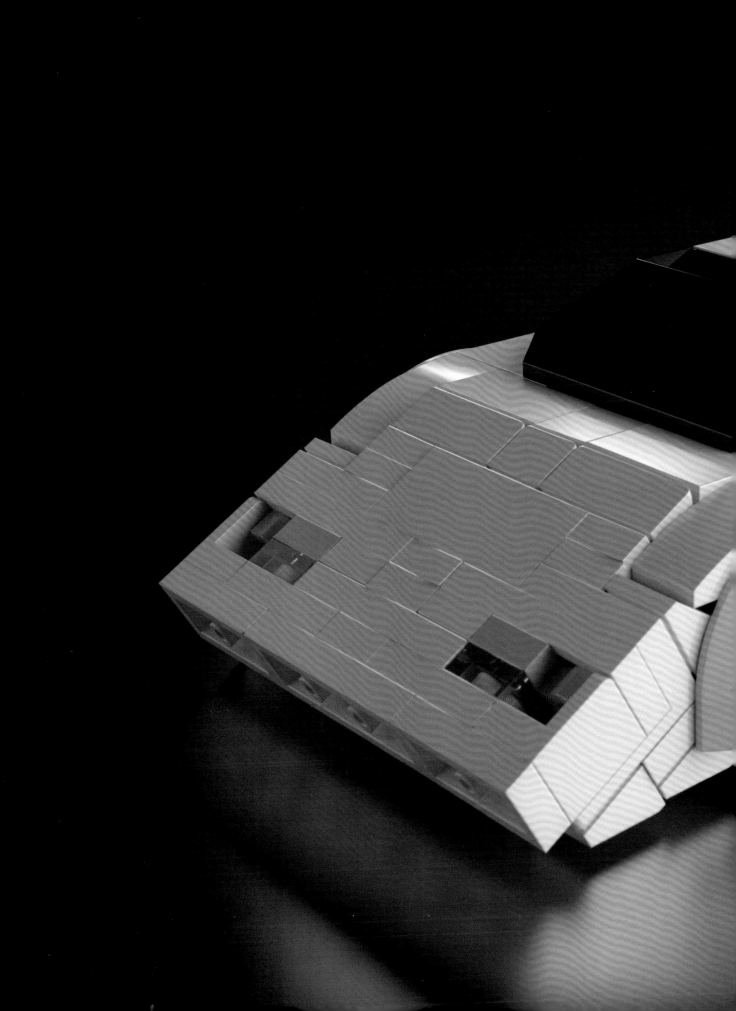

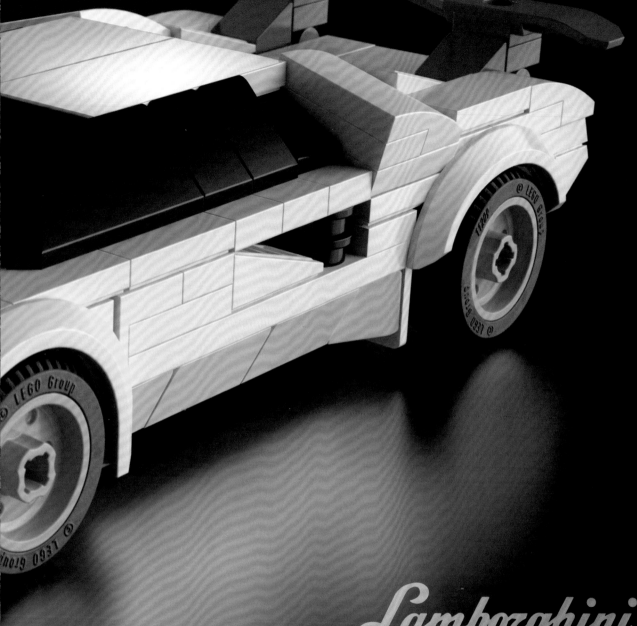

Lamborghini
Countach

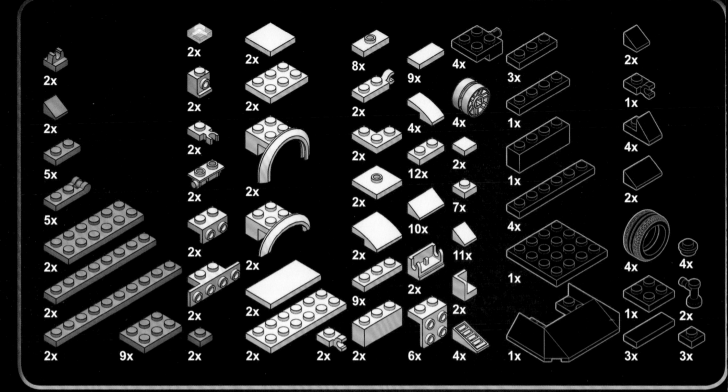

2x
2x
5x
5x
2x
2x
2x

9x
2x
2x
2x
2x
2x
2x

2x
2x
2x
2x
2x

8x
2x
2x
12x
2x
9x

9x
4x
10x
2x
2x
9x
2x

4x
4x
2x
7x
11x
2x
2x
6x

3x
1x
1x
4x
1x
1x

2x
1x
4x
2x

4x
4x
4x
1x
2x
3x
3x

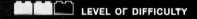

LEVEL OF DIFFICULTY

www.nuinui.ch/upload/lego-dream-cars-lamborghini.zip

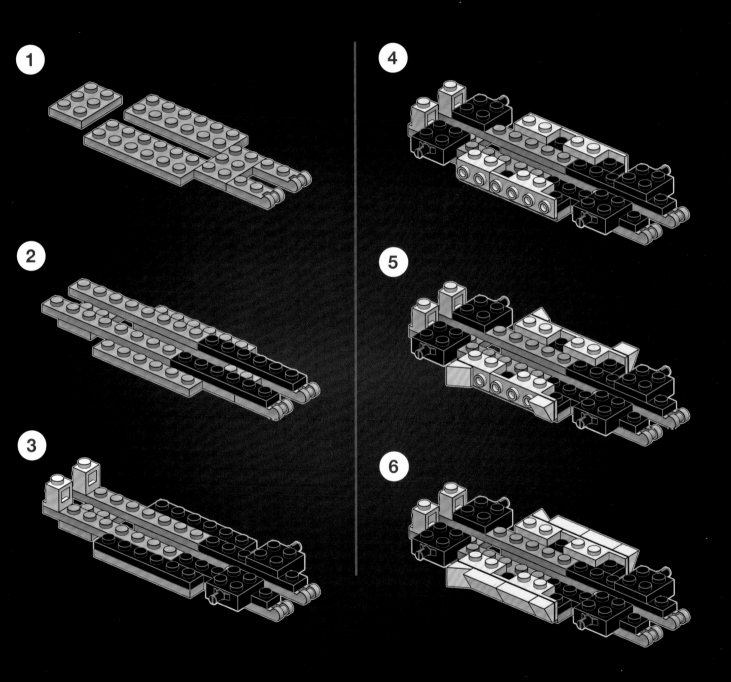

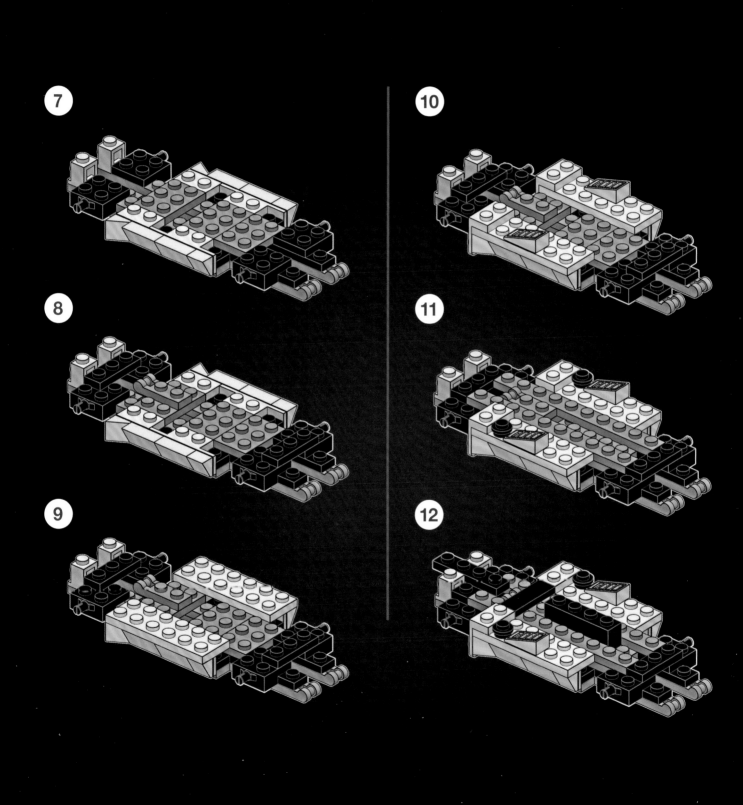

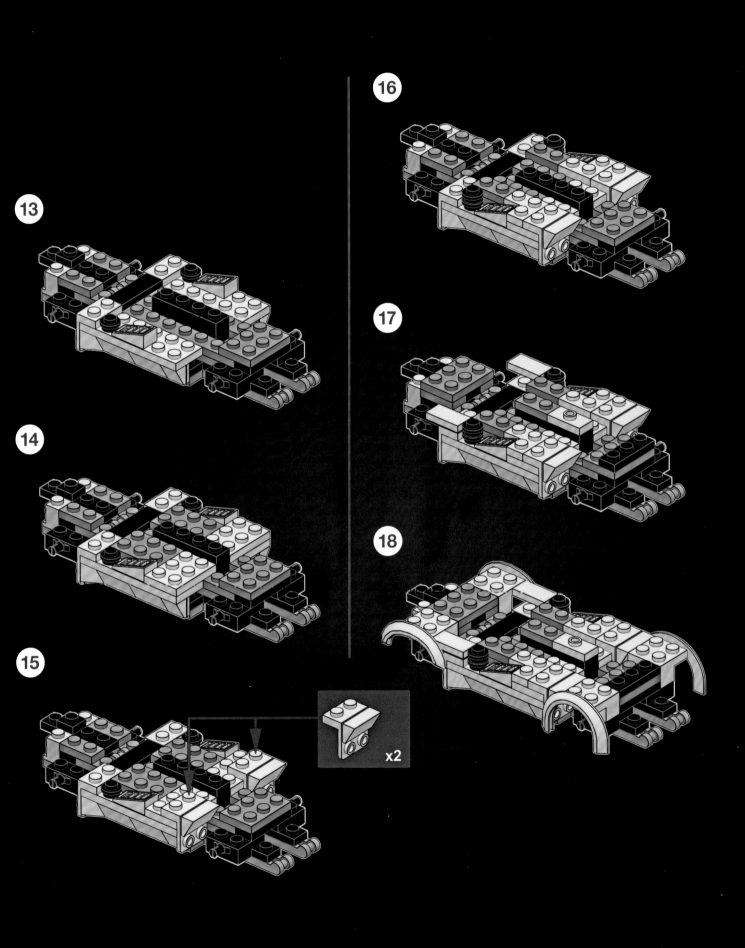

13

14

15

16

17

18

x2

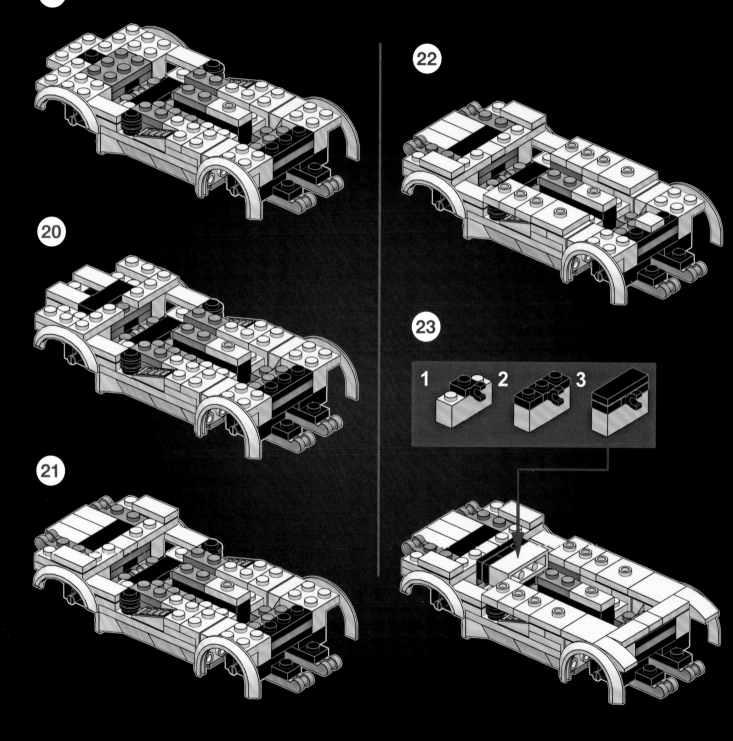

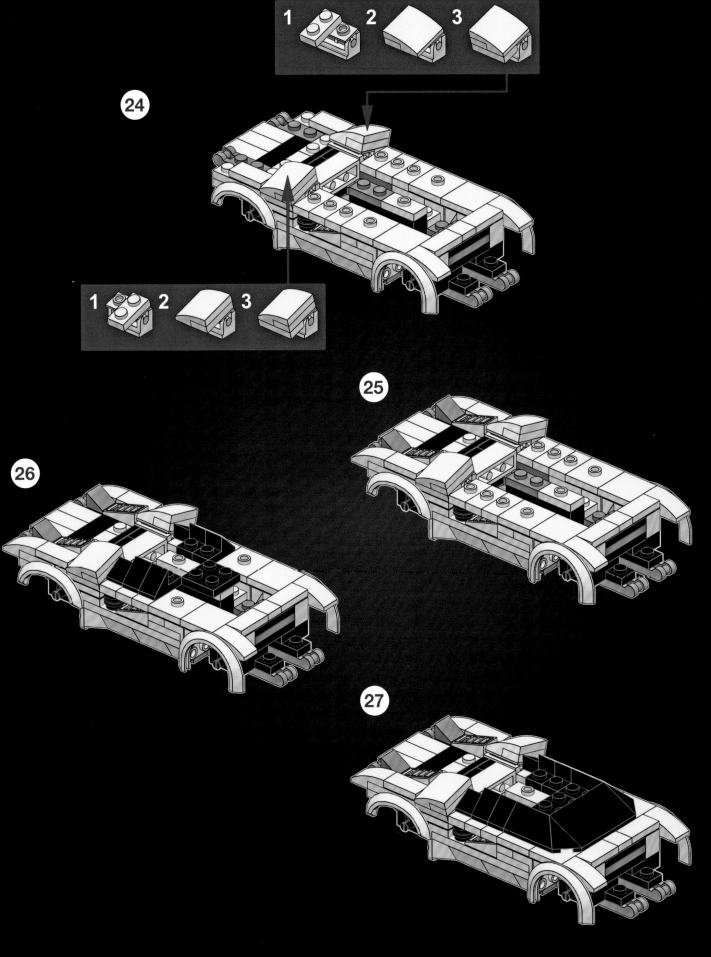

28

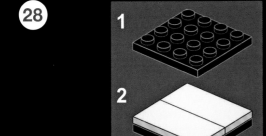

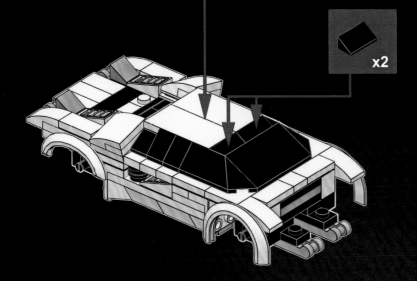

29

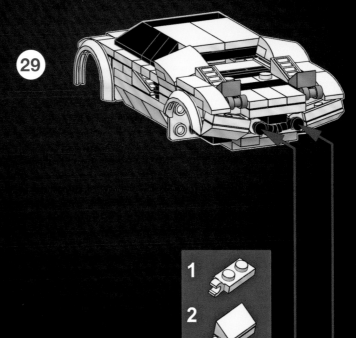

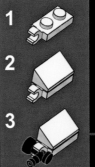

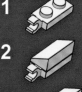

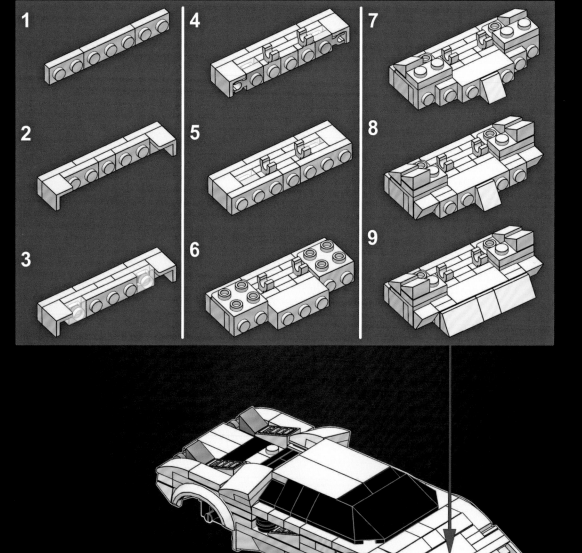

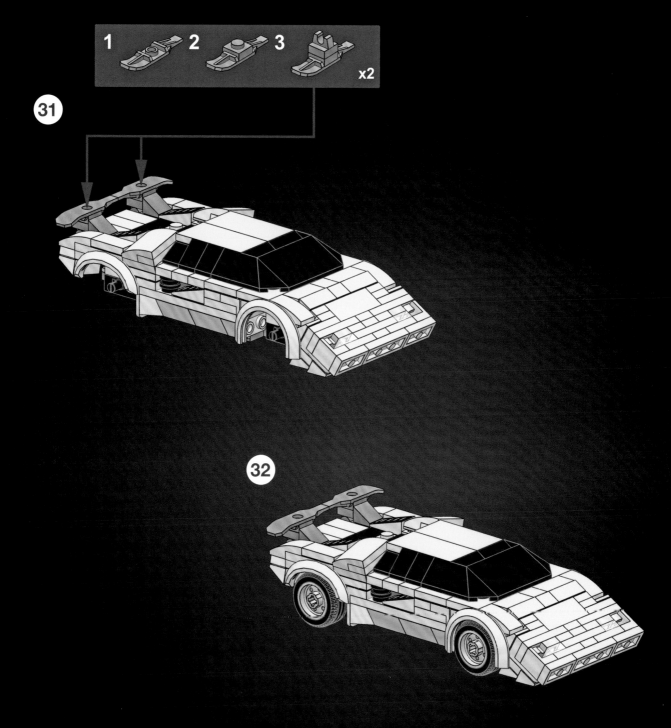

Alternative Versions

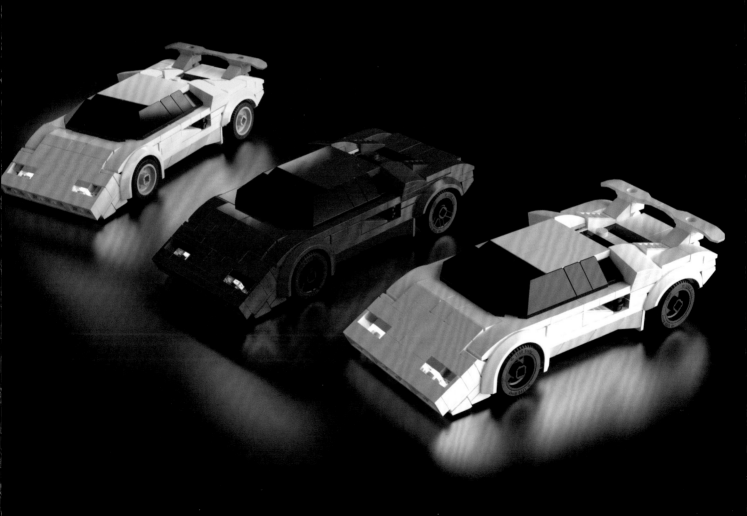

Ferrari

F40

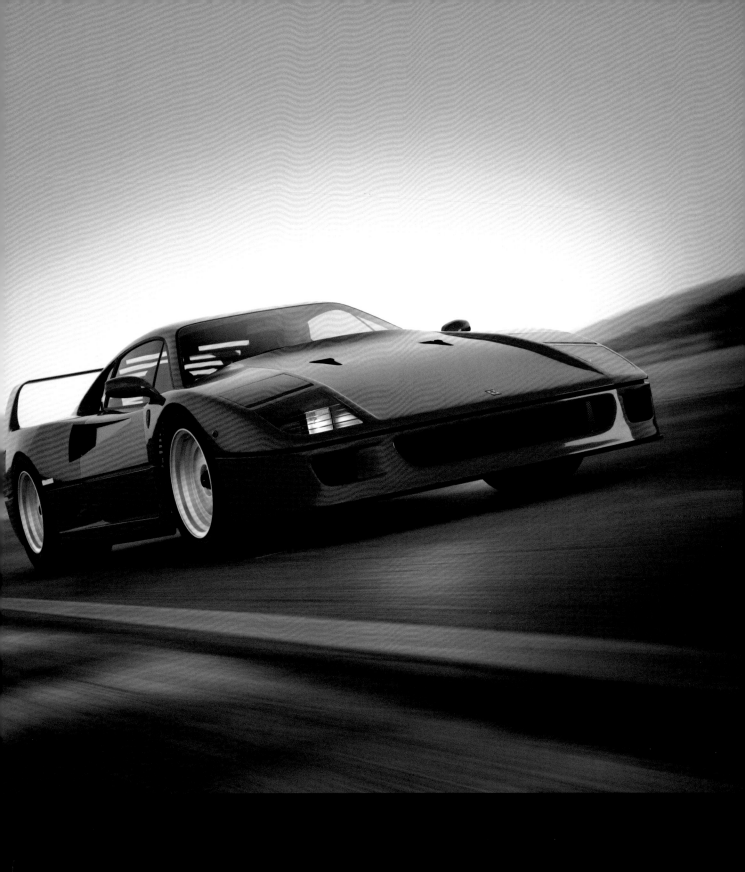

The Ferrari F40 is a milestone for at least two reasons: it was planned to celebrate the fortieth anniversary of the company and was Enzo Ferrari's last creation. He supervised its planning as his final legacy to the world of sports cars and racing cars that he personally had shaped. Conceived for racing and designed to be the very essence of speed, the F40 was extremely spartan, whether to achieve greater lightness or to do away with some of the frills that made the Ferrari too plush for some people. There were no car mats, stereos, central locking device, leather details, etc. Instead, Ferrari used Kevlar, a carbon-aluminum fiber, for the body, plexiglass for the windshield and windows, and a strangely angular design signed Pininfarina. Even the surface was so thin that one could almost see the weaving of the underlying materials.

The results were evident. The 3-liter twin-turbocharged V8 engine made the skeletal F40 a car for robust drivers. It was unruly and problematic under normal driving conditions, vibrating and creaking when one needed immediate acceleration. It was also uncomfortable and had almost no rear visibility. Moreover, it was a racing car for the straightaway, the first to exceed a speed of 200 mph. Enzo Ferrari himself clarified this point, asserting that he didn't care a bit about the details. What he wanted was for the driver to be scared out of his wits when he stepped on the accelerator.

On the other hand, with his ultimate creation, Ferrari conquered a much wider public than the intrepid racers he had in mind, who could afford the $400,000 list price in those days. The F40, appearing on so many posters in the late 1980s, has now been driven by countless fans of video games like *F40 Pursuit Simulator* as well as transformed into ingenious scale models like this one.

SPECIFICATIONS

GENERAL DESCRIPTION:

Years produced:	1987-1992
Number produced:	1,337
Average price:	$400,000
Estimated present market value:	$1,400,000
Model it replaced:	Ferrari 288 GTO
Replaced by:	Ferrari F50

PHYSICAL CHARACTERISTICS:

Dimensions:	14.3 x 6.5 x 3.7 ft
Weight:	2,866 lb

POWER:

Maximum speed:	201.32 mph
Acceleration:	0-60 in 4.2 seconds
Fuel consumption:	16 mpg

ENGINE:

Number of cylinders:	V8
Displacement:	177 cu. in.
Engine power:	470 hp
Drive:	rear-wheel drive

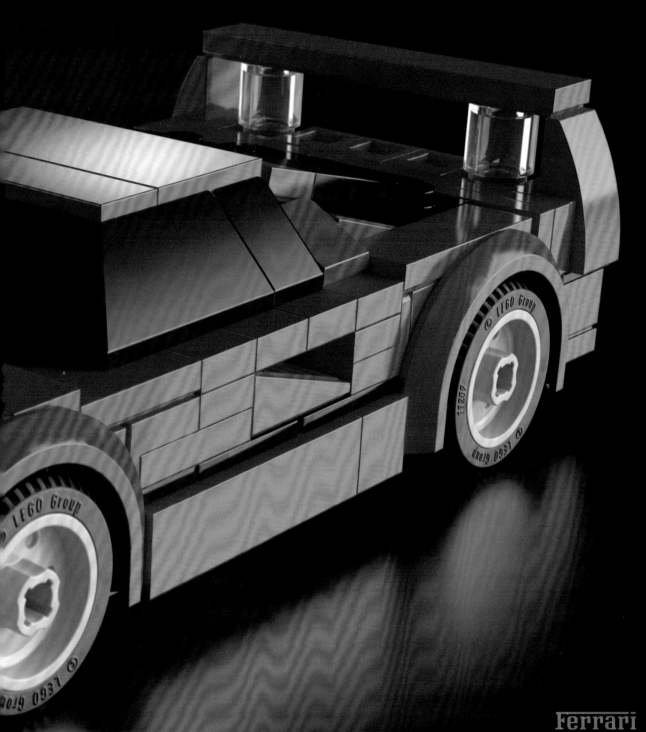

Ferrari
F40

Ferrari

F40

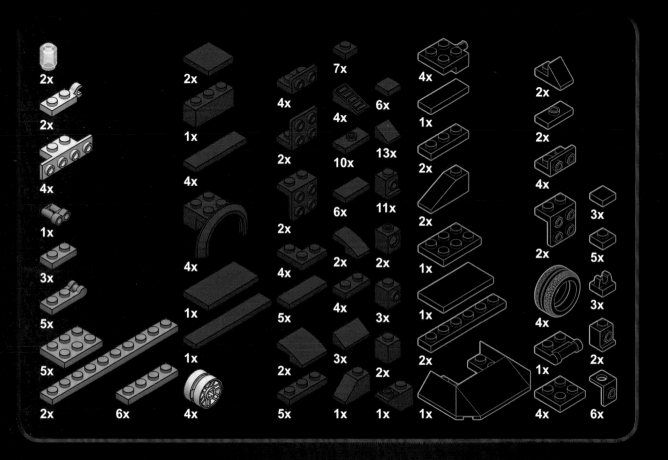

2x
2x
4x
1x
3x
5x
5x
2x

6x

2x
1x
4x
4x
1x
1x
4x

4x
2x
2x
4x
2x
4x
5x
2x
5x

7x
4x
10x
6x
2x
4x
3x
1x

6x
13x
11x
2x
3x
2x
1x

4x
1x
2x
2x
1x
1x
2x
1x

2x
2x
4x
2x
4x
1x
4x

3x
5x
3x
2x
6x

LEVEL OF DIFFICULTY

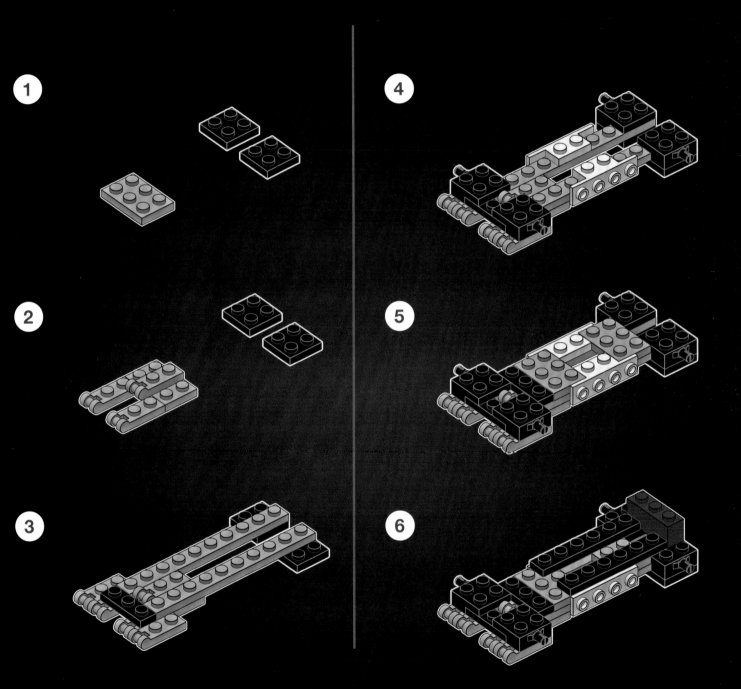

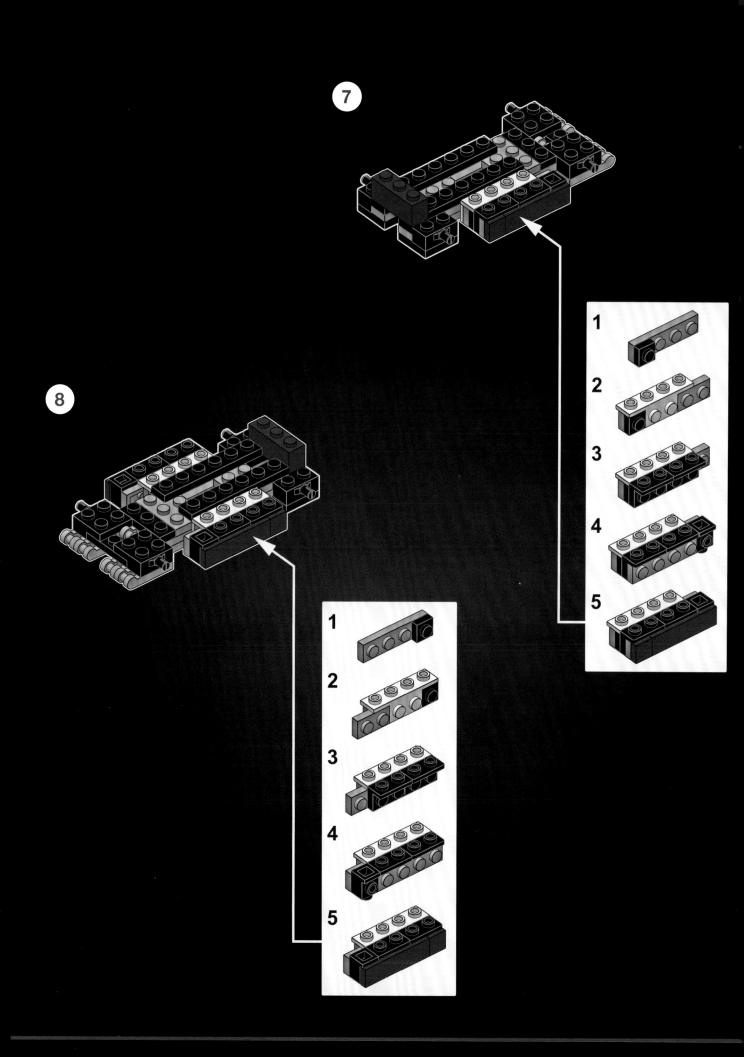

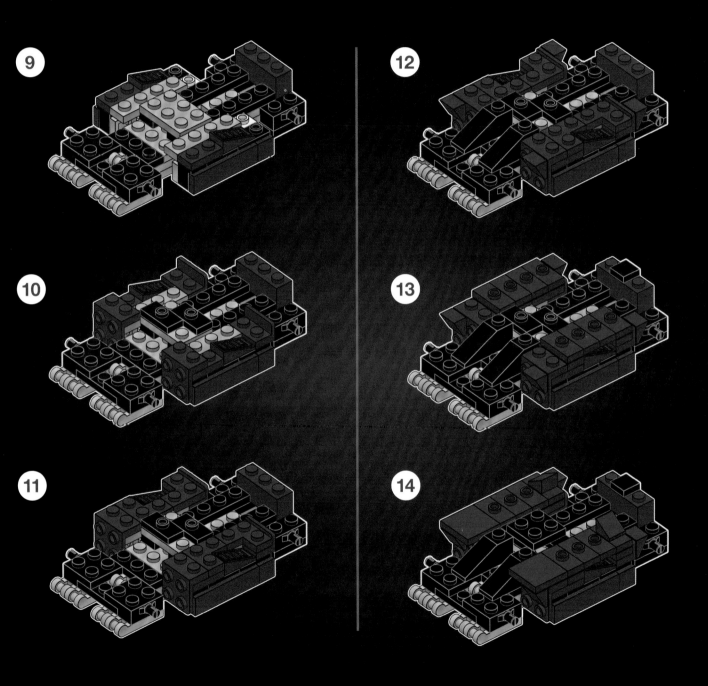

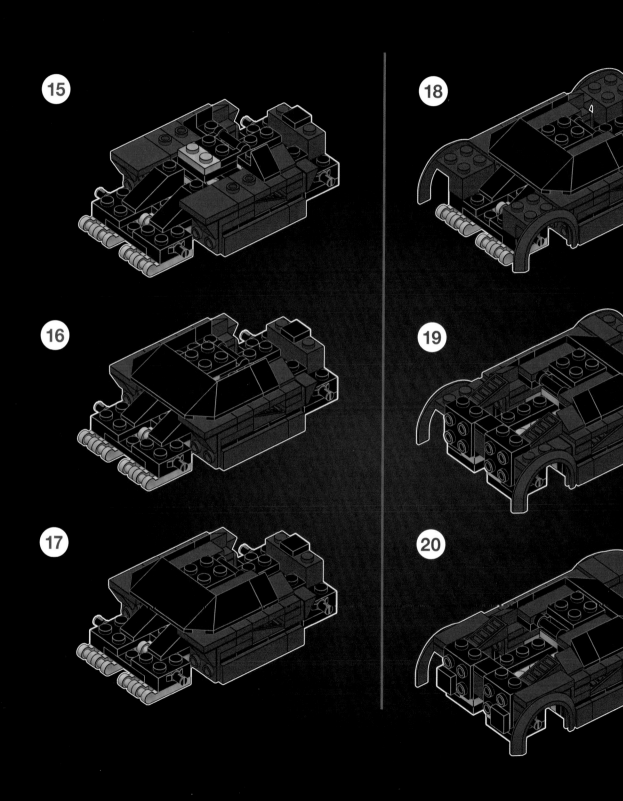

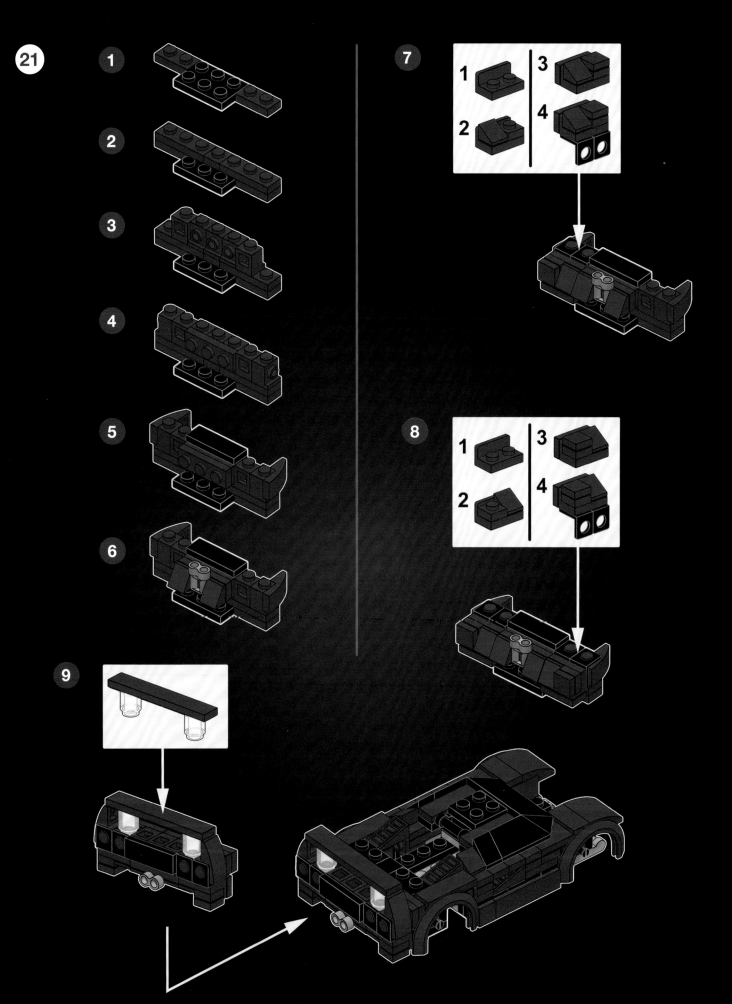

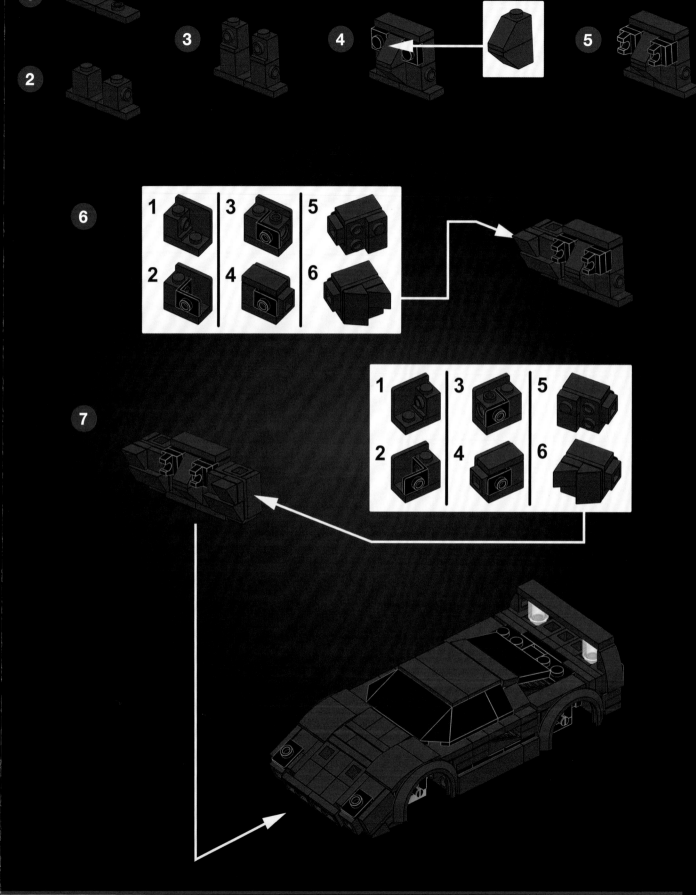

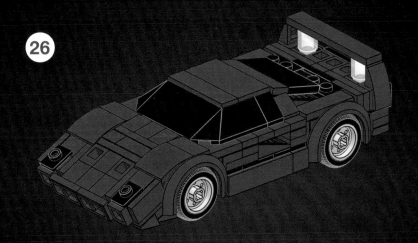

26

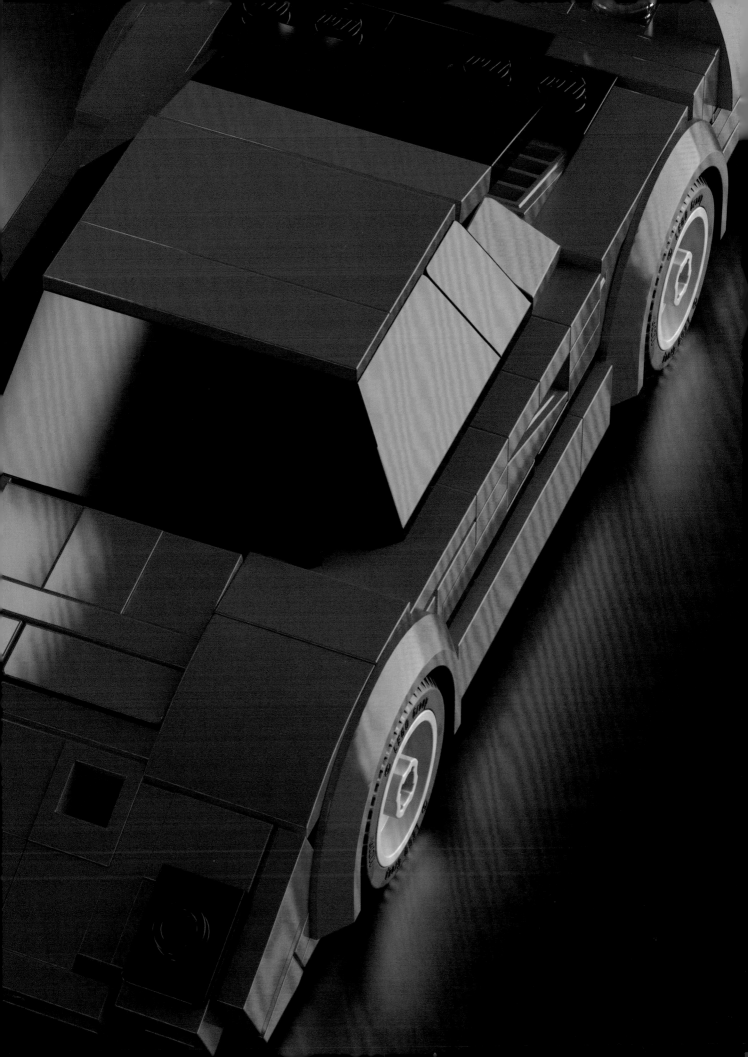

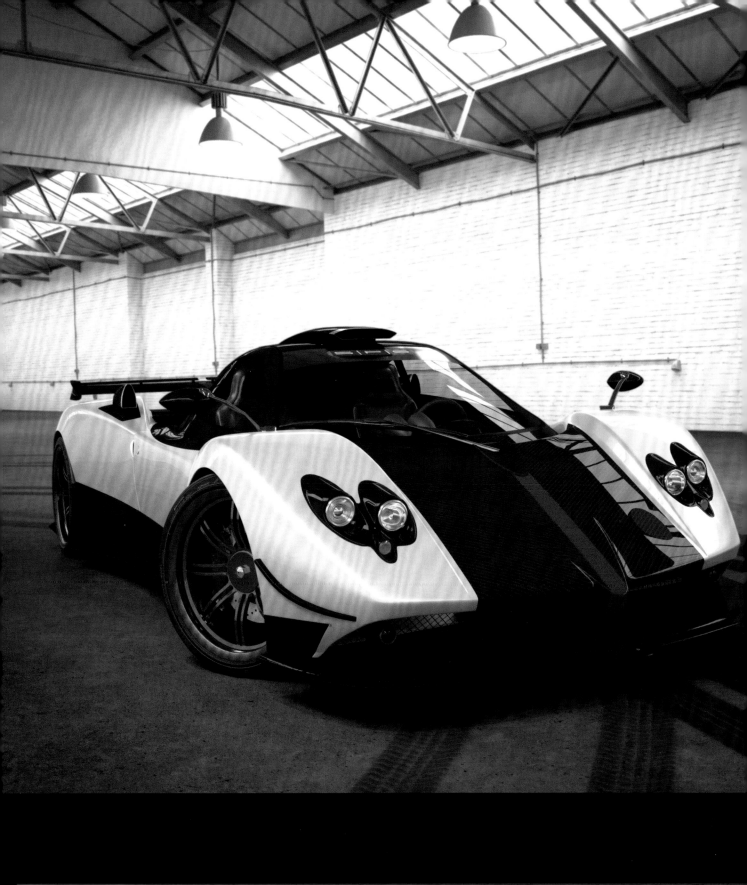

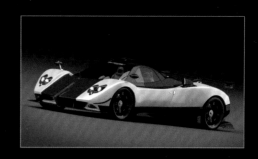

The Pagani Zonda Cinque is a dream car whose very name conjures up auto racing. It is dedicated to the *viento Zonda*—the Zonda wind—which descends violently from the Andes to whip through the Argentine pampas and whose name is inextricably linked to this automobile. The Pagani Zonda came into being thanks to two extraordinary Argentinians, Horacio Pagani, a former Lamborghini worker who had immigrated to Italy, and Manuel Fangio, the Formula 1 hero. It was the former who had the dream—and the ability—to create extraordinary racing cars, while the latter had the necessary connections to convince Mercedes to partner with the company that made the engines.

The first Zonda (C12) was produced in 1999. It should have been called the "Fangio F1", but Fangio had died five years earlier, so the name Zonda was chosen, to evoke both the passion and native land of the old champion. And the new car did him justice: it reached a speed of 205 mph and was far ahead of the pack in the use of the strong yet super-light materials of which it was constructed, adapted into a design that took the look of the Mercedes racing car to extremes. In the three years following the appearance of the Zonda, the central engine was beefed up, its speed reached 217 mph, and it got a new rear spoiler, but the Zonda didn't make it to the racecourse. This would happen with the Zonda GR, with improved aerodynamic design, suspension, and brakes—brilliant but not victorious at Le Mans and Sebring. In 2005, the Zonda F appeared, with the F for Fangio finally in its name and the latest innovations: not only a modified airbox and exhaust pipe but also new spoilers, redesigned headlights, and a convertible model. Following the F came the Zonda R, used as a test model for the future Pagani Huayra, and the Zonda Cinque, reproduced from the R and given this name because only five of them were made. Nothing unusual, though: in a span of twenty years, there were only five versions and 25 one-of-a-kind models—all in all, no more than 137 Zondas were produced!

GENERAL DESCRIPTION:

Years produced:	2008-2010
Number produced:	5
Average price:	$1,400,000
Estimated present market value:	$2,200,000
Model it replaced:	Pagani Zonda F
Replaced by:	Zonda HP Barchetta

PHYSICAL CHARACTERISTICS:

Dimensions:	14.6 x 6.8 x 3.7 ft
Weight:	2,667 lb

POWER:

Maximum speed:	217.48 mph
Acceleration:	0-60 in 3.4 seconds
Fuel consumption:	14.7 mpg

ENGINE:

Number of cylinders:	V12
Displacement:	445.47 cu. in.
Engine power:	668 hp
Drive:	rear-wheel drive

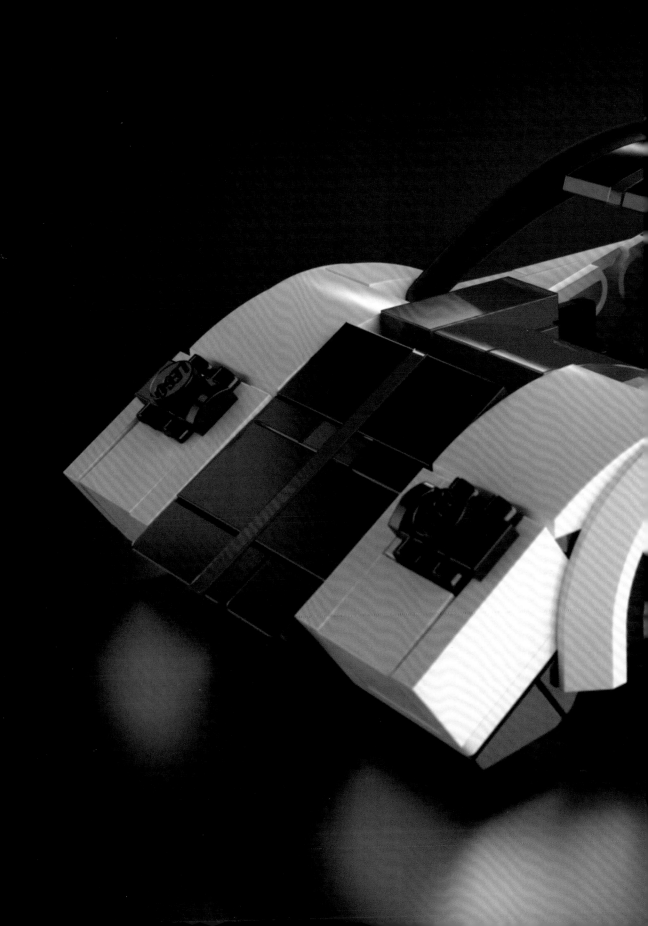

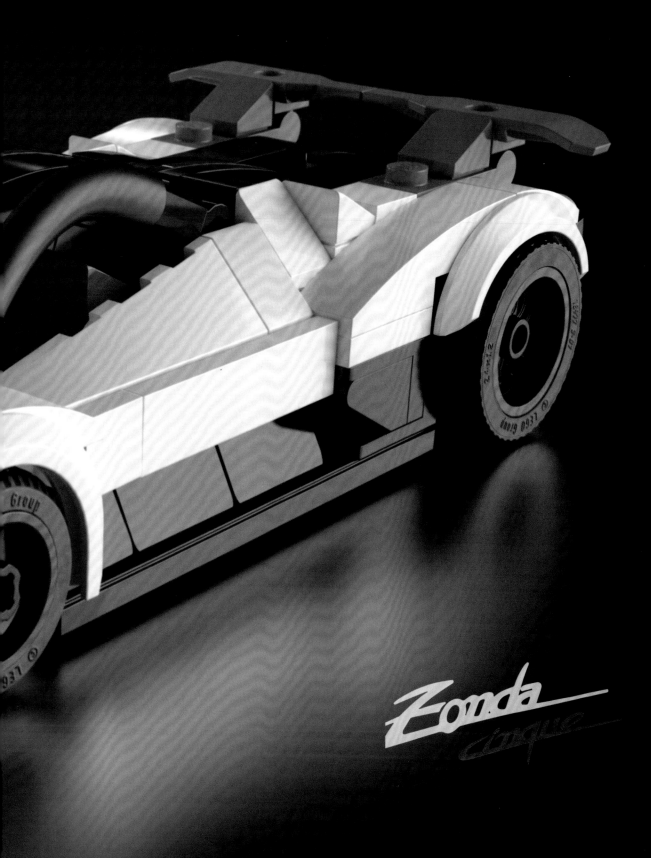

PAGANI

Zonda cinque

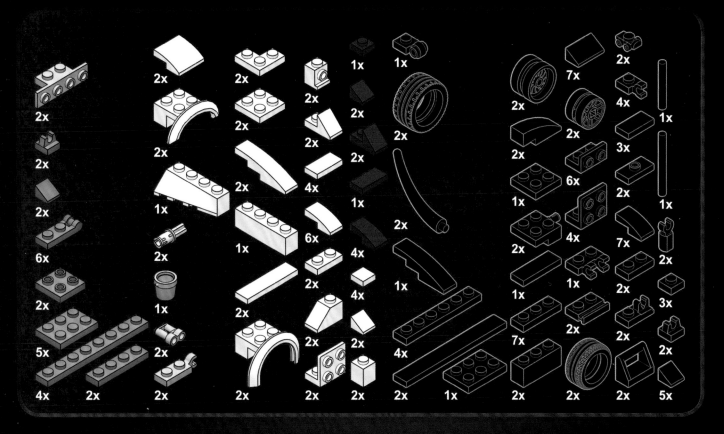

2x · 2x · 2x · 1x · 1x · 2x · 7x · 2x
2x · 2x · 2x · 2x · 2x · 4x · 1x
2x · 2x · 2x · 2x · 2x · 2x · 3x
2x · 1x · 4x · 1x · 6x · 2x · 2x · 1x
6x · 2x · 1x · 4x · 2x · 6x · 7x · 2x
2x · 1x · 1x · 4x · 4x · 1x · 4x · 1x · 2x
5x · 2x · 2x · 2x · 2x · 1x · 2x · 2x · 3x
4x · 2x · 2x · 2x · 2x · 2x · 2x · 1x · 2x · 2x · 7x · 2x · 2x · 5x

LEVEL OF DIFFICULTY

www.nuinui.ch/upload/lego-dream-cars-pagani.zip

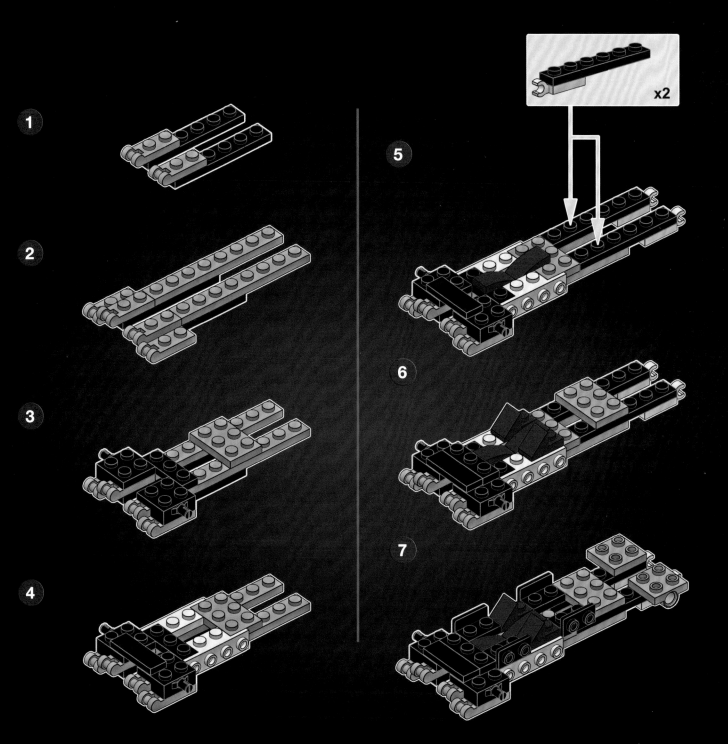

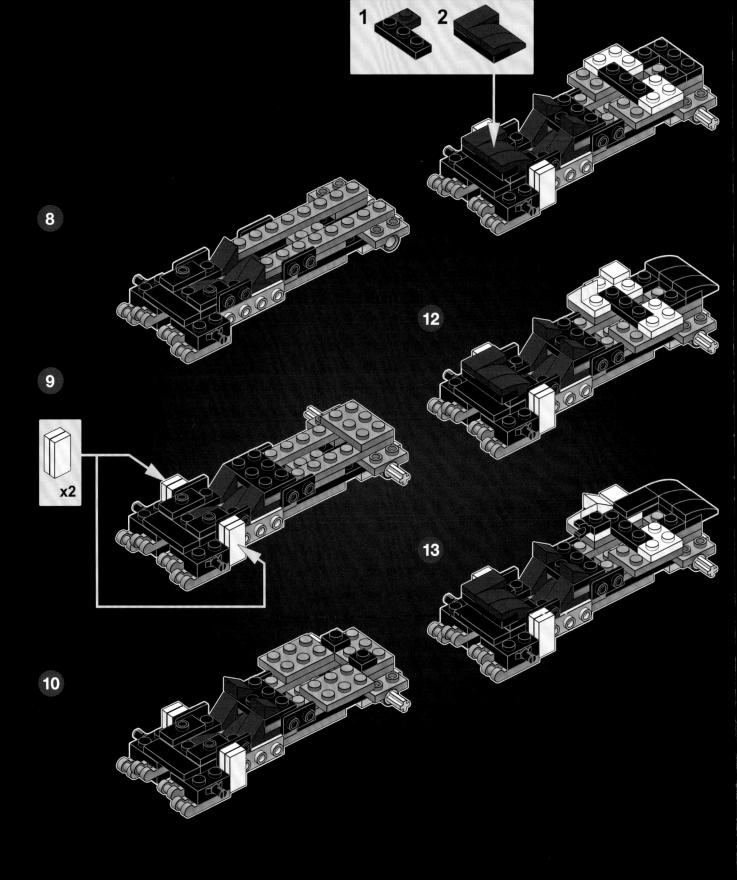

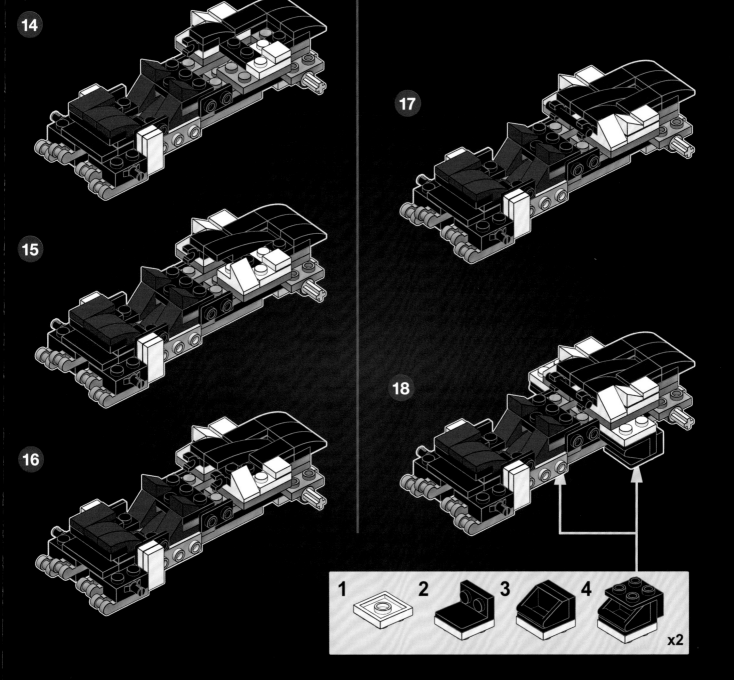

14

15

16

17

18

1 2 3 4

x2

119

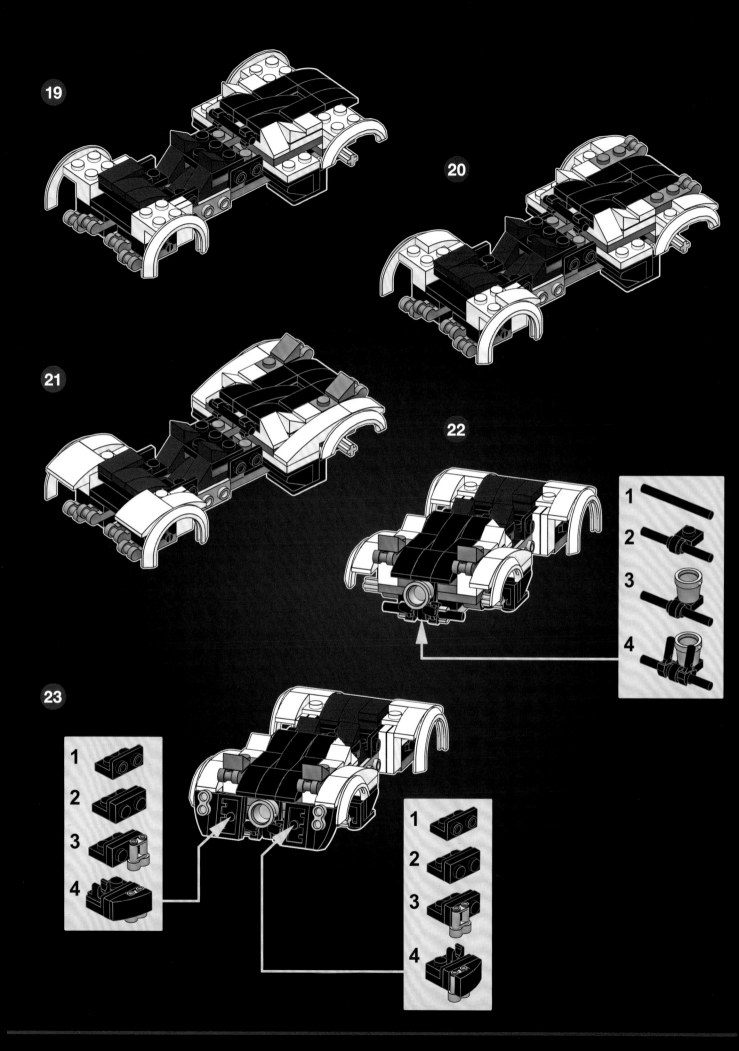

24

1 2 3

25

1 2

26

1 2 3

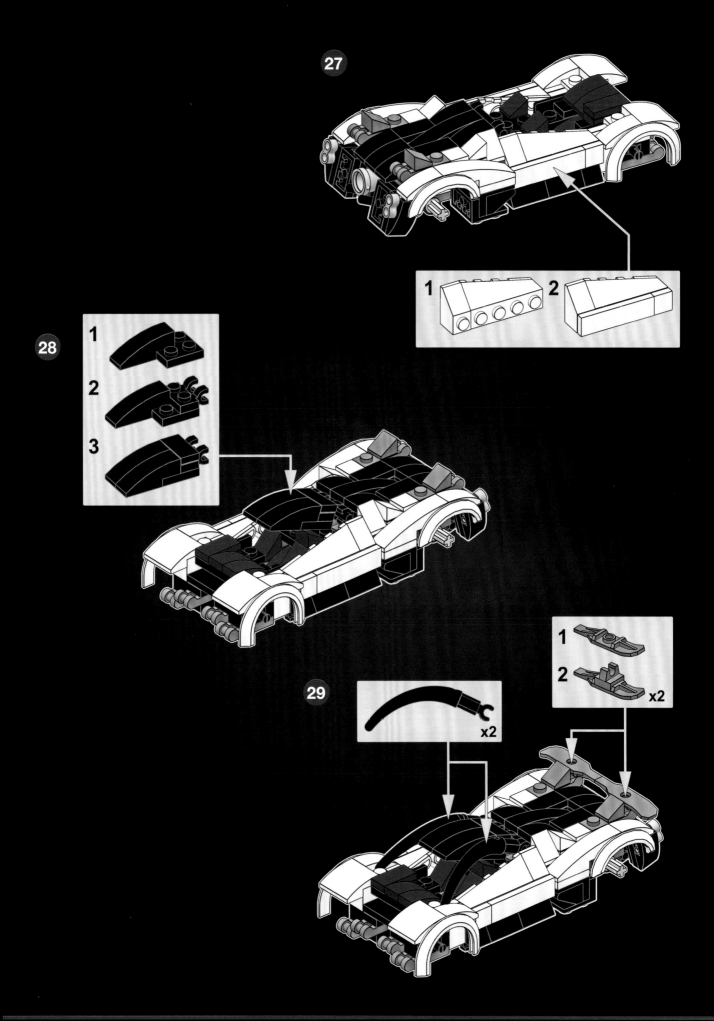

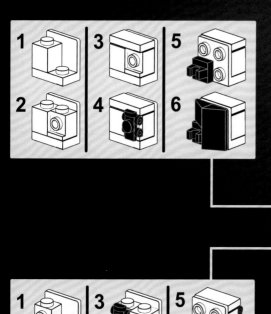

30

1
2
3
4

31

1
2
3
4
5
6

1
2
3
4
5
6

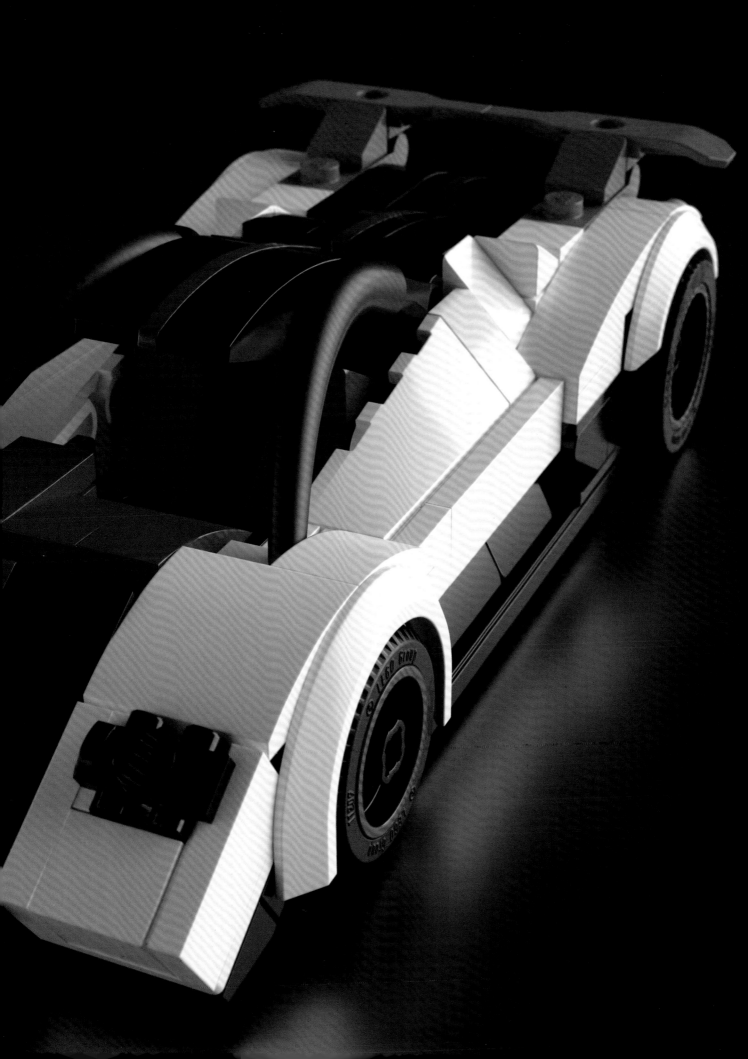

32

33

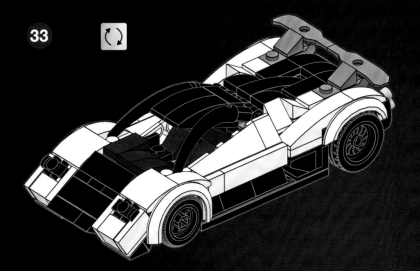

34

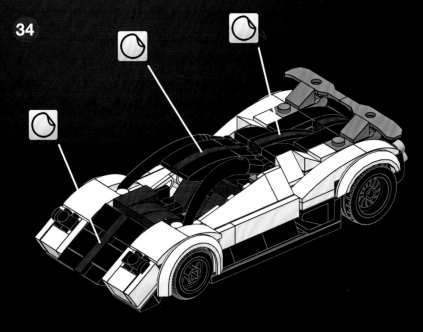

GT Fastback

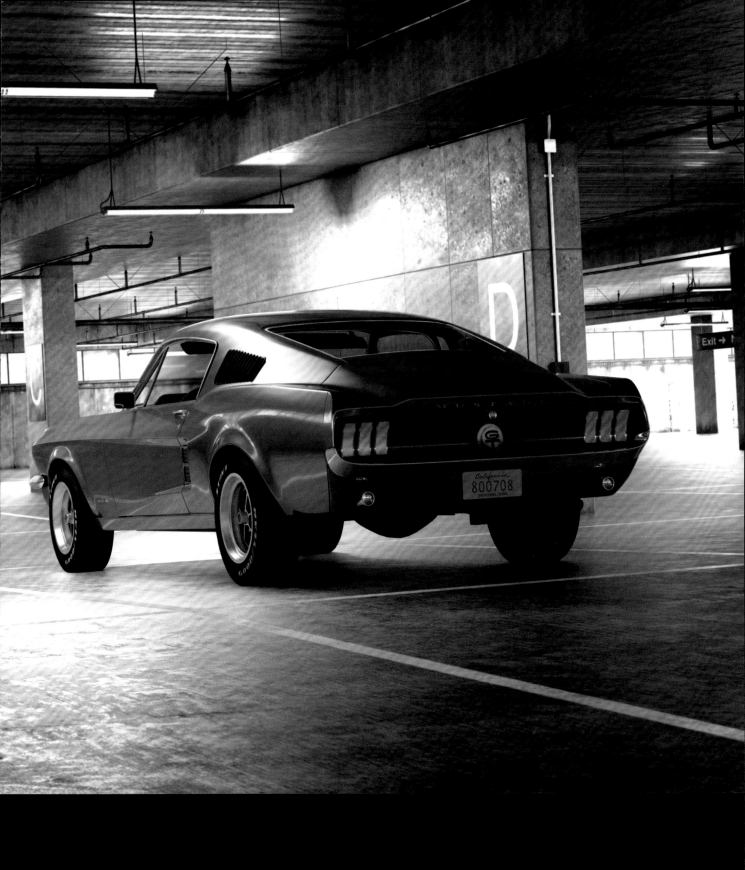

Mustang
GT Fastback

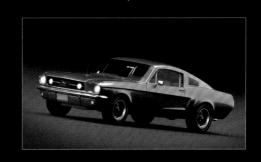

HISTORY

The Ford Mustang is a dream car that has been around for a long time. It is still in production today after its spectacular debut at the New York World's Fair in 1964, when it captured the imagination of car enthusiasts. To find the elixir of life, however Ford designers had to do a complete makeover of the Mustang in 1967. Created in fact as the first *pony car*, a coupe with a long hood and a shortened rear section for sporty young people, the car was copied by competitors three years later. From the moment the design process began moving primarily in the direction of enhanced performance (and therefore greater power), Ford decided to make this obvious at first glance. Every part of the car was strengthened, with deeper lateral air vents, an enlarged grille, a more aggressive front and back, but above all by the introduction of the 6.4-liter V8 big-block engine, the Thunderbird Special, with a four-barrel carburetor and a hot-blooded 320 hp. Only the chassis remained unchanged.

Everyone was happy, and the Mustang became a bestseller in the auto industry. If that wasn't enough, the famous racing driver and entrepreneur Carroll Shelby created his own interpretation of the Mustang 67, installing an even larger big-block, the 7-liter 480 Police Interceptor, thus giving birth to the Shelby Mustang GT500, a high-performance version with unique features like lateral air vents, a fiberglass hood and spoiler, and history's first standard anti-roll bar.

Speaking of history, the Fastback version of the Mustang 67 (with two doors and a rear trunk) was the star of the most exciting car chase ever, in the 1968 film *Bullitt*, with Steve McQueen at the wheel.

SPECIFICATIONS

GENERAL DESCRIPTION:

Years produced:	1968
Number produced:	42,581
Average price:	$2,700
Estimated present market value:	
	$36,000-$85,000
Model it replaced:	N/A
Replaced by:	Mustang II generation

PHYSICAL CHARACTERISTICS:

Dimensions:	15.1 x 5.9 x 4.3 ft
Weight:	2,744 lb

POWER:

Maximum speed:	130.5 mph
Acceleration:	0-60 in 6 seconds
Fuel consumption:	11.5 mpg

ENGINE:

Number of cylinders:	V8
Displacement:	390.55 cu. in.
Engine power:	319 hp
Drive:	rear-wheel drive

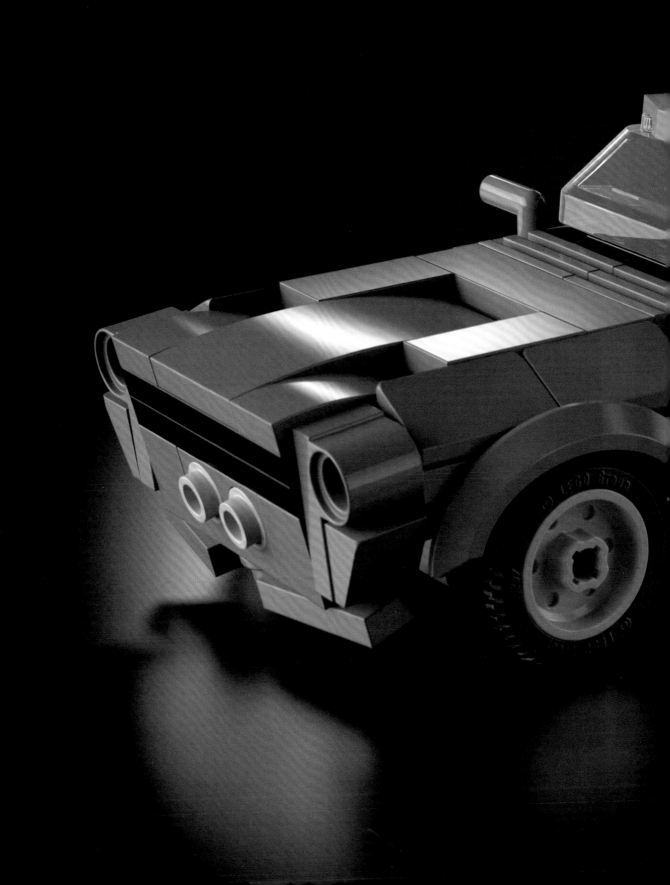

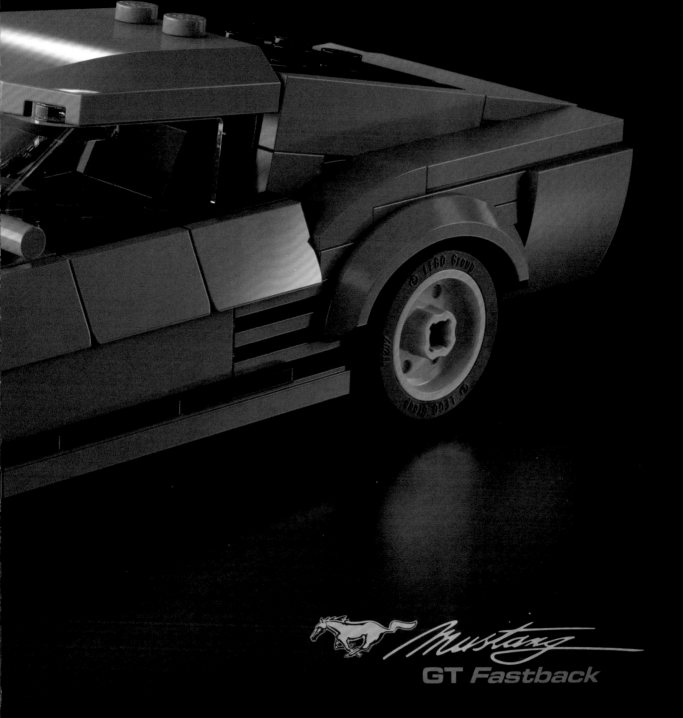

Mustang
GT Fastback

Mustang

GT Fastback

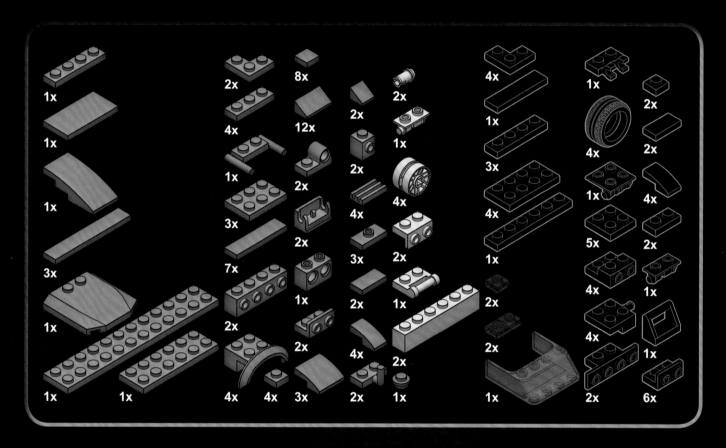

1x	
1x	
1x	
3x	
1x	
1x	1x

2x
4x
1x
3x
7x
2x
4x 4x 3x

8x
12x
2x
2x
4x
2x
4x

2x
2x
1x
2x
4x
2x
3x
2x
1x
2x
1x

2x
1x
2x
4x
2x
1x
2x
1x
2x
4x
2x
1x

4x
1x
3x
4x
1x

2x
2x
1x

1x
1x
1x
3x
4x
5x
4x
4x
2x

1x
2x
2x
2x
4x
2x
1x
1x
6x

█ █ █ ▢ **LEVEL OF DIFFICULTY**

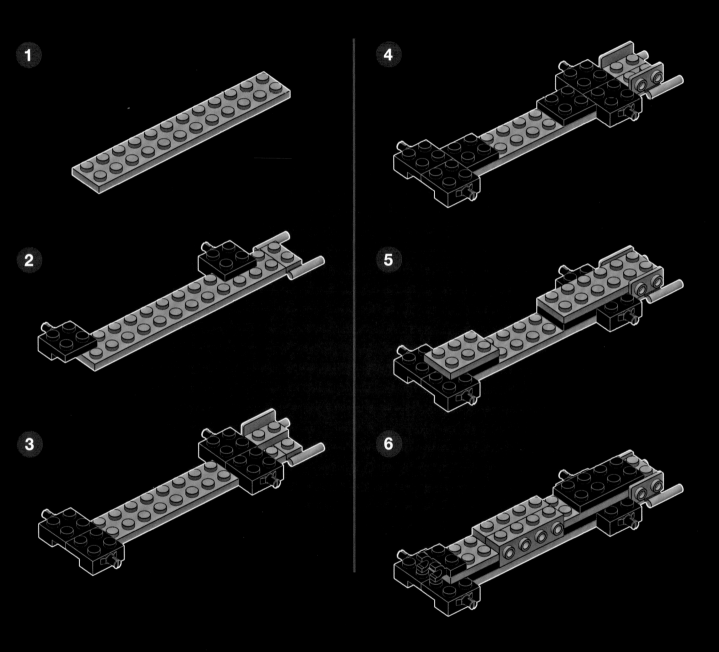

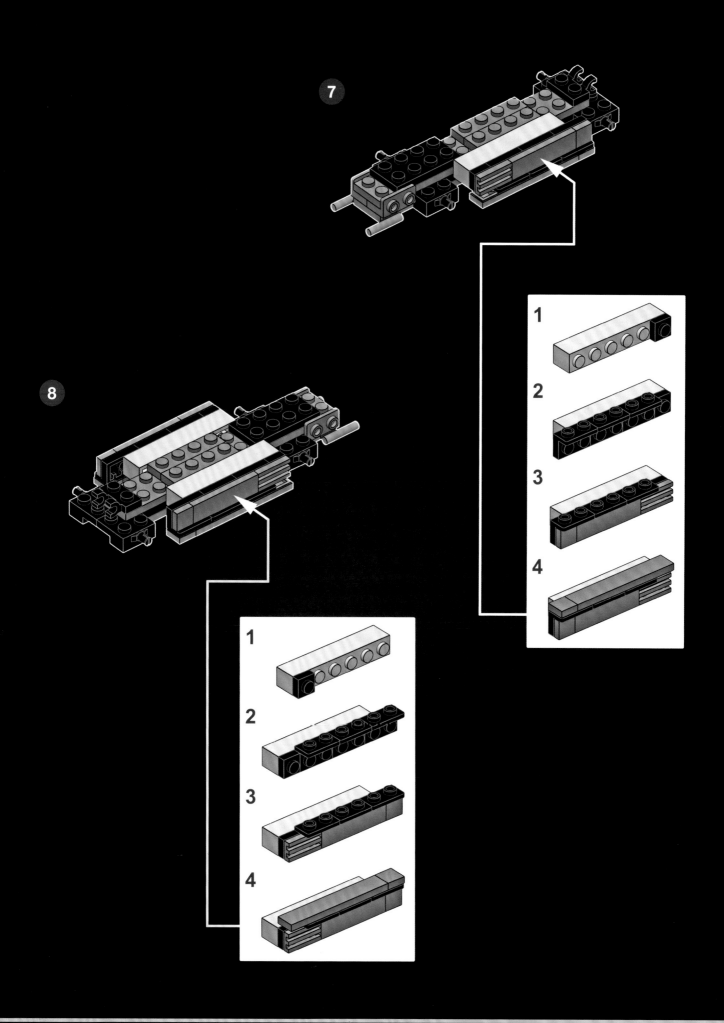

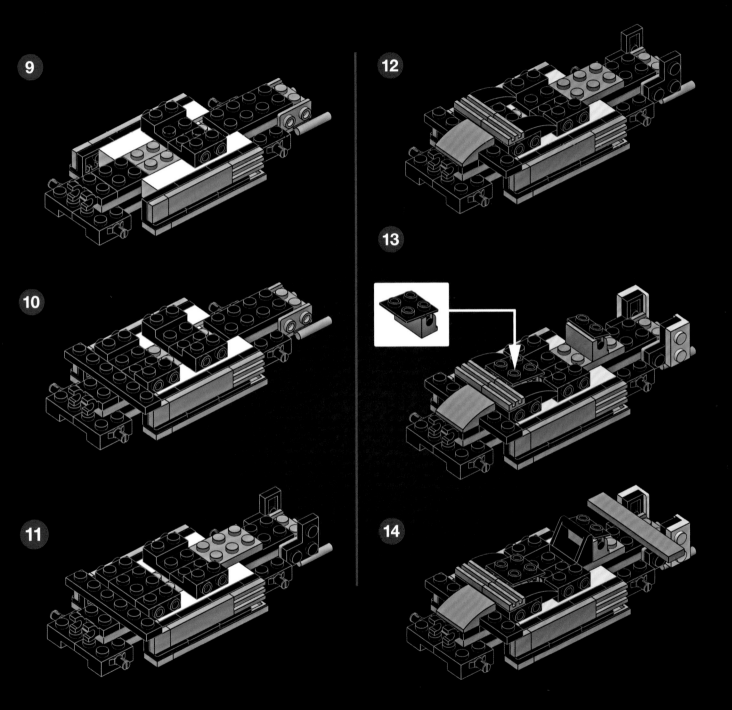

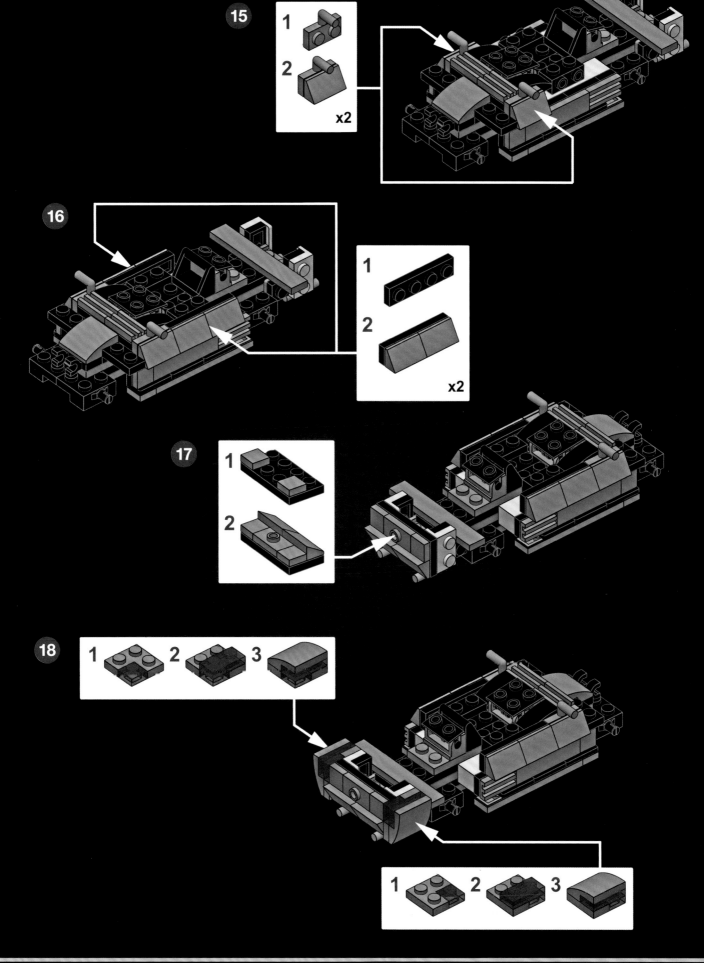

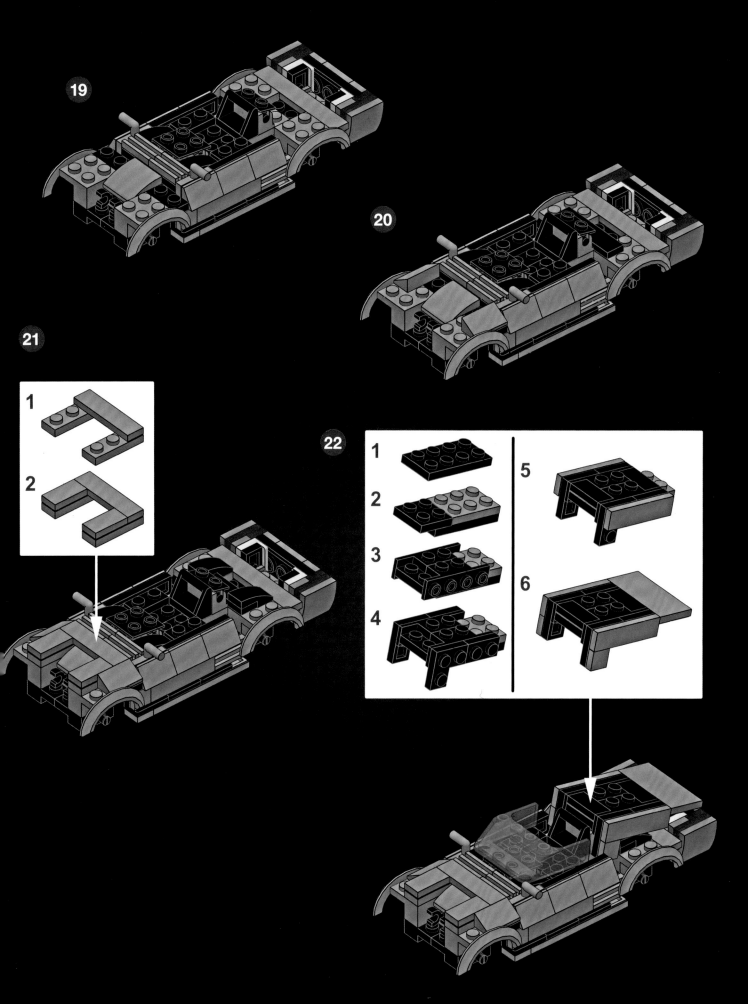

19

20

21

22

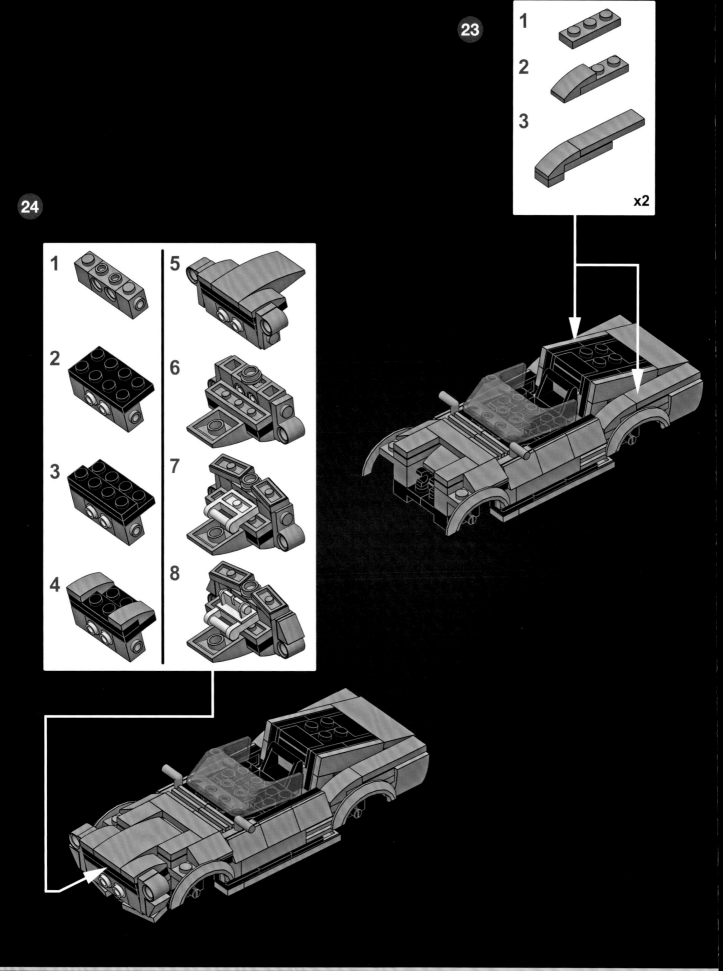

25

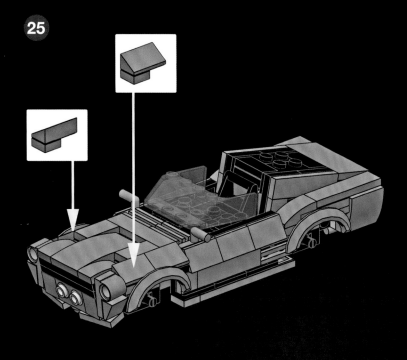

26

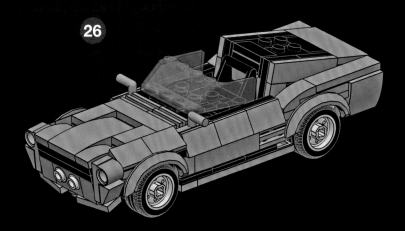

27

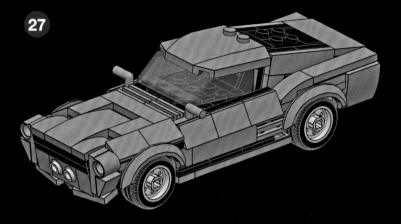

B **Bonus step**

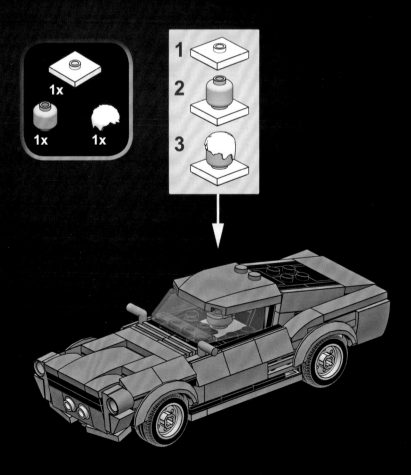

Alternative Versions

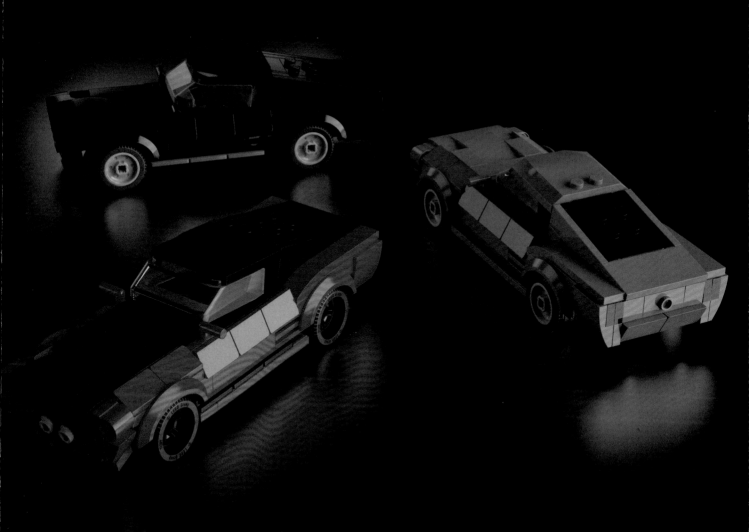

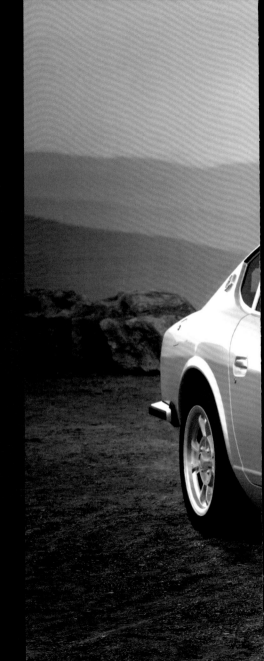

DATSUN
240Z

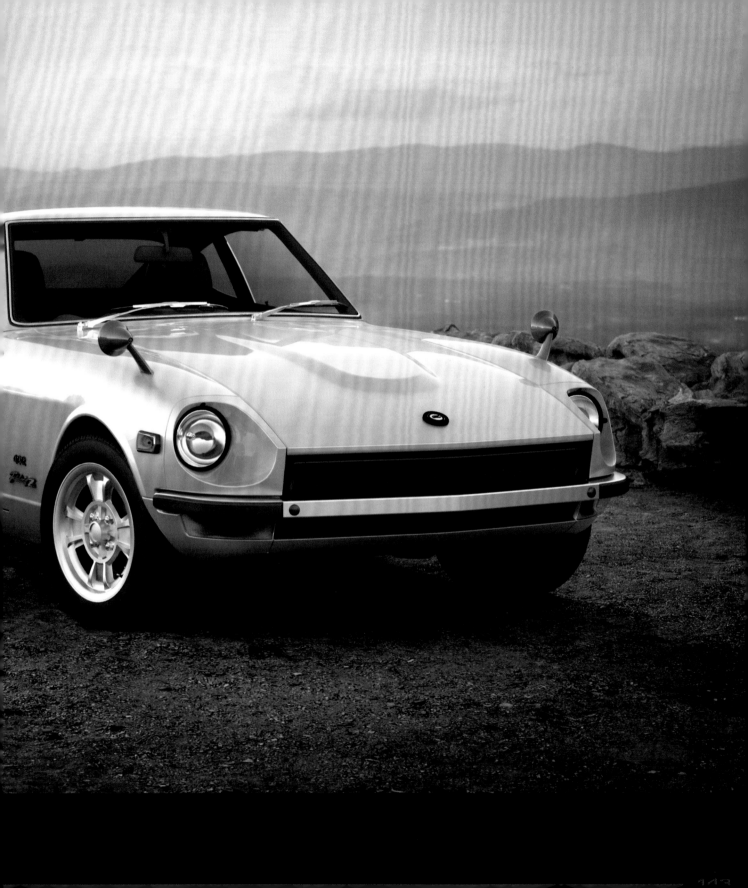

DATSUN
240Z

HISTORY

The Japanese phoenix, risen from the ashes of World War II thanks to American aid and Japanese tenacity, didn't take long to forge ahead in the automobile industry, eventually shaking up the Western World in the 1980s. One reason was the Nissan/Datsun 240Z, produced from 1969 to 1972 and deliberately intended to hammer the American auto market. To this end, design, engineering, and performance joined forces, allowing Nissan to leap ahead of its US competitors. The Nissan 240Z, a two-seater coupe marketed abroad beginning in 1970 under the name Datsun, held all the trump cards, including one that was truly significant: a moderate sales price that really caught the attention of its potential clients. Originally equipped with a 2-liter 6-cylinder in-line engine, increased to 2.4 liters with two carburetors for the American version, the Datsun 240Z was so successful that it became known as the "Japanese Porsche 911"—only much less demanding and expensive.

Everyday drivers liked the car because it was good-looking and reliable. It also was a hit with racing fans (since it won a variety of races, especially rallies) and even collectors, although more than 100,000 240Zs were produced. The 240Z's racing model became even more famous because of one of its drivers, Paul Newman, who was often photographed next to Bob Sharp's team's red, white, and blue number 33. This contributed in no small way to immortalizing the car's design, with its seductive slender hood in harmonious contrast to the sloping retro *fastback* roofline. To complete this success story, in 2004 the magazine *Sports Car International* placed the 240Z in second place among the most beautiful cars of the 1970s—and that's saying something, since it was the decade of the Ferrari Daytona and the Countach.

SPECIFICATIONS

GENERAL DESCRIPTION:
Years produced:	1970-1973
Number produced:	168,000
Average price:	$3,700
Estimated present market value:	
	$15,000 to $24,000
Model it replaced:	Datsun Sports/Fairlady
Replaced by:	Datsun 280ZX

PHYSICAL CHARACTERISTICS:
Dimensions:	13.6 x 5.3 x 4.2 ft
Weight:	2,301 lb

POWER:
Maximum speed:	125 mph
Acceleration:	0-60 in 8.3 seconds
Fuel consumption:	21 mpg

ENGINE:
Number of cylinders:	inline 6
Displacement:	146.46 cu. in.
Engine power:	151 hp
Drive:	rear-wheel drive

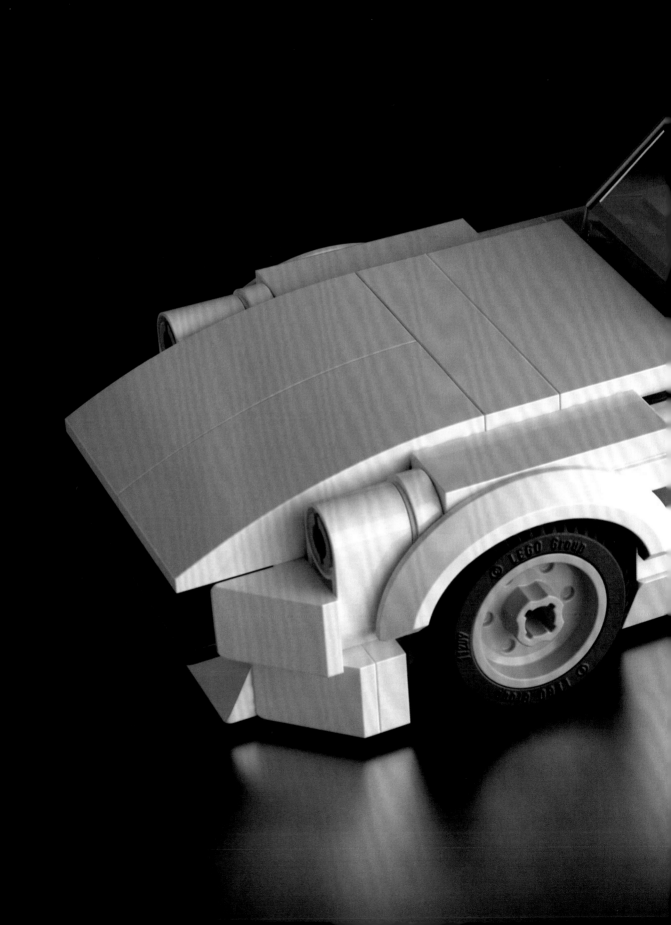

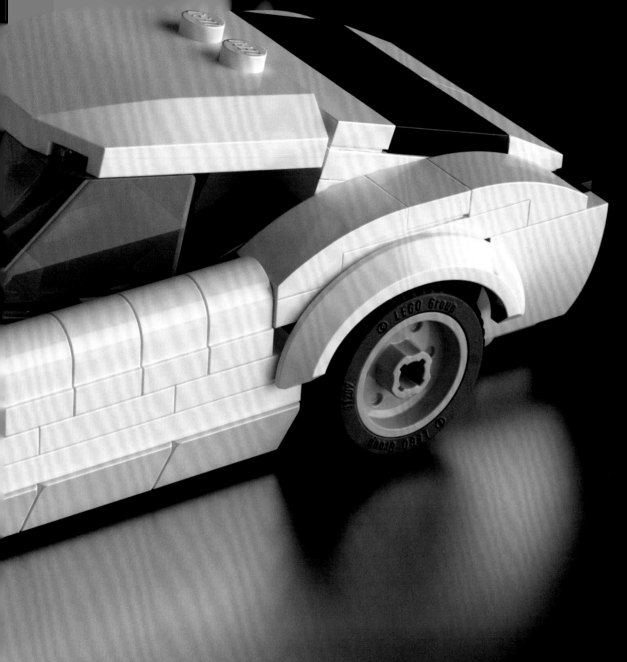

DATSUN
240Z

DATSUN 240Z

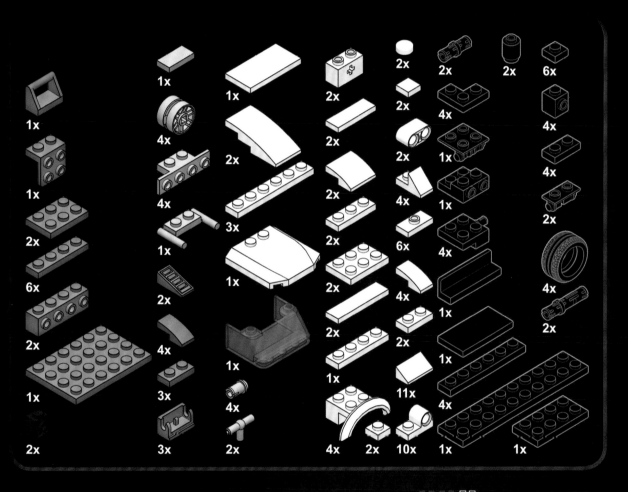

1x
1x
4x
2x
6x
2x
1x
2x

1x
4x
4x
1x
2x
4x
3x
3x
2x
4x
1x
4x
2x

1x
2x
2x
2x
2x
1x
6x
2x
2x
1x
11x
4x 2x 10x

2x
2x
2x
2x
2x
1x

2x
4x
1x
1x
4x
6x
4x
1x
2x
1x

2x
2x
6x
4x
4x
1x
4x
2x
4x
2x

4x
1x
4x
1x 1x

██ ██ ██ ▢ LEVEL OF DIFFICULTY

www.nuinui.ch/upload/lego-dream-cars-datsun.zip

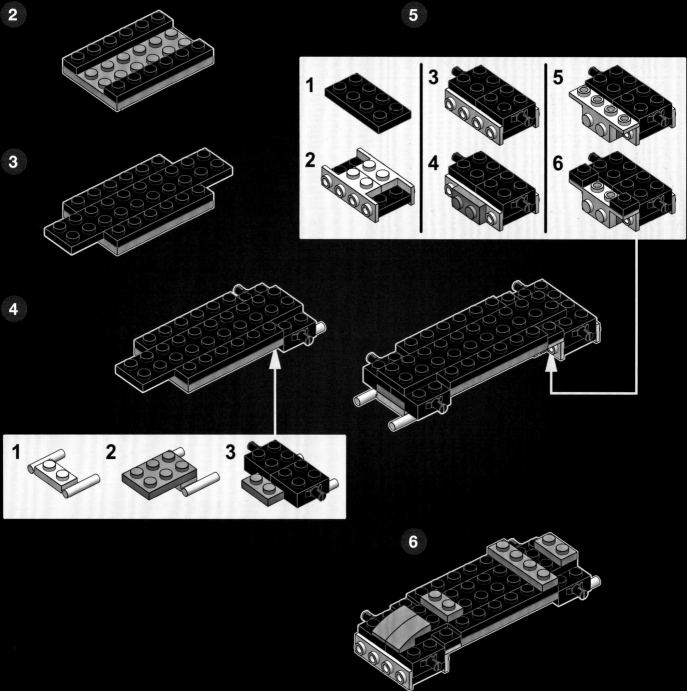

10

11

1

x2

12

13

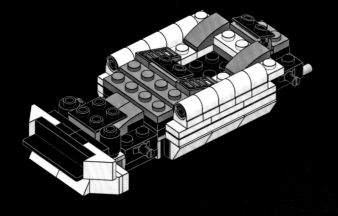

14

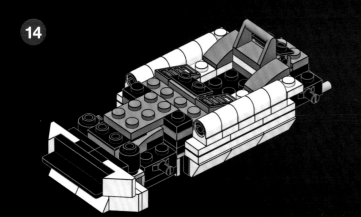

15

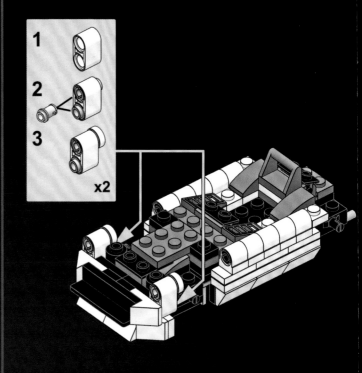

1
2
3

x2

16

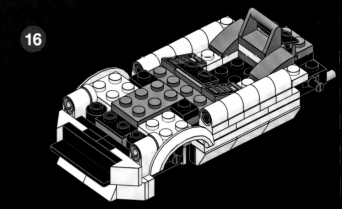

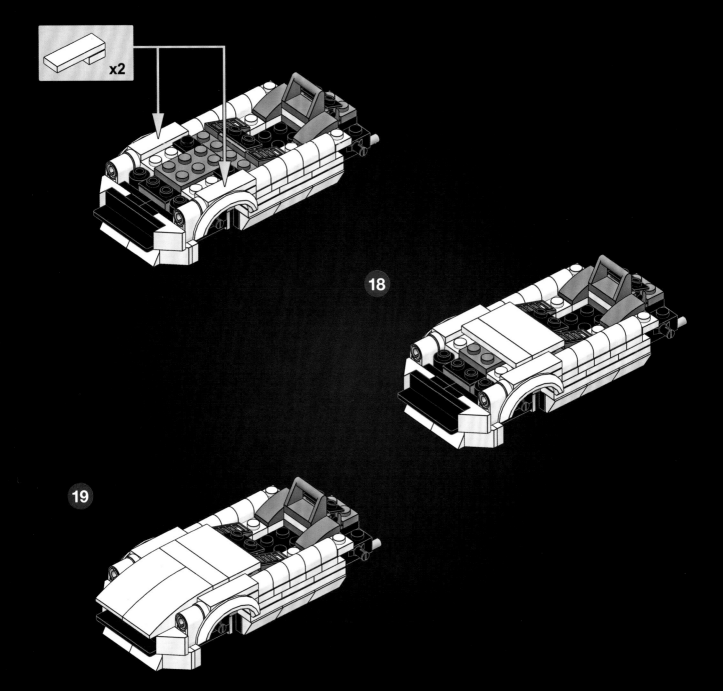

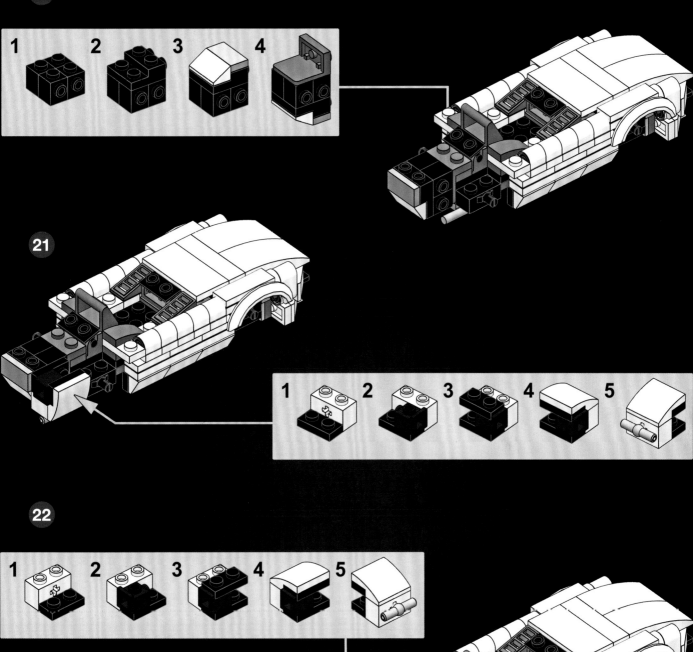

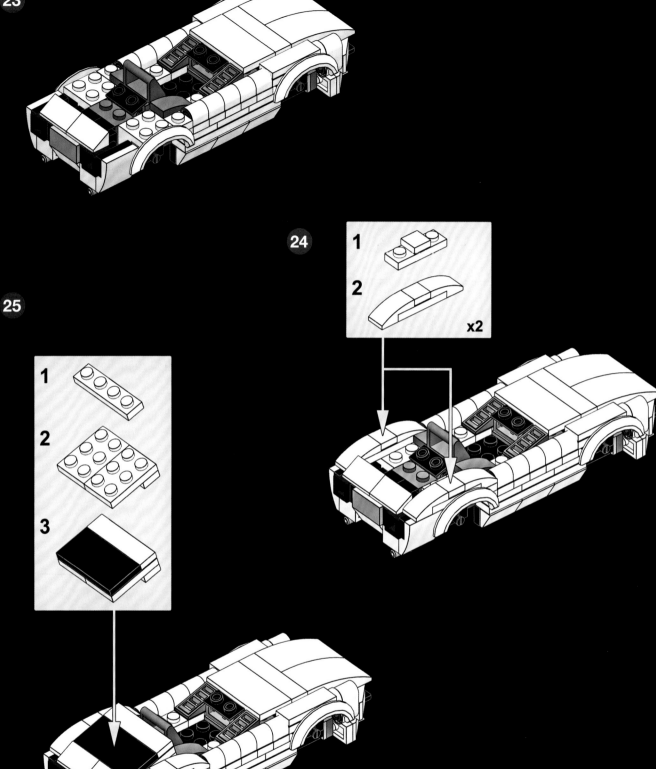

26

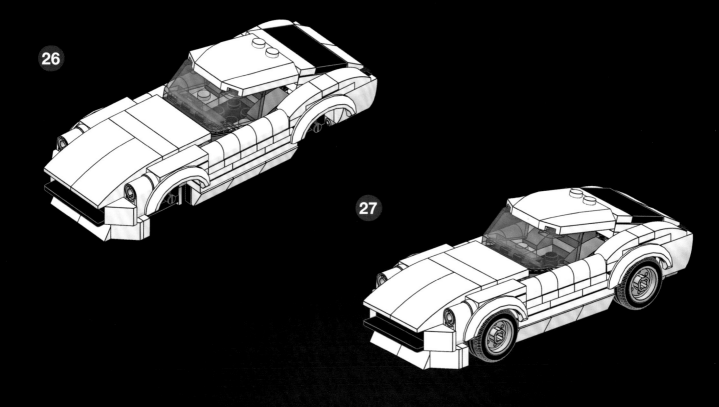

27

B **Bonus step**

1x
1x 3x

1
2
3
4

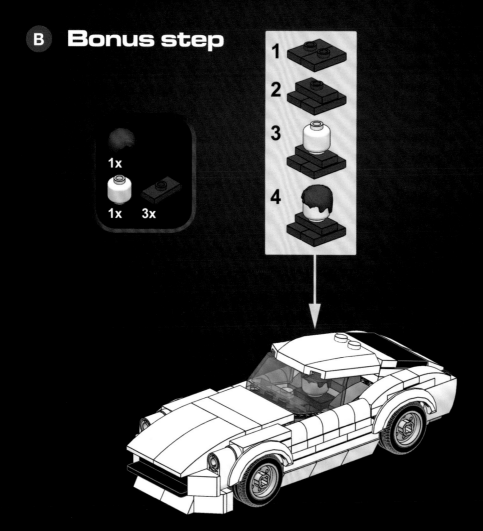

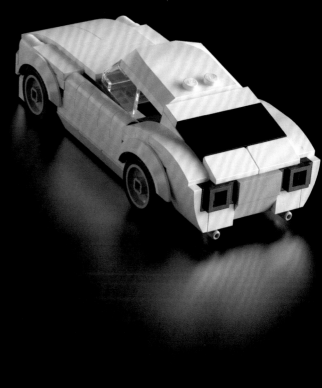

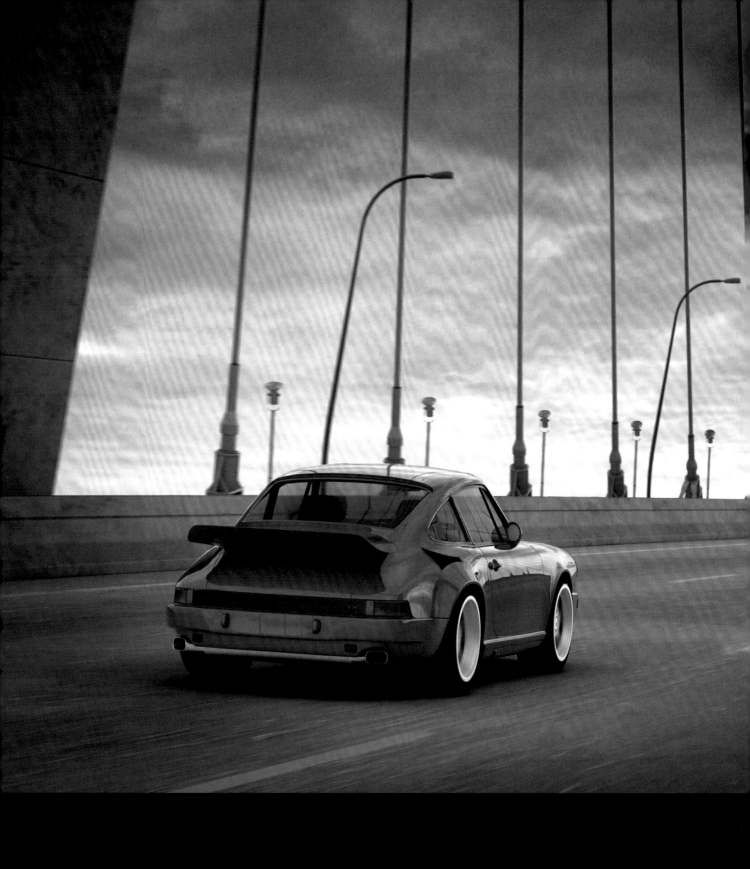

PORSCHE
911 turbo

PORSCHE
911 turbo

HISTORY

To sketch the history of the Porsche 911 Turbo Type 964, introduced in Geneva in 1990, one must go back to Frankfurt in 1963, when the first model of this sports car appeared. It is one of the oldest produced to this day with its original name and boasts a million sales through 2017. Over the years, there have been many versions: the 911 has undergone continual evolution, which led to its winning important victories in the '70s: Daytona, Sebring, and the Targa Florio. In 1989, the 964 series finally appeared, a major re-engineering of the 911 concept, with significant innovations like the hidden rear spoiler, the Triptonic automatic transmission, all-wheel drive, more integrated bumpers, and taillights protected by a single red cover.

In 1990, it was the turn of the 3.3-liter 320 hp Turbo option, which inherited a great deal from the preceding model, even adopting the classic rear drive, with a spoiler and enlarged fenders to protect wider tires. 1993 brought the Turbo 3.6, with a beefed-up motor (3.6 liters and 360 hp), turbo compression, and an improved pressure-friction ratio. The crown jewels of this series were rare models like the 1993 3.3-liter Turbo S, of which 80 were produced, or the 1994 Turbo 3.6S, constructed for a few months with the 90 chassis remaining from the production of the Turbo S. There is, however, an even rarer gem from the earliest days: in Frankfurt, in 1963, the model that would have come down in history as the Porsche 911 made its grand entrance as the Porsche 901. There were no problems until the next year, in Paris, when Peugeot took notice and claimed exclusive ownership of the three digits with a central 0, the model 405. Officially, none of the eighty-two 901 models produced made it to market, although, years later, a few found lucky private owners.

SPECIFICATIONS

GENERAL DESCRIPTION:

Years produced:	1989-1994
Number produced:	62,172
Average price:	$60,000
Estimated present market value:	
	$150,000 to $350,000
Model it replaced:	Porsche 911, type 930
Replaced by:	Porsche 911, type 993

PHYSICAL CHARACTERISTICS:

Dimensions:	13.8 x 5.4 x 4.3 ft
Weight:	3,031 lb

POWER:

Maximum speed:	162 mph
Acceleration:	0-60 in 5.5 seconds
Fuel consumption:	24 mpg

ENGINE:

Number of cylinders:	counterpoise 6
Displacement:	201.38/219.69/228.84 cu. in.
Engine power:	315 to 355 hp
Drive:	rear-wheel drive

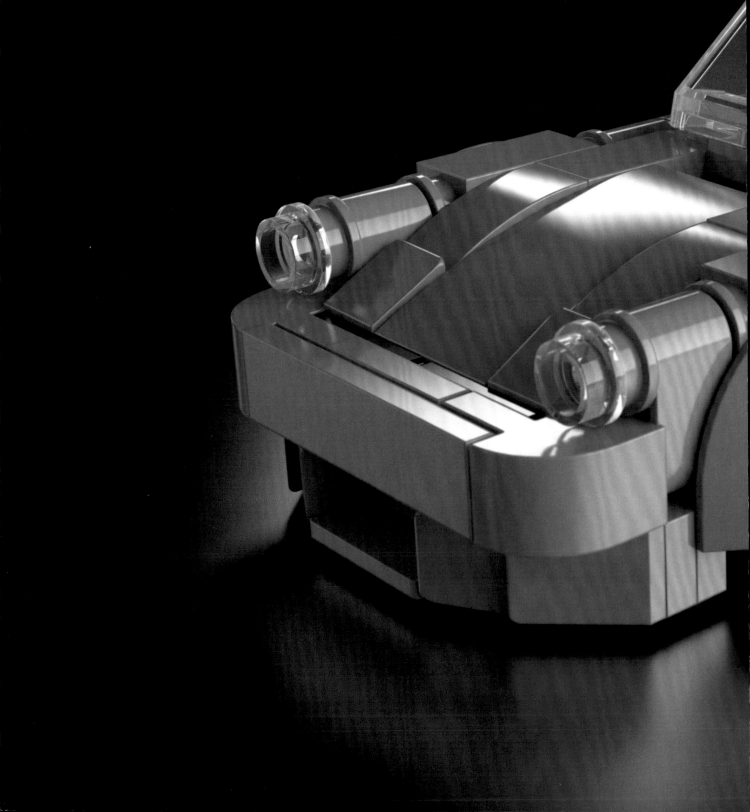

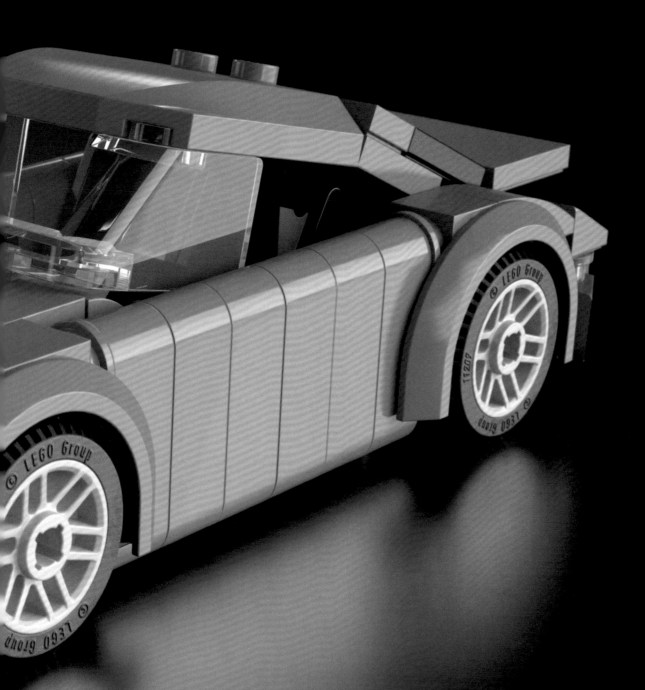

PORSCHE
911 turbo

PORSCHE
911 turbo

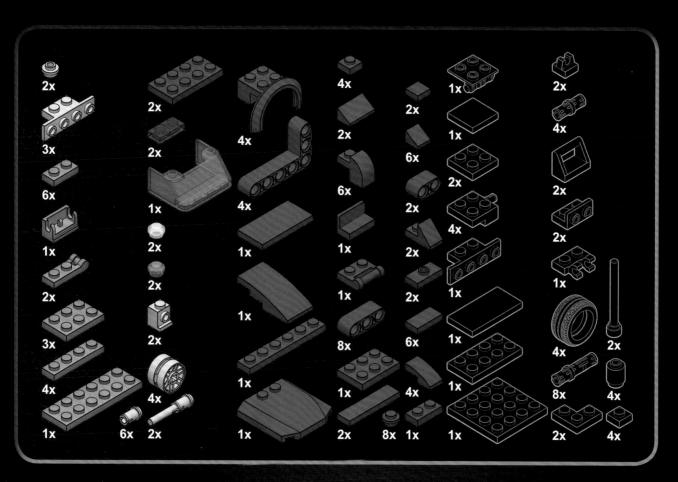

2x 2x 4x 4x 2x 1x 2x
3x 2x 2x 6x 1x 4x
6x 2x 4x 2x 2x
 1x 6x 2x 2x
1x 2x 4x 6x 4x 2x
2x 2x 1x 2x 4x 2x
3x 2x 1x 1x 1x 1x
 2x 1x 1x 2x
4x 4x 8x 6x 1x 4x 2x
1x 6x 2x 1x 1x 1x 1x 8x 4x
 1x 2x 8x 1x 1x 2x 4x

◾◼◾ **LEVEL OF DIFFICULTY**

www.nuinui.ch/upload/lego-dream-cars-porsche.zip

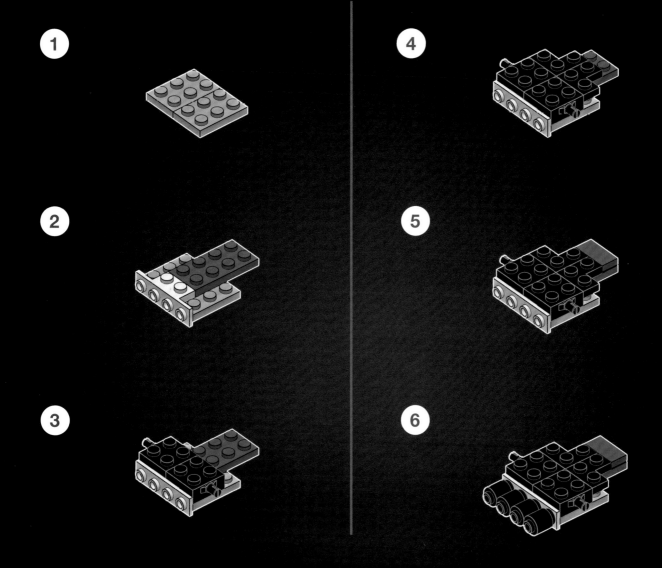

7

1

2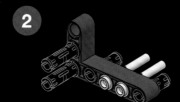

3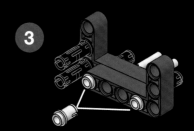

4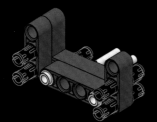

8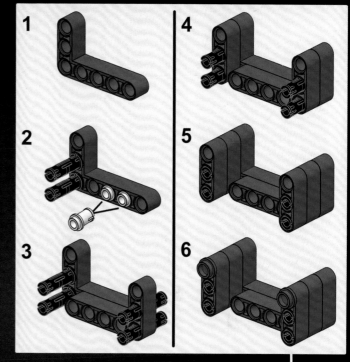

5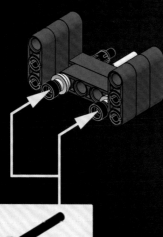

6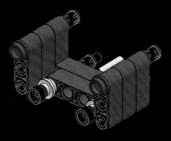

x2

7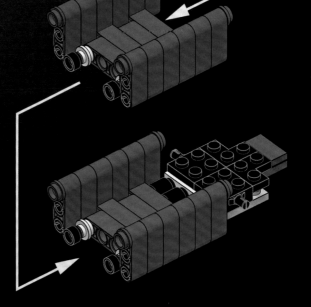

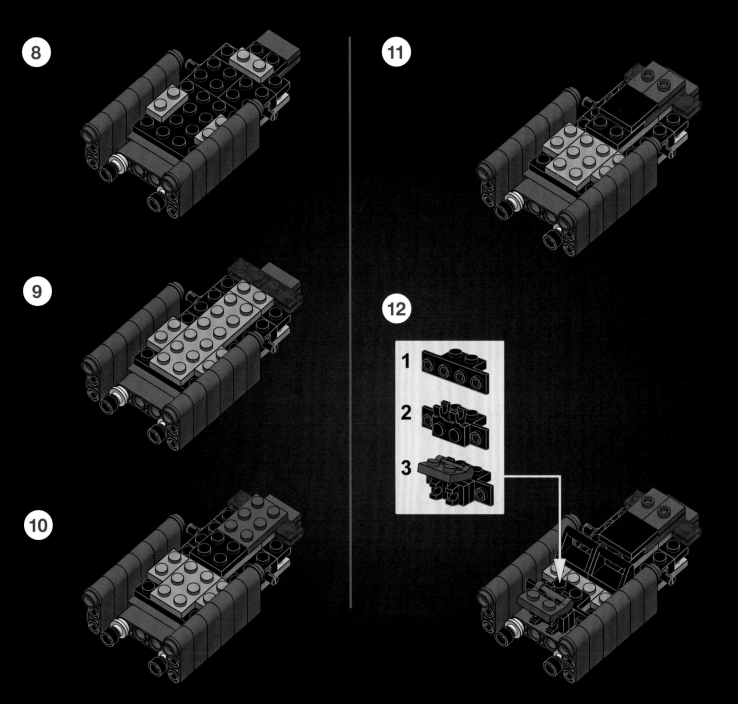

13

1

2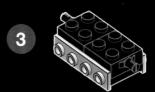

3

4

5

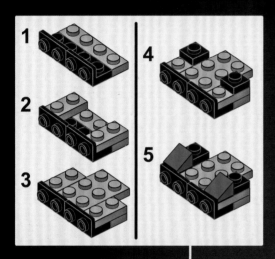

6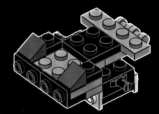

7

8

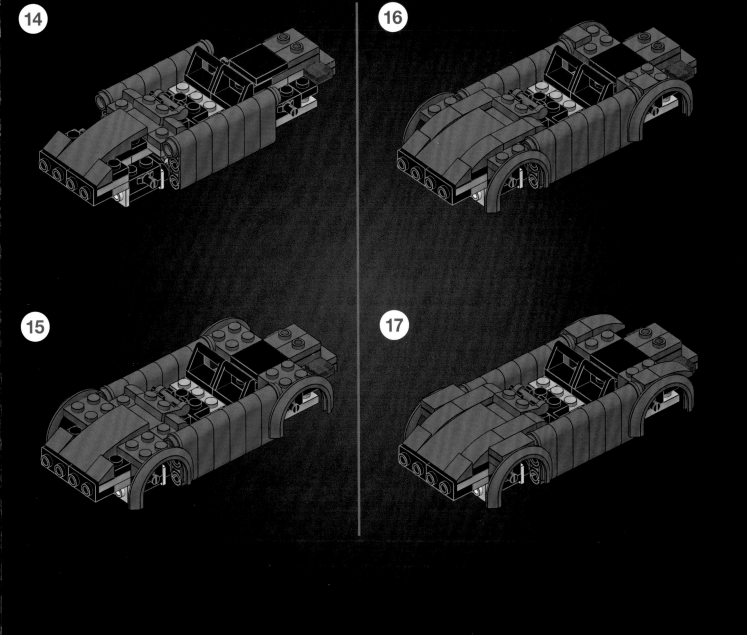

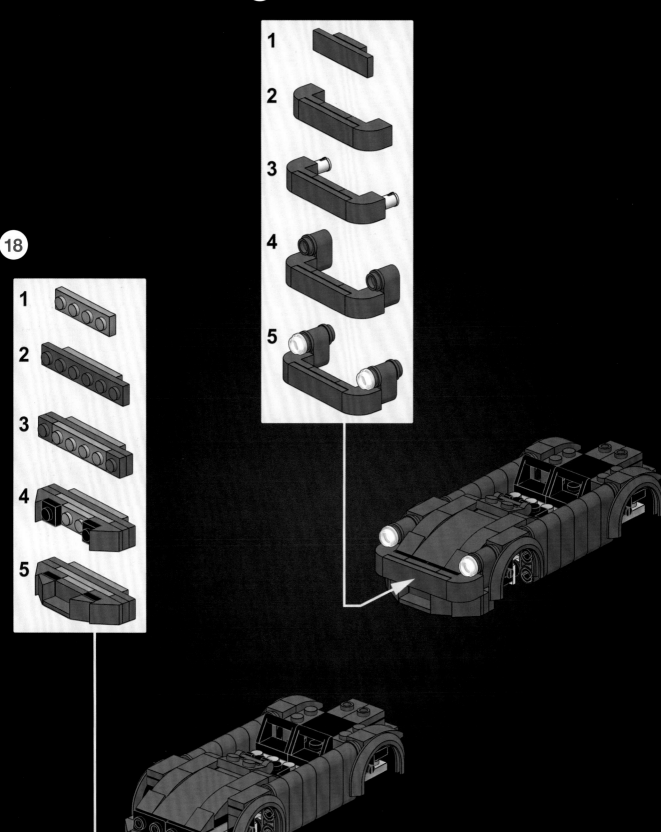

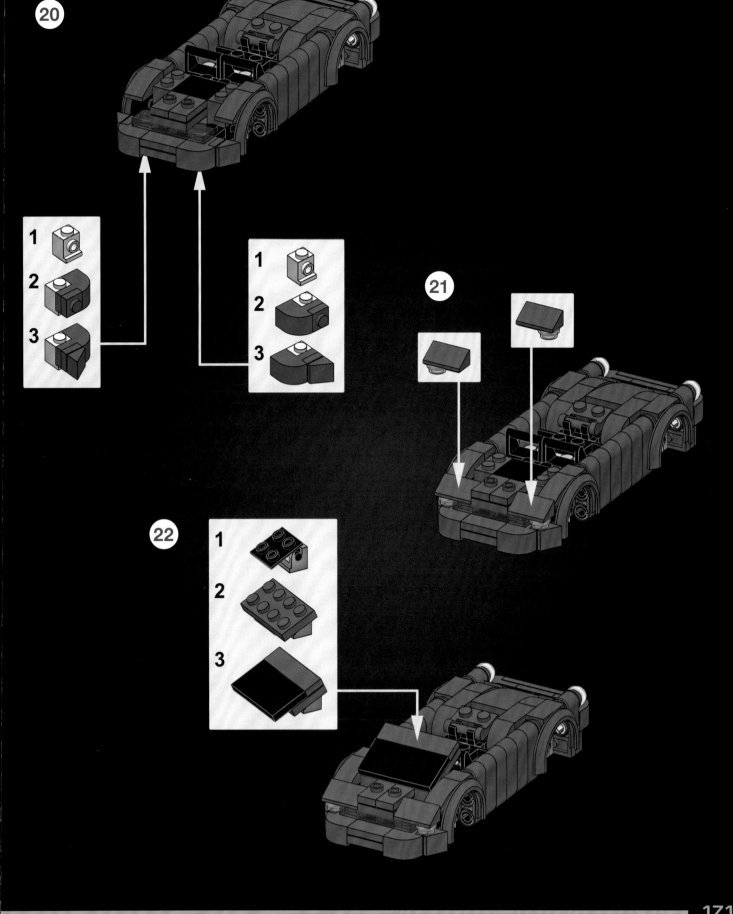

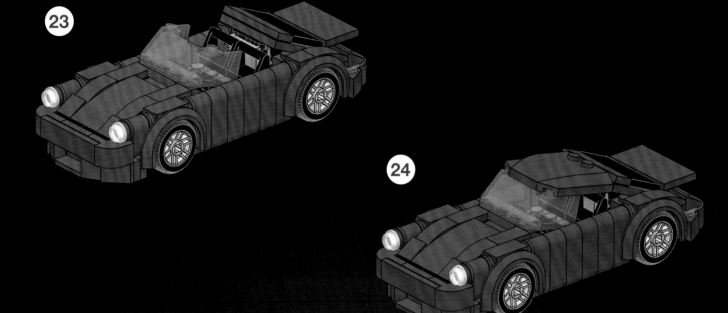

23 **24**

B Bonus step

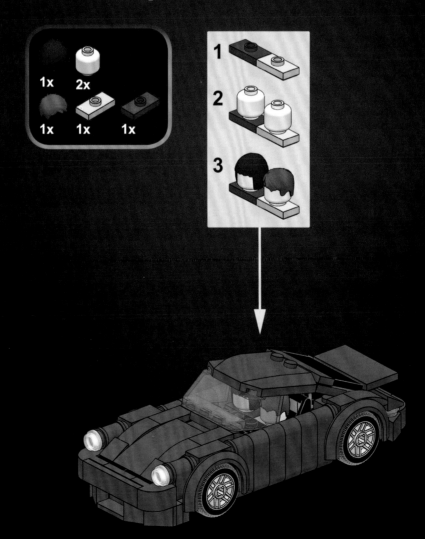

1x 2x

1x 1x 1x

1

2

3

Alternative Versions

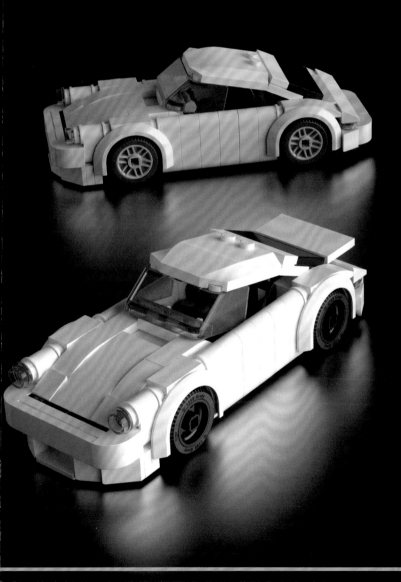

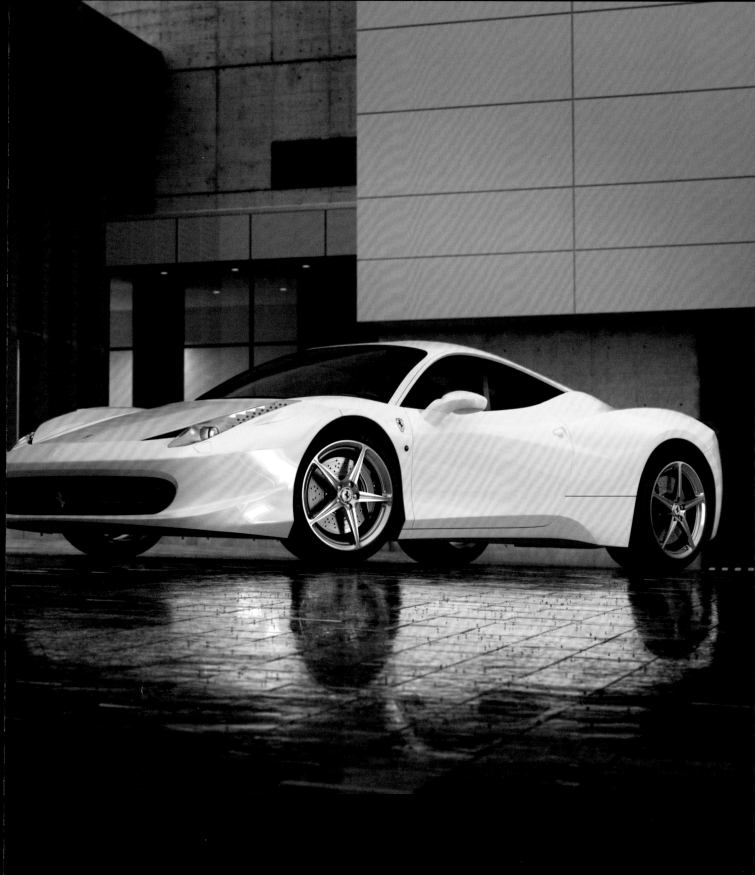

Ferrari 458 ITALIA

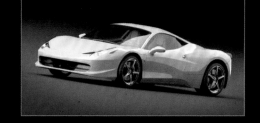

HISTORY

Calling it a sporty coupe is an oversimplification. The Ferrari 458 (with its 4.5-liter award-winning 8-cylinder F136 direct injection engine) is a space capsule. This is no frivolous statement. The series, launched by Ferrari in 2009, was built using materials and techniques borrowed from the aerospace industry, perfect for creating a racing car that is stable and maneuverable at 200 mph. The 458 brought together all of Ferrari's Formula 1 experience, starting with the innovative Pininfarina design intended to combine looks with aerodynamic construction, making it the best Ferrari in this category. The 458 Italia has an aggressive presence, with reptilian "scimitar" headlight units and deformable winglets on the radiator that lower at high speeds, reducing drag. The formidable naturally aspirated engine allows the car to go from 0 to 60 in three seconds and is held at bay by carbon ceramic brakes that, at 100 mph, can bring the car to a halt in a space of 105 feet.

The 458 is designed for more than efficiency, though. The exhaust pipes have been devised to reduce noise to a minimum, in order to be pleasing to the ear, like a symphony.

As for the interior, it recalls the space capsule mentioned above, with many of its controls concentrated in the Formula 1-like steering wheel and an onboard computer that provides data such as acceleration rate and temperature, useful in a "hot" car like this one. In fact, the Ferrari 458 has so much energy that its computer has sensed fires caused by overheating of the wheel arch adhesive. The company has duly replaced the faulty pieces, substituting an adhesive that is attached mechanically in all other models. On the other hand, there are risks to be aware of for anyone who climbs into a Ferrari of this caliber, which, let's not forget, has benefited from the expert advice of Michael Schumacher, one of the greatest drivers of all time.

SPECIFICATIONS

GENERAL DESCRIPTION:

Years produced:	2009-2015
Number produced:	around 15,000
Average price:	$250,000
Estimated present market value:	
	$190,000 to $250,000
Model it replaced:	Ferrari F430
Replaced by:	Ferrari 488 GTB

PHYSICAL CHARACTERISTICS:

Dimensions:	14.8 x 6.3 x 4 ft
Weight:	2,844 to 3,152 lb

POWER:

Maximum speed:	202 mph
Acceleration:	0-60 in 3.4 seconds
Fuel consumption:	21.2 mpg

ENGINE:

Number of cylinders:	V8
Displacement:	274.6 cu. in.
Engine power:	562 hp
Drive:	rear-wheel drive

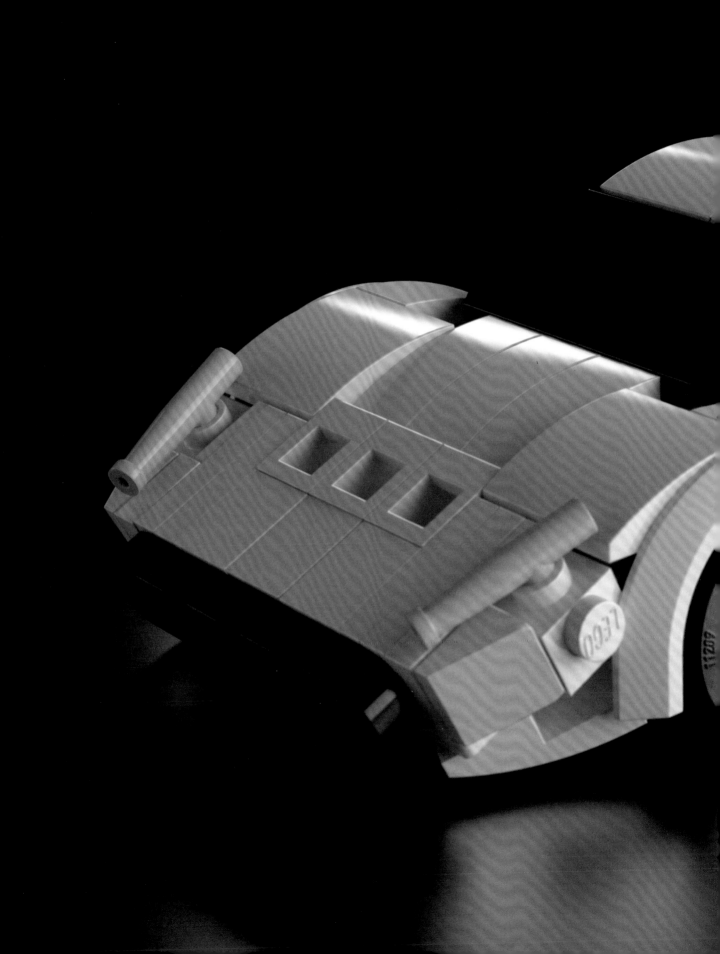

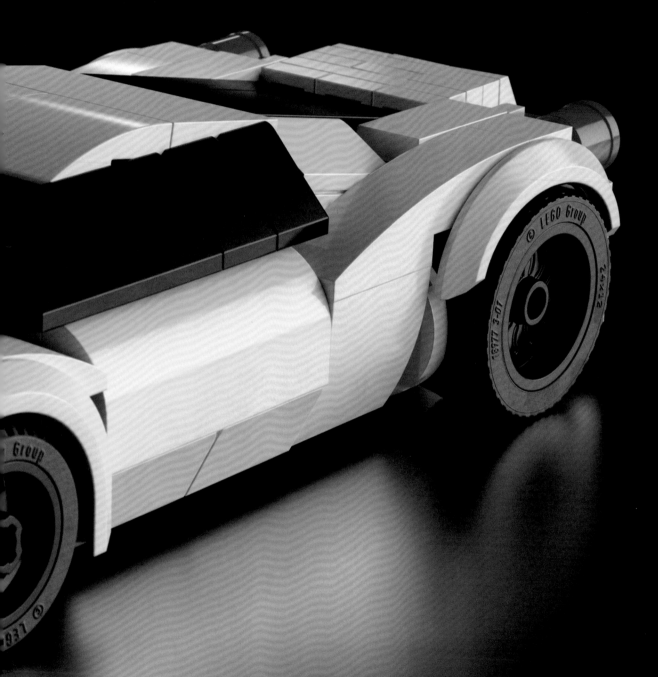

Ferrari
458
ITALIA

Ferrari
458 ITALIA

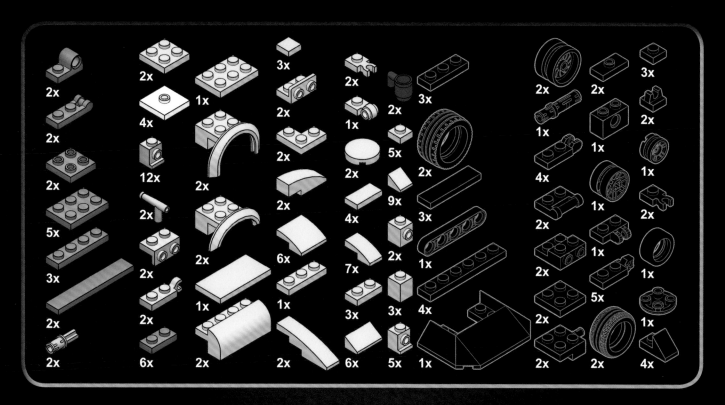

LEVEL OF DIFFICULTY

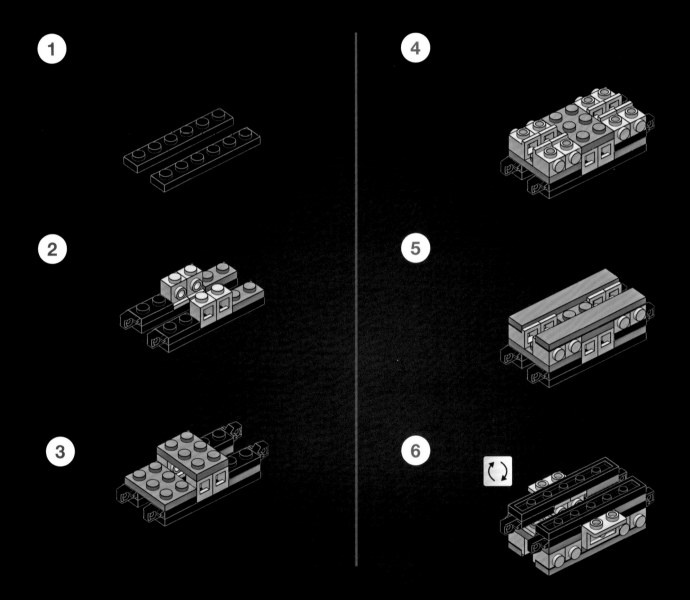

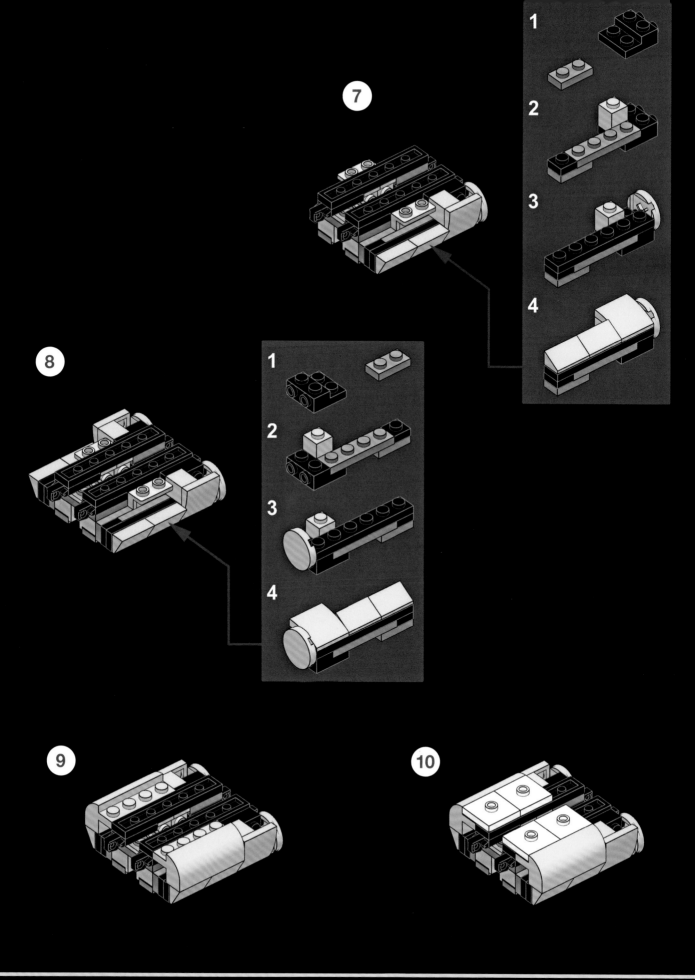

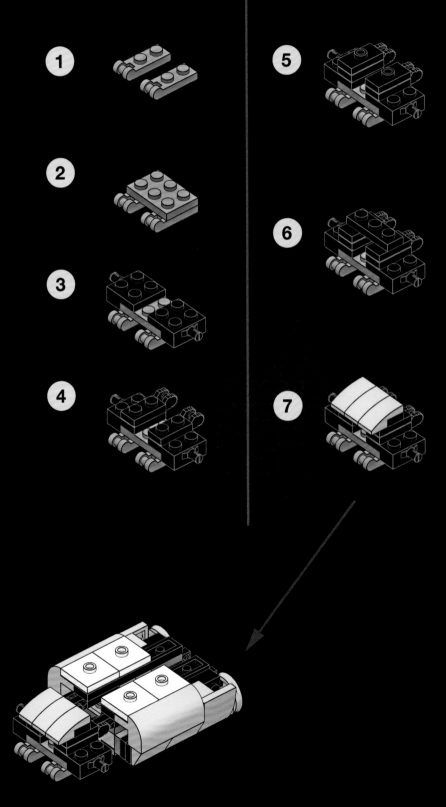

1

2

3

4

5

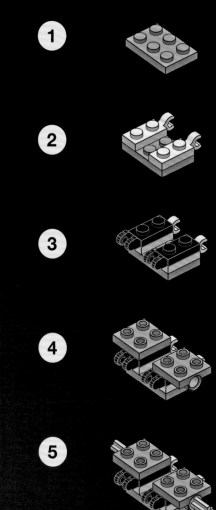

6

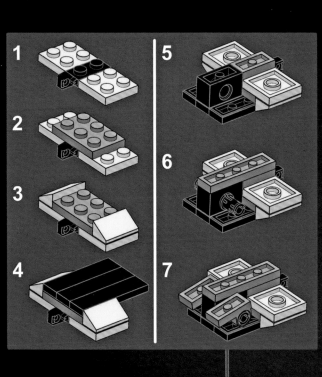

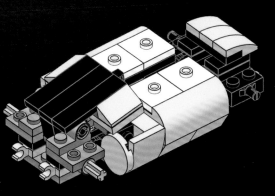

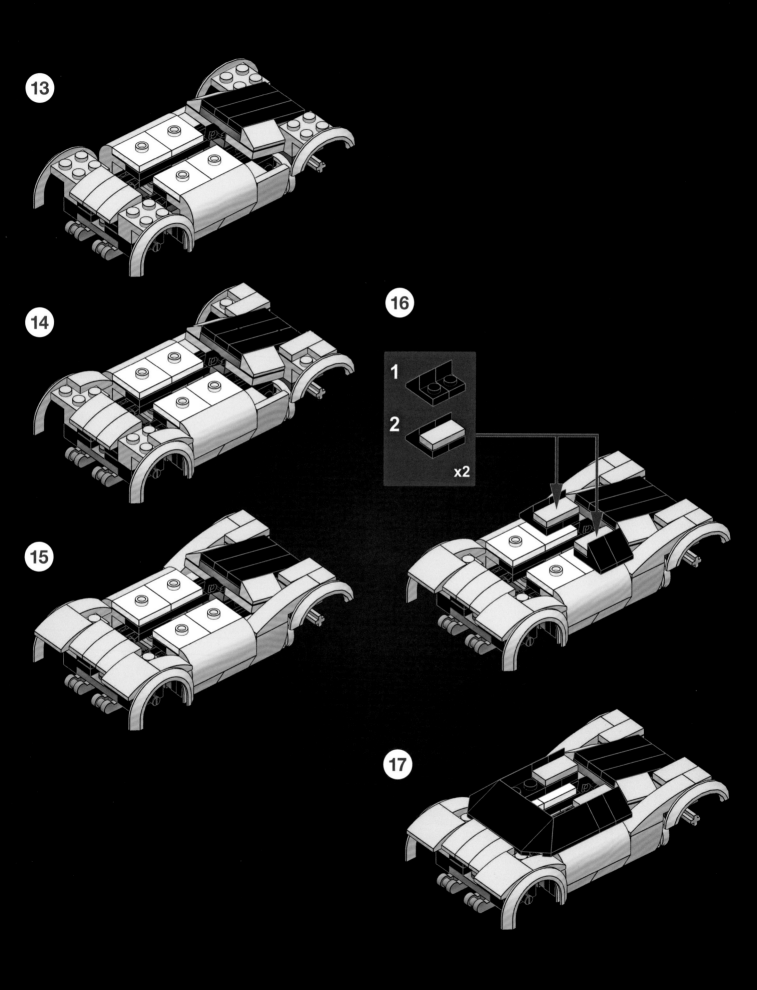

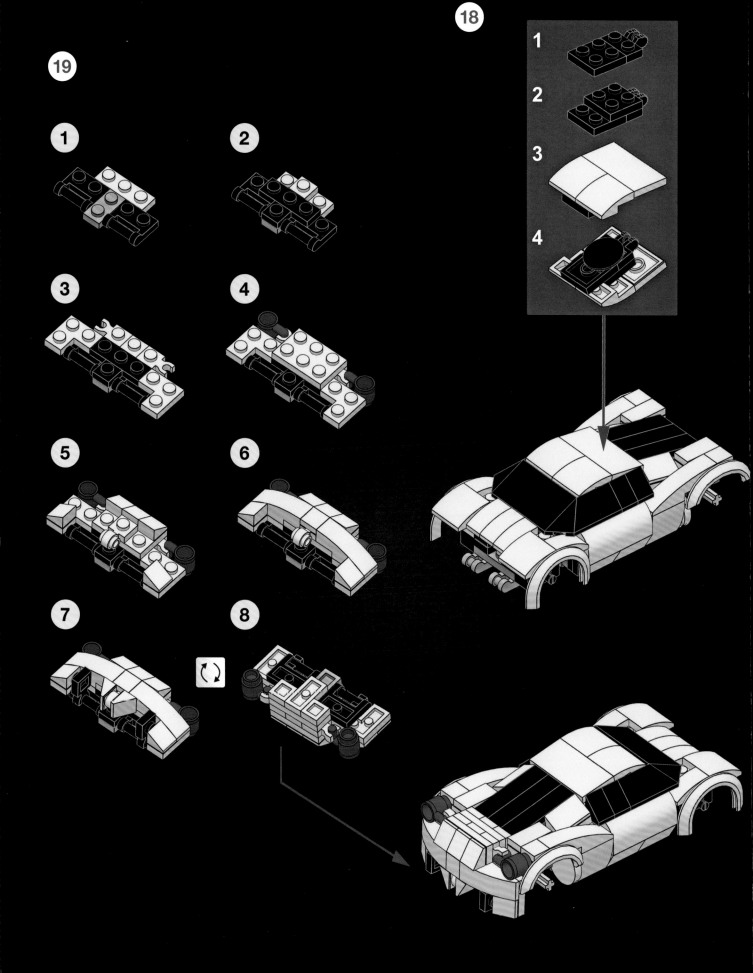

20

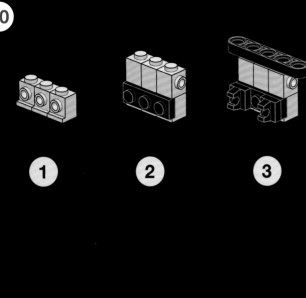

1 **2** **3**

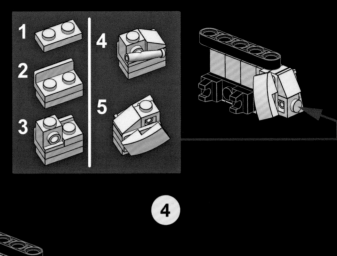

4

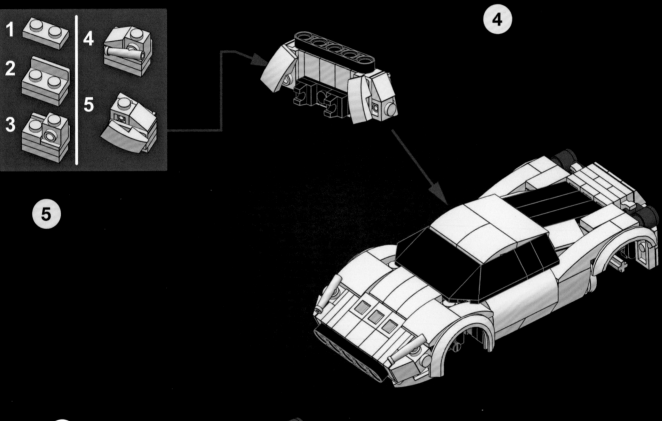

5

21

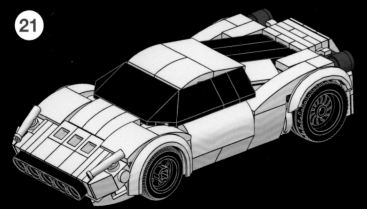

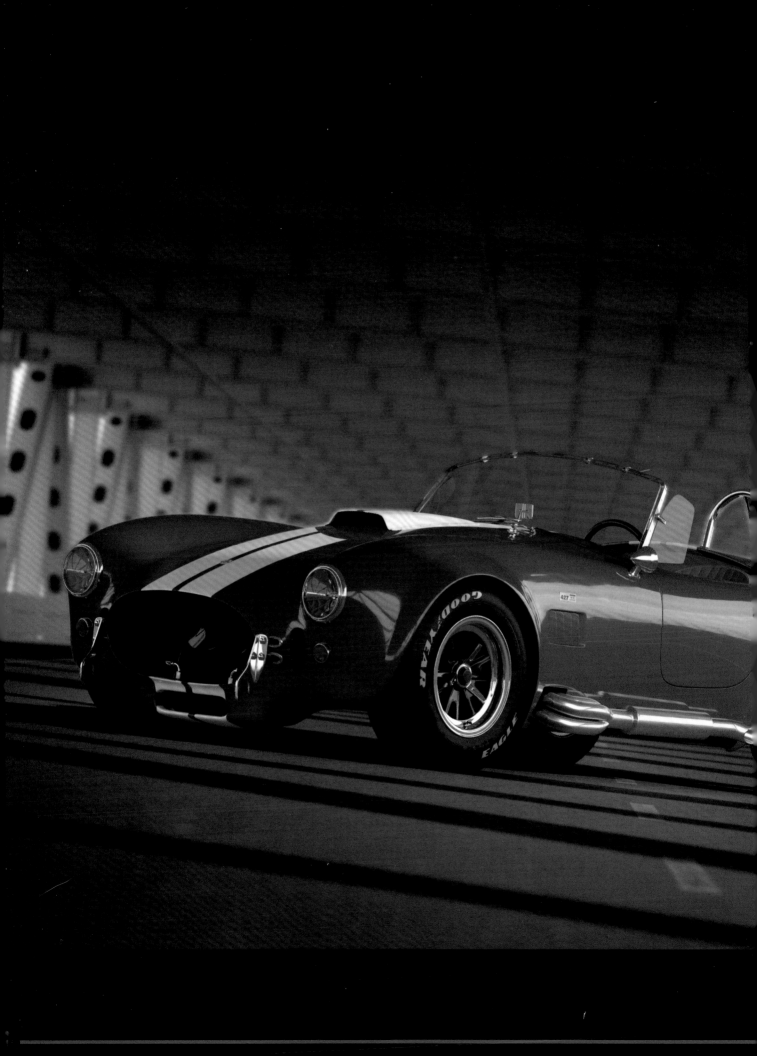

COBRA
427 S/C

HISTORY

If there is a gran turismo whose story is closely identified with that of its creator, it's the Shelby Cobra, created by Carroll Shelby, ex-US Air Force pilot, ex-poultry farmer, and ex-champion, who drove an Aston Martin to victory in the 24 Hours of Le Mans in 1959. Having returned to the US hoping to build winning racing cars, Shelby had the idea of joining the superiority of English auto bodies constructed by hand with the power of American engines. And so, in 1962, the Cobra was born, adapting the chassis and shell of the British AC Ace to Ford's 2.6-liter small-block engine, quickly providing him with victories on the race track.

In 1965, based on this success, Shelby took the challenge to extremes with the Cobra 427, equipped with the heavy 4.5-liter Ford big-block 427 engine, designed to win in the NASCAR category. However, the project broke the Fédération Internationale de l'Automobile's rules and fell through, leaving Shelby with 53 already-built Cobras to dispose of. It was at this moment that what some consider a "revolution" occurred: the Shelby Cobra 427 SC (SC for "semi-competition"), converted for normal driving use, came into being. Its suspension and brakes were reinforced to handle the massive Ford big-block engine, and it was provided with prominent wheel arches, enlarged rims and tires, and side exhaust pipes that released compressed power. It introduced the concept of the supercar in which everything was exaggerated: power, speed, performance, and quality. The 427 is the model most beloved by collectors, but it's not the only one. When Shelby said, "The difference between the racing Cobra and the one for everyday use is how hard one steps on the gas", he was expressing the free spirit typical of the American dream, evoked so successfully in the film *The Gumball Rally*, in which the Cobra faces a memorable challenge with the Ferrari Daytona in a river bed.

SPECIFICATIONS

GENERAL DESCRIPTION:

Years produced:	1965-1967
Number produced:	53
Average price:	$9,500
Estimated present market value:	
	$1,500,000 to $2,400,000
Model it replaced:	AC Ace
Replaced by:	AC Mk IV

PHYSICAL CHARACTERISTICS:

Dimensions:	13 x 5.6 x 4 ft
Weight:	2,281 lb

POWER:

Maximum speed:	163 mph
Acceleration:	0-60 in 4.2 seconds
Fuel consumption:	11 mpg

ENGINE:

Number of cylinders:	V8
Displacement:	274.6 cu. in.
Engine power:	424 hp
Drive:	rear-wheel drive

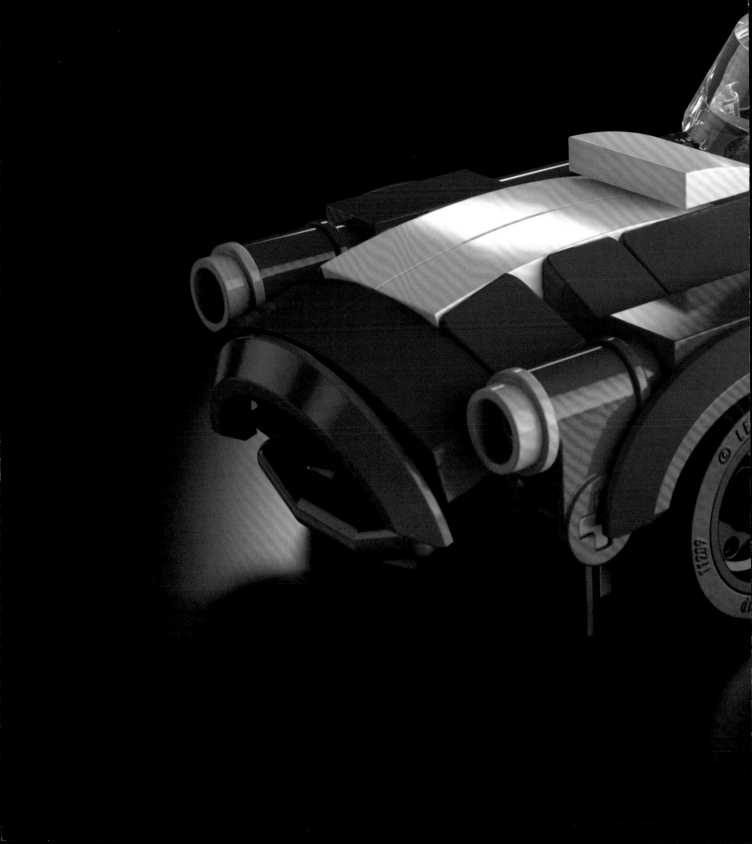

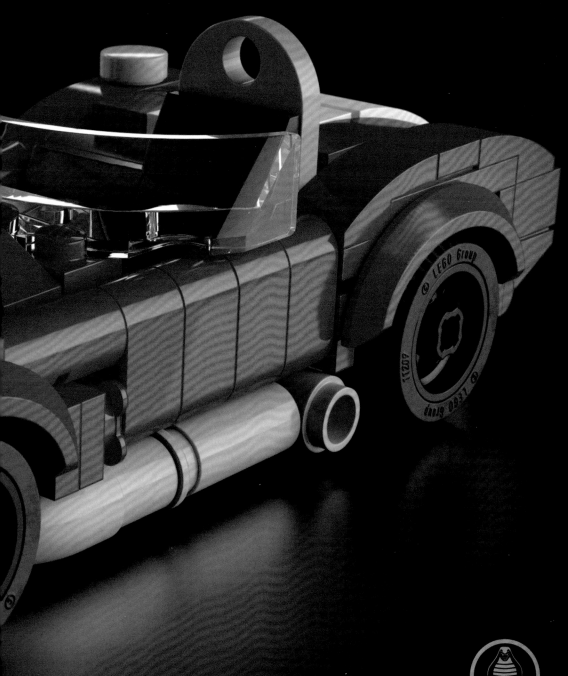

COBRA
427 S/C

COBRA
427 S/C

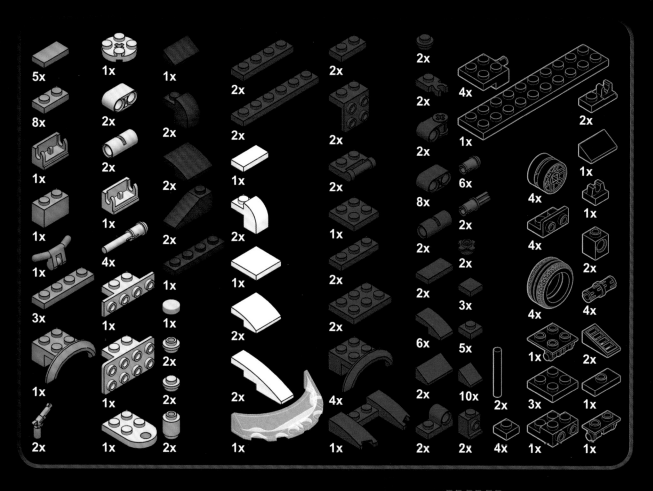

LEVEL OF DIFFICULTY

www.nuinui.ch/upload/lego-dream-cars-cobra.zip

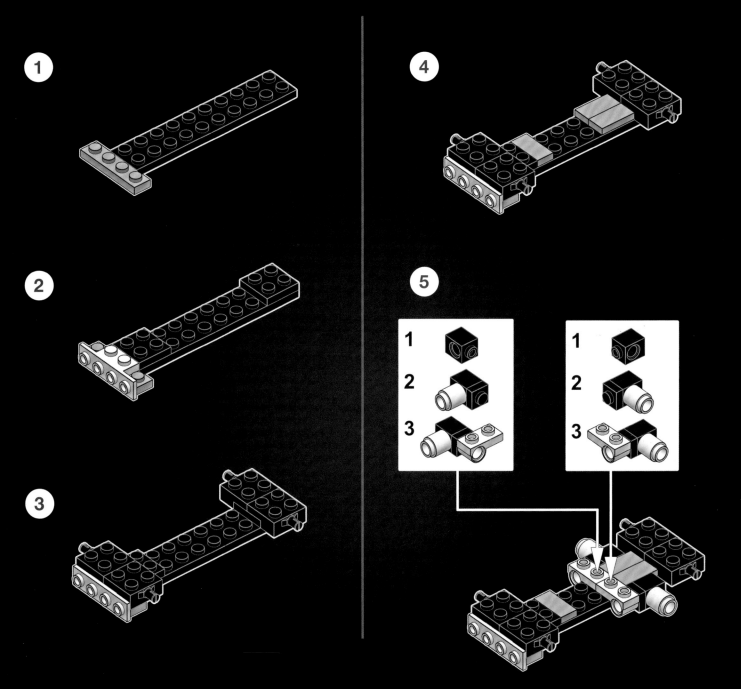

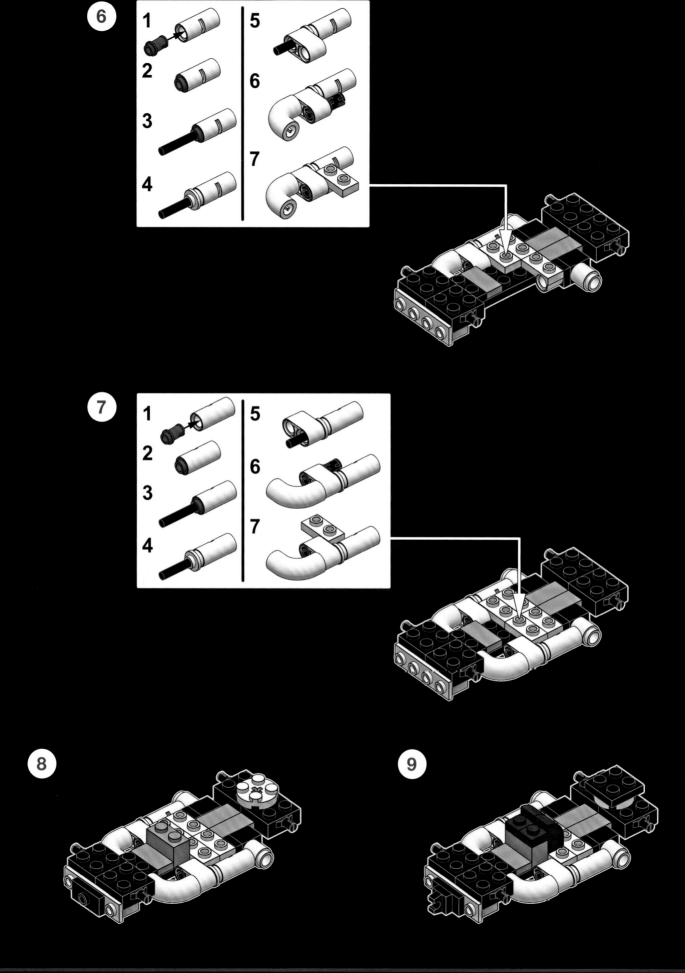

10

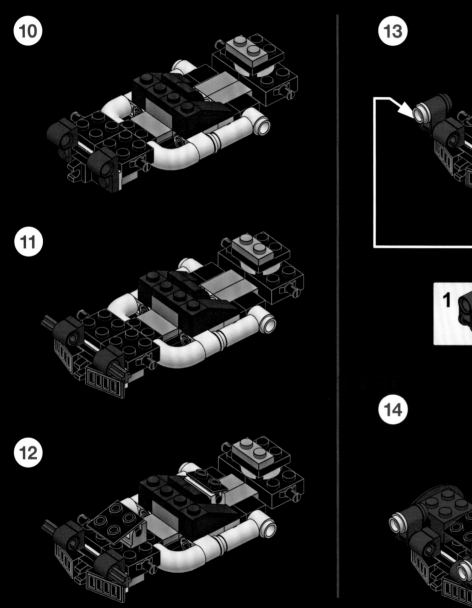

11

12

13

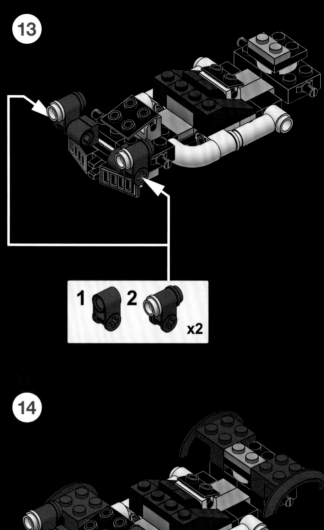

1	2	
		x2

14

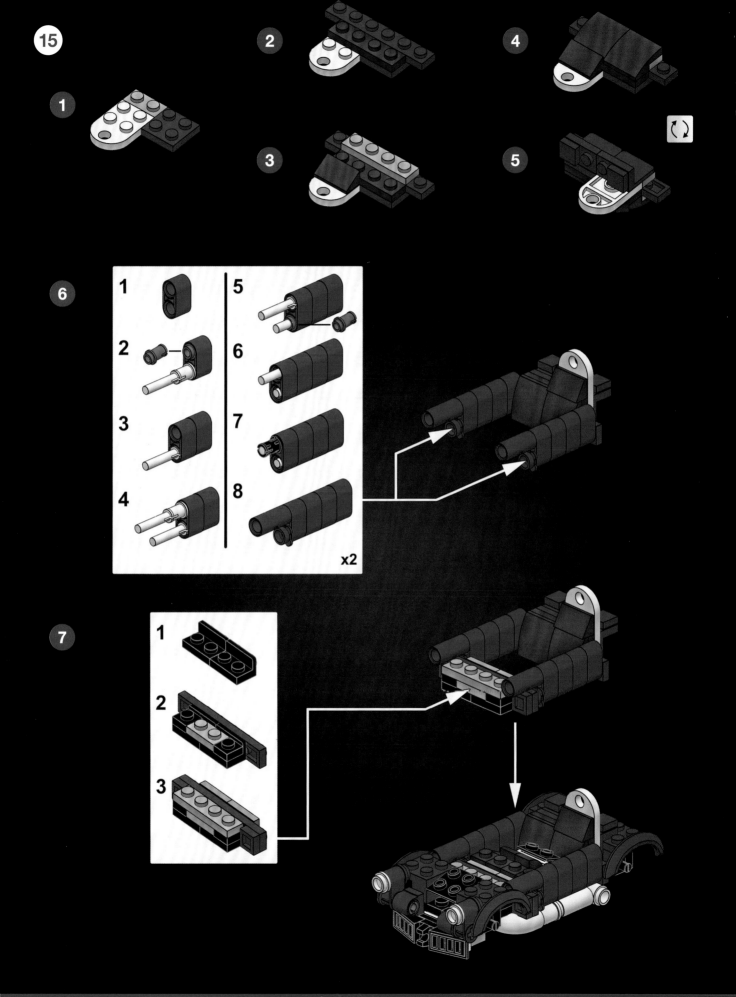

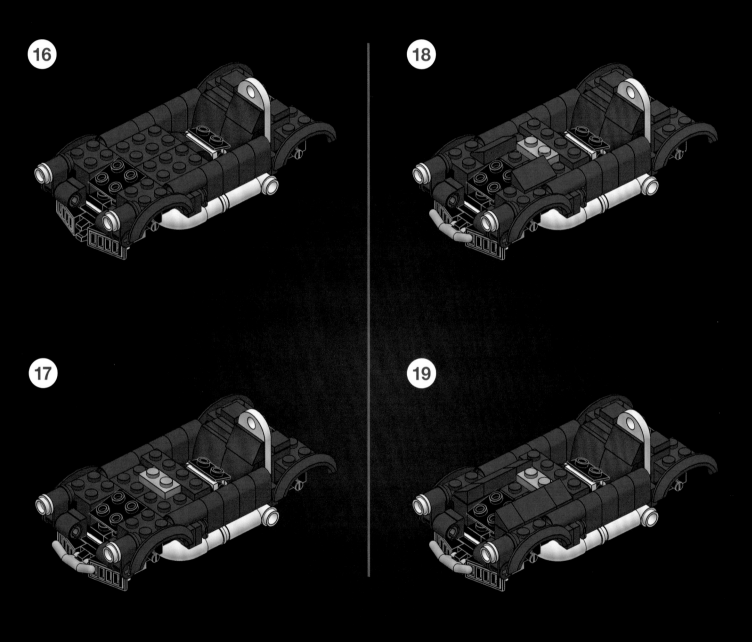

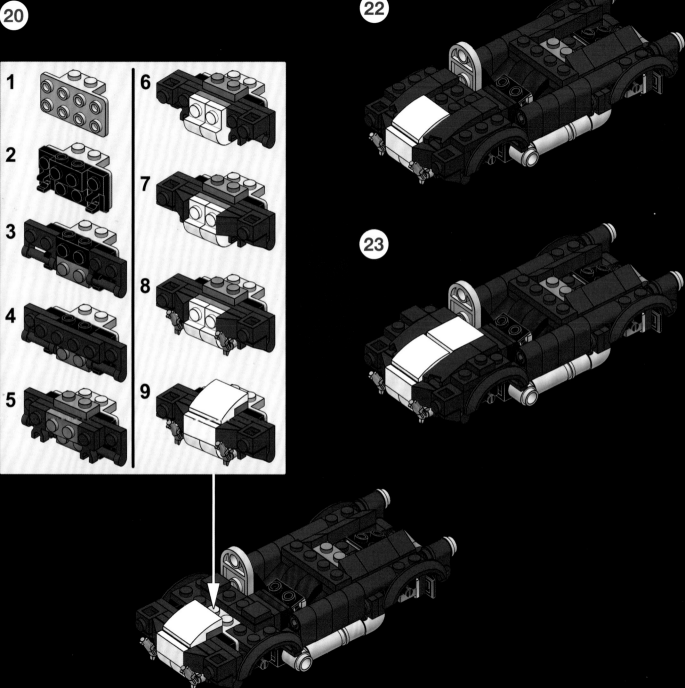

27

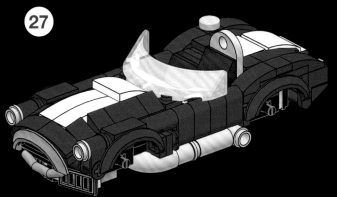

28

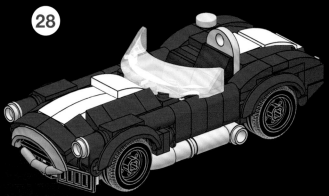

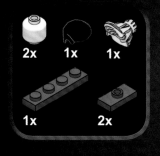

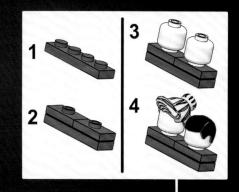

B **Bonus step**

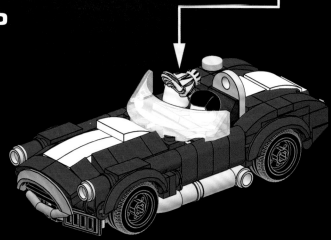

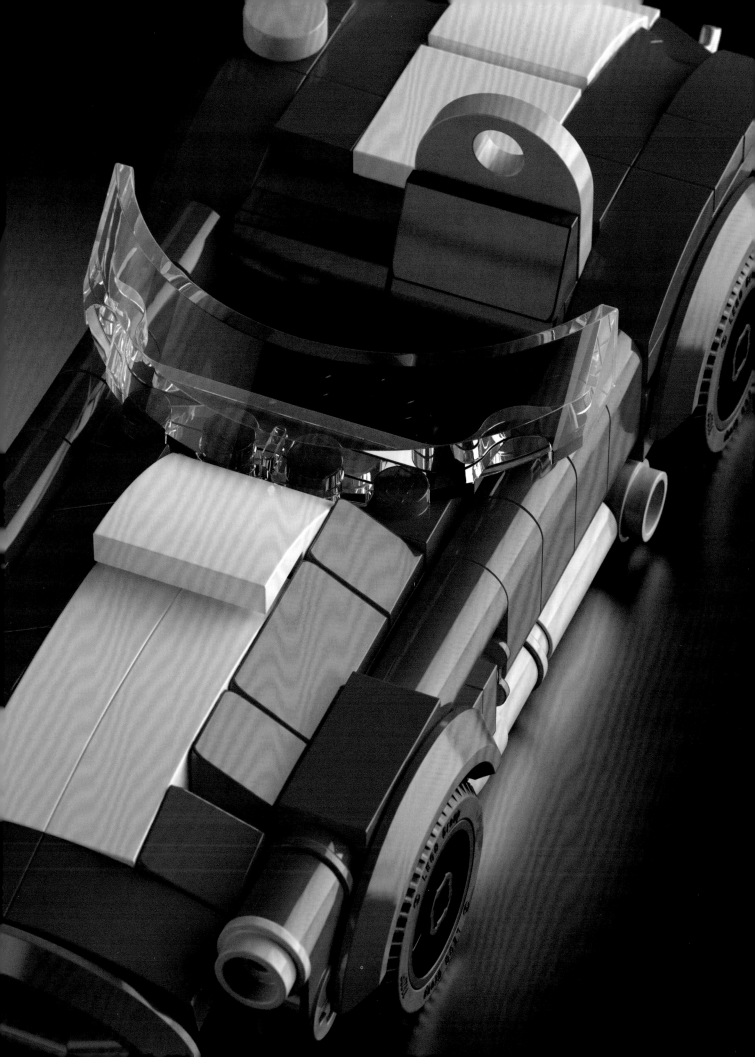

 30155

 11209

Custom wheels and rims

A

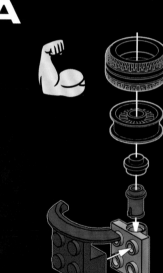

1

93595

50944

30155

50951

93593

55982

B

Options

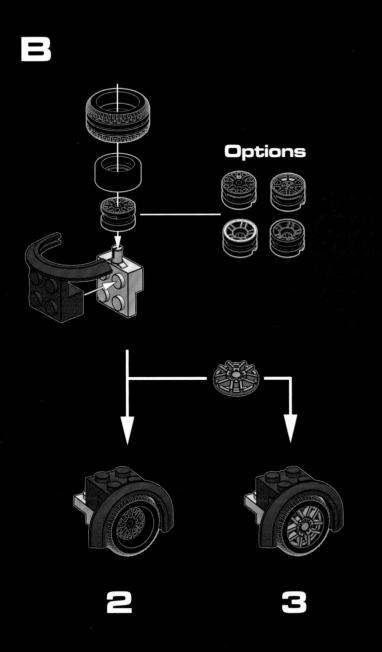

2

3

C

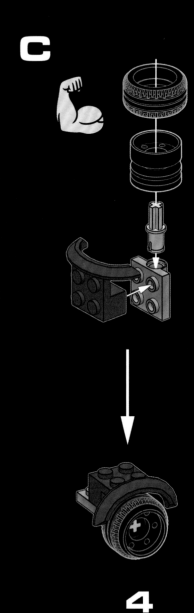

4

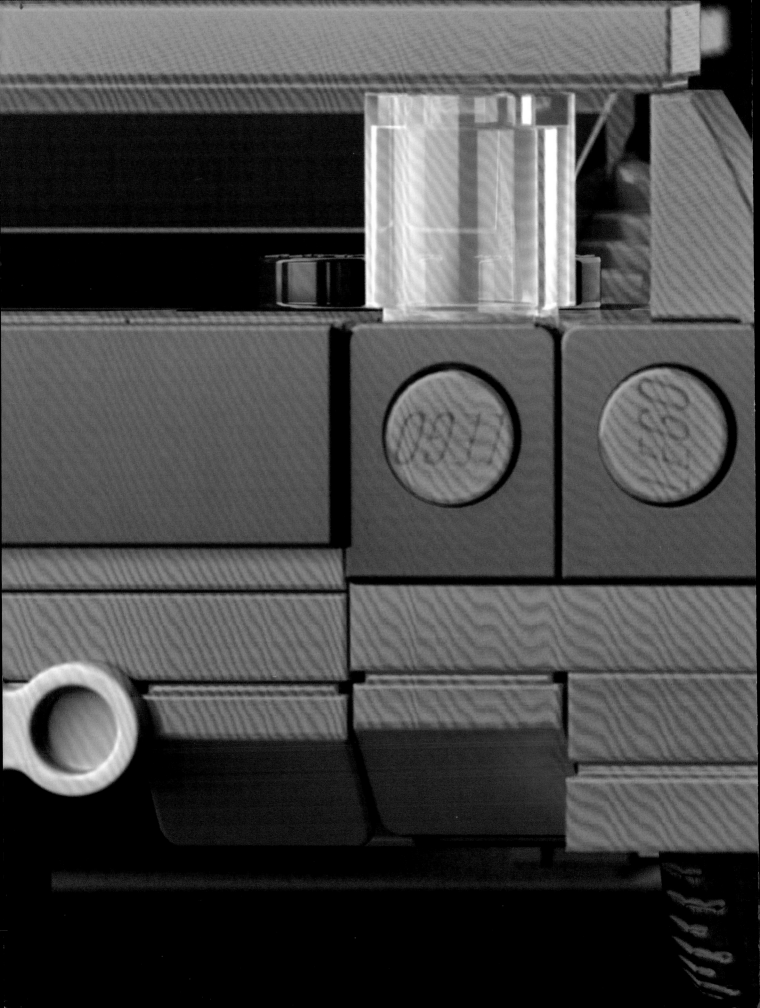

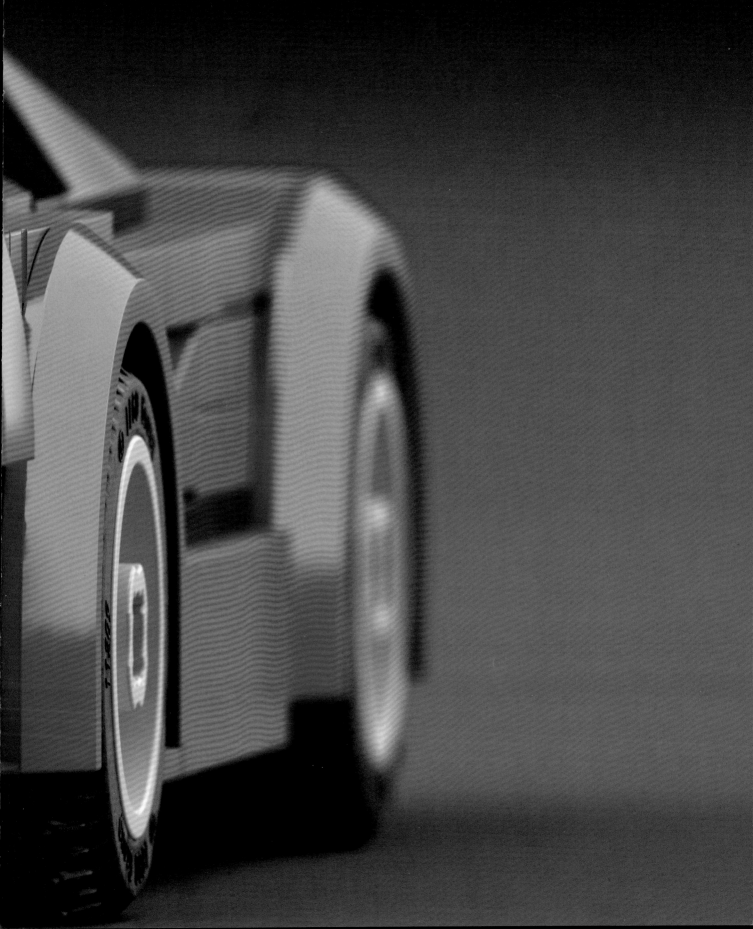

Thunder Bay Press
An imprint of Printers Row
Publishing Group
10350 Barnes Canyon Road,
Suite 100
San Diego, CA 92121
www.thunderbaybooks.com

Copyright © 2018 Nuinui, Italy

Printers Row Publishing Group is a division of Readerlink Distribution Services, LLC.
Thunder Bay Press is a registered trademark of Readerlink Distribution Services, LLC.

All notations of errors or omissions should be addressed to Thunder Bay Press, Editorial Department, at the above address. All other correspondence (author inquiries, permissions) concerning the content of this book should be addressed to Nuinui Srl, Via Galileo Ferraris 34, 13100 Vercelli, Italy.

Thunder Bay Press
Publisher: Peter Norton
Associate Publisher: Ana Parker
Publishing/Editorial Team: April Farr, Kelly Larsen, Kathryn C. Dalby
Editorial Team: JoAnn Padgett, Melinda Allman, Dan Mansfield

Cover Design: Clara Zanotti
Graphic Design: Mattia Zamboni, Marinella Debernardi
Texts: Enrico Lavagno
Translation: Contextus s.r.l., Pavia (Richard Kutner)

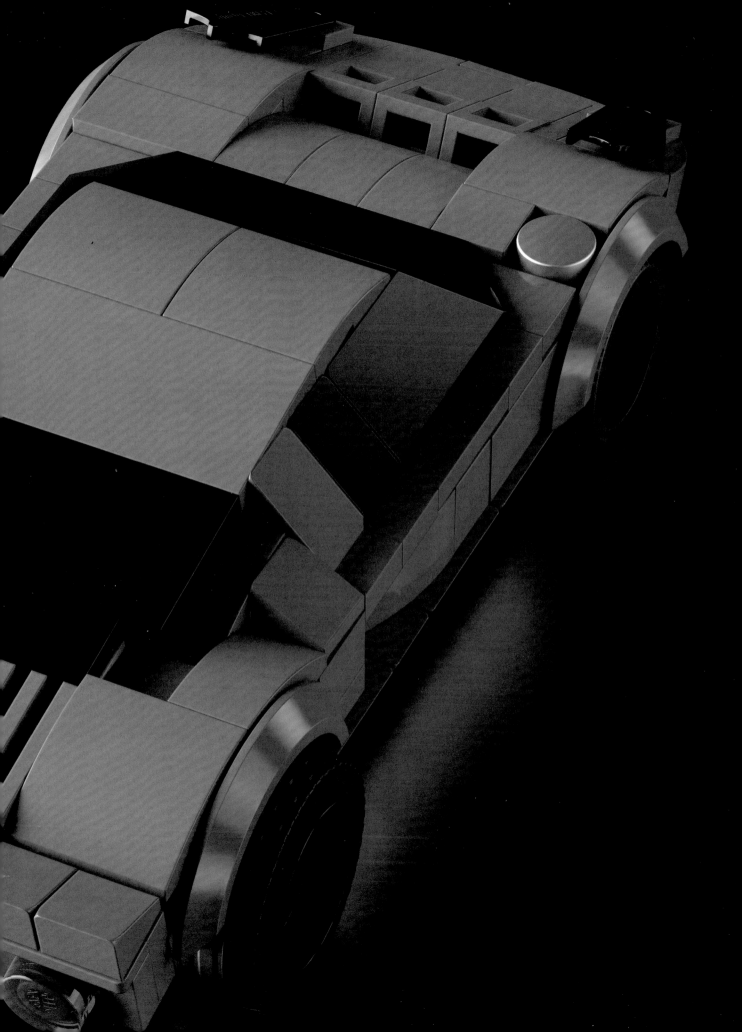

HOW TO BUILD
DREAM CARS
WITH LEGO® BRICKS

Mattia Zamboni • George Panteleon

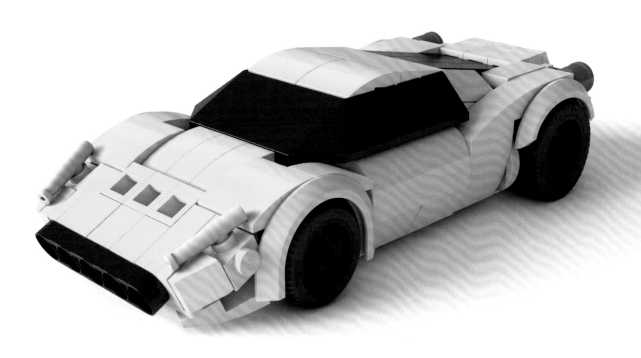

THUNDER BAY
P·R·E·S·S

San Diego, California